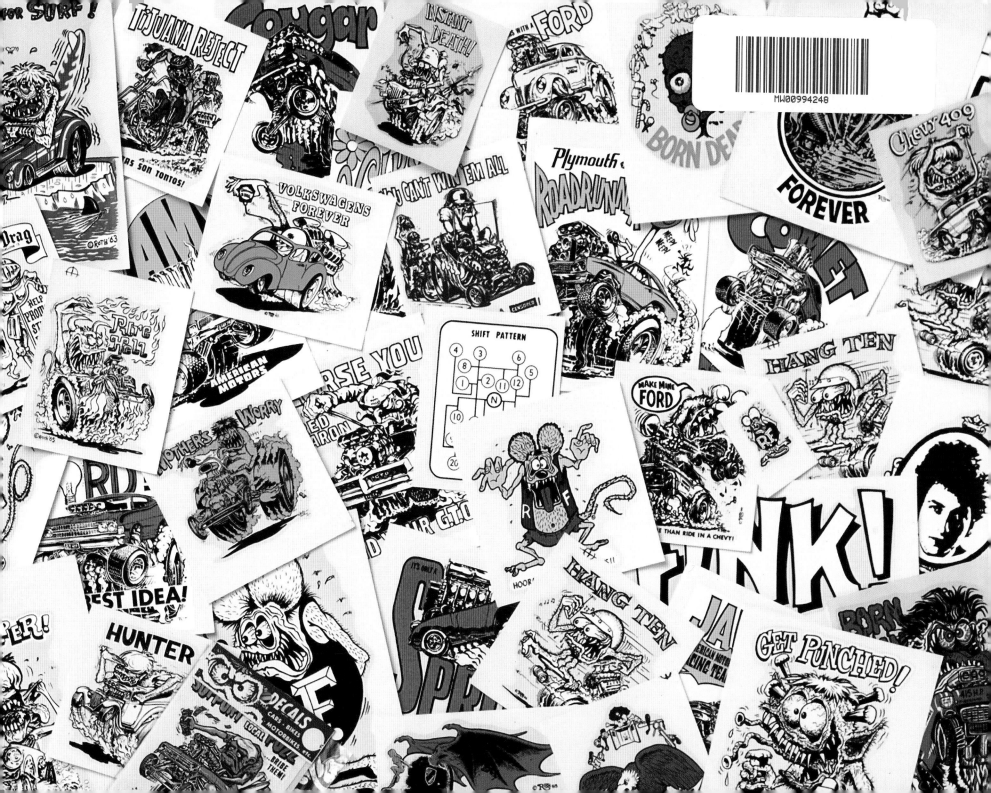

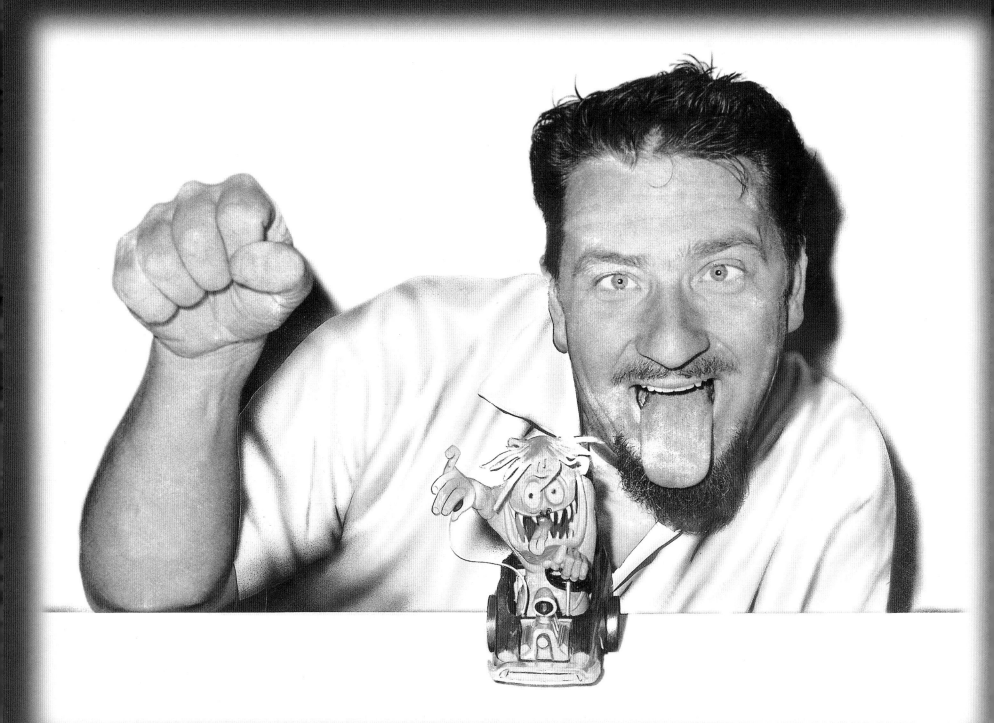

RAT FINK: THE ART OF ED "BIG DADDY" ROTH

Published and Distributed by

Last Gasp of San Francisco
777 Florida Street
San Francisco, California 94110

Phone: 415-824-6636
Fax: 415-824-1836
www.lastgasp.com

Book and Jacket Design: Tornado Design, Los Angeles
www.tornadodesign.la

Art Direction/Design: Al Quattrocchi, Jeff Smith and Aaron Kahan
Design Assistance: Tritia Khournso, B. Scott Hanna and Mikako Ito

Editors: Ren Messer and Drew Hardin

Contributing Writers: George Barris, Dave Burke, Jimmy C.,
Chris "Coop" Cooper, David Chodosh, Greg Escalante, Von Franco,
Rob Fortier, George Goodrich, Bert "The Shirt" Grimm, Verne Hammond,
Doug Harvey, House Industries, Dr. Arthur Katz, Ren Messer,
Ken "Mitch" Mitchroney, Douglas Nason, Ed Newton, The Pizz, Ilene Roth,
Todd Schorr, C. R. Stecyk III, Robert Williams and Nash Yoshii

Contributing Photography: Carlos Alejandro, Jere Alhadeff, Joe Barnett,
Chan Bush, Steve Coonan, Greg Escalante, Von Franco, Ron Freeman,
Pat Ganahl, Marc Gewertz, Randy Halt, Aaron Kahan, Nicole Kahan,
Ren Messer, Douglas Nason, Fred O'Connor, Ken Roshak, Ilene Roth,
Mike Salisbury, Junior Sammet, Ron Slenzak, Z. Diane Sopher, C.R. Stecyk III,
Jim Staub, Gerald Twamley and Nash Yoshii

Editorial Assistance: Drew Garcia-Price, George Goodrich, Aaron Kahan,
Randy Kelley, George Roth, Ashley Sakai and Zan Dubin-Scott

Corner Flip Book Animation: Max McIntyre

Licensing: Ed "Big Daddy" Roth, Inc.: Ilene Roth and David Chodosh

Computer Technical Assistance: Tim O'Neill and Fred "Red Rocket" Ruby

Contributing Collectors: Shawn and Sheridan Attema; Jim Aust; B. E. Baldwin;
Mickey Bernheim; Ted Blackman; Jim and Danny Brucker; Dave Burke;
Jimmy C.; Mike Calamusa; Stan Chersky; David Chodosh; Lynn Coleman;
Tom "Top Cat" Cook; Chris "Coop" Cooper; Adam Cruz, Andy Cruz,
Ken Barber and Rich Roat with House Industries; Jeffrey Decker;
Downtown Willy; Greg and Kirstin Escalante; Jon "Fish" Fisher;
Roy Fjastad; Ray Flores; Von Franco; Coby Gewertz; George Goodrich;
Bert "The Shirt" Grimm; Verne Hammond; Eric Herrmann; Debi Jacobson;
Aaron Kahan; Merry Karnowsky; Dr. Arthur Katz; Jason Kennedy;
Brooke Levasseur; Long Gone John; Dena Lux; Richard Martinez;
Mark McGovern; Martin McIntosh; Dennis McPhail; Charlie Miller;
Ken "Mitch" Mitchroney; Craig and Jolene Myers; Douglas Nason;
Ed Newton; Adrian Olabuenaga; Fred O'Connor; Mark Parker;
Lou Perdomo; Gregory and Marcela Phillips; Gary Pressman; Dale Reppert;
Junior Sammet; Keisuke and Shinsuke Sawa with Random; Todd Schorr;
Z. Diane Sopher; C.R. Stecyk III; Dan Stiel; Fausto Vitello; Shawn Warcot;
Suzanne Williams and Gil Wright

Preface © 2003 Ilene Roth.

Foreword, Introduction: From Monsters to Mormonism, and captions © 2003
Douglas Nason.

Road to Rumpsville © 2003 C.R. Stecyk III & Ren Messer.

Anti-Detroit: Automotive Works of Art by Big Daddy © 2003 Rob Fortier.

Roth Studios © 2003 Ed Newton.

Brother Rat Fink and the Eruption of the Grotesque in Pop Culture © 2003
Doug Harvey.

Afterword: Is It Really "Art"? © 2003 Robert Williams.

Authors Douglas Nason and Greg Escalante
may be contacted at:

Copro/Nason Fine Art, Inc.
11265 Washington Boulevard
Culver City, California 90230

Phone: 310-398-2643
Fax: 310-398-7643
www.copronason.com

ISBN-13 978-0-86719-544-6 Softcover (First Edition: 6,000 copies)
ISBN-13 978-0-86719-545-3 Hardcover (First Edition: 2,000 copies)

Second Printing, October 2003
Third Printing, January 2005
Fourth Printing, May 2006
Fifth Printing, March 2008

Printed at: Prolong Press in Hong Kong

This book is typeset in the following fonts: Adobe Futura; House Industries
Fink Bold, Fink Heavy, Fink Sans, House Upright and House Brush
Paperstock: Cover/Curious Metallic Ice Gold, Book/Tri-Pine Glossy Text

Front Cover: Ed "Big Daddy" Roth (detail) from the original Revell Rat Fink model kit,
1963 (courtesy of Revell-Monogram), Rat Fink by Ed "Big Daddy" Roth and Jean
Bastarache (courtesy of Copro/Nason) and perimeter pinstriping by Von Franco.

Back Cover: Ed Roth (courtesy of Ed "Big Daddy" Roth, Inc.) and perimeter
pinstriping by Von Franco.

Endpaper (Inside Front Cover): Ed "Big Daddy" Roth 1960s decals.
(photo by Ron Slenzak; collections of Aaron Kahan and Verne Hammond)

Endpaper (Inside Back Cover): Ed "Big Daddy" Roth 1960s decals.
(photo by Ron Slenzak; collection of Jon "Fish" Fisher)

Frontispiece: Ed "Big Daddy" Roth posing with his Revell "Mr. Gasser!" model kit.
(photo collection of Verne Hammond)

This Page: Profile of a Fink (Sweep) (Courtesy of Bert "The Shirt" Grimm)

Opposite Page: Ed "Big Daddy" Roth with RF neon top hat at the Kustom Kulture
opening in 1993 and perimeter pinstriping by Von Franco. (photo by Greg Escalante)

RAT FINK

THE ART OF

Ed "BIG DADDY" ROTH™

Preface by Ilene Roth

Forword, Introduction & Compilation by Douglas Nason

Contributing Essays by Rob Fortier, Doug Harvey, Ed Newton, C.R. Stecyk III & Ren Messer

Afterword by Robert Williams

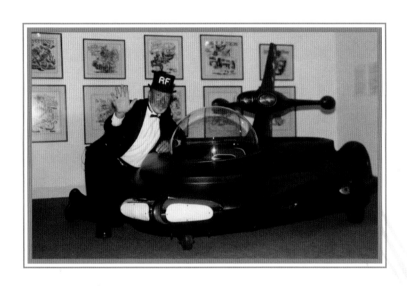

Dedicated to Ed "Big Daddy" Roth and the legacy you left us.

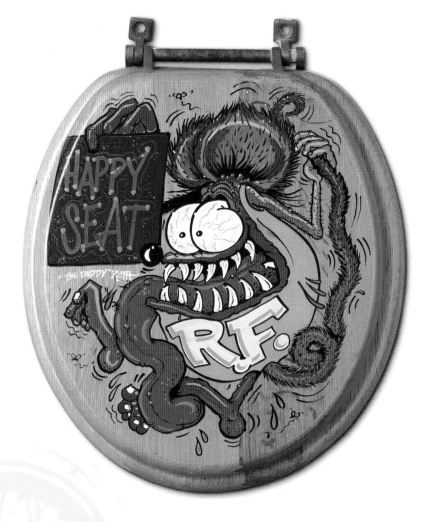

Contents

Opposite: Ed "Big Daddy" Roth with the Rotar at the opening of the Kustom Kulture exhibition, Laguna Art Museum, 1993. (photo by Z. Diane Sopher; courtesy of Downtown Willy)

Centerspread: Detail of Harley Hound decal, Ed "Big Daddy" Roth, 1965. (collection of Aaron Kahan)

Above: Happy Seat, 1994. Big Daddy spent most of the day painting this toilet seat at a Rat Fink party at Hot Rod's shop in Norco, California. (photo by Ren Messer; courtesy of Copro/Nason Gallery)

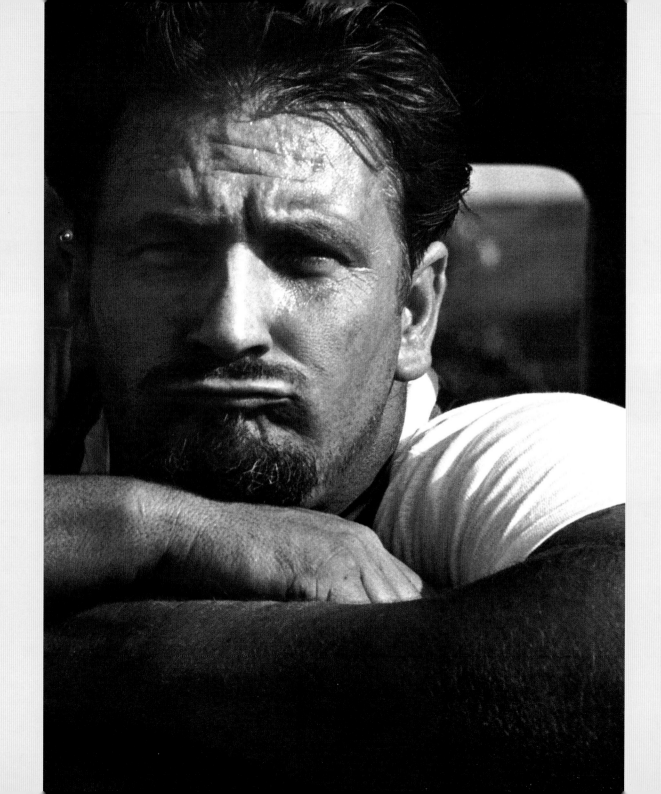

8

Preface

Ed was a very spiritual man. He believed that his talents were a gift from our Father, and that he was to use them and share his creations with everyone. Ed attributed his inspiration for each of his car designs to God. The idea would just come to him, and he would then build it. Building each car was an act of faith.

Ed loved to learn. At car shows he would ask people, "What do you do for a living?" They would share their lives with him, and Ed would retain the facts in an effort to better his own life. He would always say, "What did we learn from this?" That's why we went to the shows: We went to learn. Ed always had a car for people to enjoy, and he would sketch pictures for his fans. He was the greatest person to visit with, often taking extra time to meet with fans, sign their work and sometimes create new work for them on the spot.

Ed loved to draw. I loved watching him create through air brushing, pinstriping and sketching. His hands were always busy. He loved color. He loved his Rat Fink. He created many other monsters and left us with many more to share with you. He offered T-shirts, decals, stickers, posters, models, lawn finks, clocks, magnets, statues, books, magazine articles, videos and many other products, remembering to always make something new for the "next show." Many of his car designs were honored by being turned into model kits. He said simply, "I guess they liked that one." Several large companies licensed Ed's artwork to advertise their products.

He enjoyed reaching the public through his creations. He was a very ambitious man and worked extremely hard, but he also knew how to love life.

He loved his many friends and fans too. It is amazing to realize how many people have become artists or car builders because of his influence. Ed's dream of earning a living through creating was fulfilled. He always encouraged other people to use their talents and pursue their dreams.

My marriage to Ed, and the time we spent together, gave me the intimate and complete life I believe everyone in this world is searching for. He was a very kind, gentle, thoughtful companion. Ed was my "Sweetie."

This book is a thoughtful reminder of all the wonderful gifts he shared and a tribute to the artist he truly was.

— **Ilene Roth**

Above: Ilene and Ed hanging out at the Moooneyes Rat Fink Reunion, 1999. (photo by Bill Trevino)

Opposite Page: Roth puckers up for a mid-'60s publicity shot. (photo by Chan Bush; photo collection of Verne Hammond)

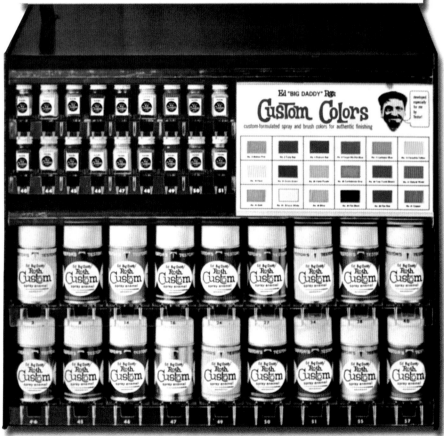

Ed "BIG DADDY" ROTH TESTOR'S

Roth Customizing Center

custom metallic, candy and metal-flake finishes in matching spray and brush colors

Ed "BIG DADDY" Roth
Custom Colors
custom-formulated spray and brush colors for authentic finishing

Foreword

BY DOUGLAS NASON

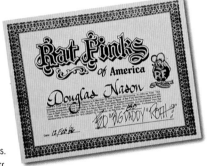

I vividly remember bicycling down to the toy store as a kid and seeing the dazzling "Big Daddy" Roth model-kit and paint-detailing displays. I couldn't take my eyes off them. Roth's designs tapped into something inside this 10-year-old kid and blew my mind. After spending my entire allowance on one of Roth's monster or car kits, I would ride down to the drug store to read *CARtoons*, a comic magazine featuring tales of Roth's antics. I would then pedal over to the Schwinn dealer and hang out with the older kids who wore Rat Fink T-shirts while customizing their Roth-inspired "chopper" style Sting-Ray bikes, some of which were equipped with Roth's Wham-o Wheelie bars. Returning home, I would build yet another of Roth's plastic models and then proudly display it to the neighborhood kids.

As much as I would like to think these cherished memories are uniquely mine, they are not. In fact, I'd venture to say that Ed "Big Daddy" Roth influenced virtually every American baby boomer in one way or another. In the mid-Sixties, every cool car magazine — as well as *Time*, *Life*, and *Sports Illustrated* — featured Roth's customized creations. Do you remember the *Outlaw*, or the *Beatnik Bandit*? Revell's model kits were ubiquitous, here and abroad. Images of Rat Fink, Big Daddy's

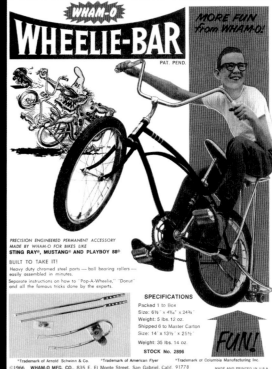

Above: Wham-o Wheelie-Bar magazine advertisement (1966). This was an
Ed "Big Daddy" Roth-endorsed aftermarket bicycle accessory designed as
a safety feature for the Schwinn Sting-Ray. With its chopper-like "long horn"
saddle-styled banana seat, ape-hanger handlebars and dragster-like rear
slick, the Sting-Ray bicycle's 1963 design was directly inspired by the Kustom
Kulture craze, which was a movement that Ed Roth helped pioneer. Obviously,
the Wham-o Wheelie bar's design was appropriated from those used on
dragsters, drag bikes and funny cars. (collection of Dale Reppert)

Left: Model Fink, 1990, by Todd Schorr. This classic painting honors Todd's
childhood memory of building styrene plastic monster kits back in the '60s.
(collection of Ted Blackman)

Opposite Top: The author's official Rat Finks of America certificate
No. 158 from 1986.

Opposite Left: Testor's Ed "Big Daddy" Roth Customizing Center.
(collection of Verne Hammond)

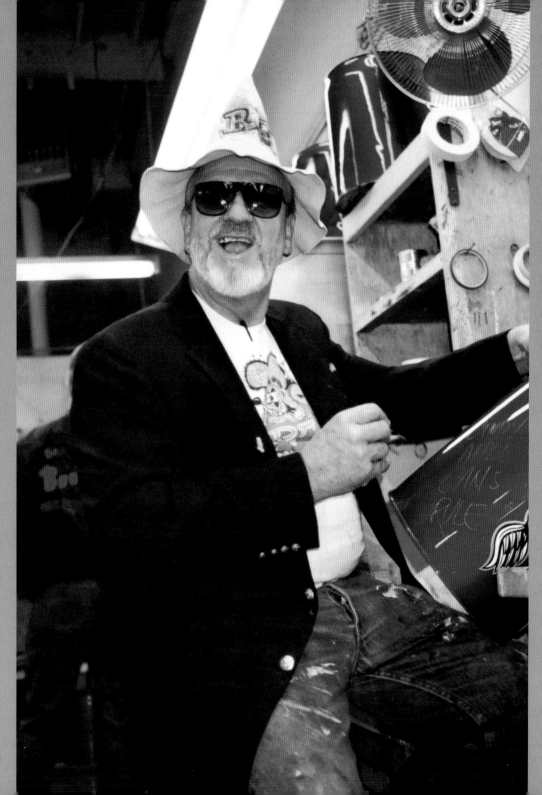

Ed "Big Daddy" Roth painting a garbage can at an early 1990s Rat Fink Reunion party at Kim Dedic's sign shop in Fullerton, California. Rat Fink Reunion parties always culminated with a charity auction where items such as these were sold to die-hard collectors. (photo by D. Nason)

12

slobbering counterculture icon of a wart-pocked, hot-rodding rodent, were everywhere. Did you have a sticker? How about a key-chain? Maybe a T-shirt?

A couple of decades later, I saw Big Daddy at a car show in Long Beach, signing autographs and churning out airbrushed T-shirts beside his wild cars. Just like in the Sixties, his booth was the most popular in the show, and memories of my zany childhood hero came flooding back. Big Daddy was still an eccentric beatnik who never seemed to lose touch with "the little boy inside the man," even if he had become a devout Mormon along the way. A short while later, I saw the epic "Western Exterminator" exhibit at Los Angeles' 01 Gallery, which featured Roth alongside artists Von Dutch and Robert Williams. Soon I began to faithfully attend the Southland's annual Rat Fink Reunion parties.

Through these events, I got to know Roth and realized he was still a major inspiration to me and to pop culture in general. In 1991, I asked BDR to allow me to publish some of his monster images as fine art prints. I envisioned elevating his T-shirt designs into high quality fine art, to put him on par with blue-chip artists famous for their limited-edition screen prints, such as Andy Warhol, Ed Ruscha, and Roy Lichtenstein. By the mid-1990s, my art publishing partner Greg Escalante and I had curated some Big Daddy art exhibitions, and we had produced several limited-edition prints with the help of master screen printer Jeff Wasserman.

Working with Roth could be a little frustrating, to put it politely. He demanded awkward meeting times — sometimes as early as 5 a.m. — and required I provide him with plenty of donuts or hot dogs before talk of business could begin. When traveling long distances,

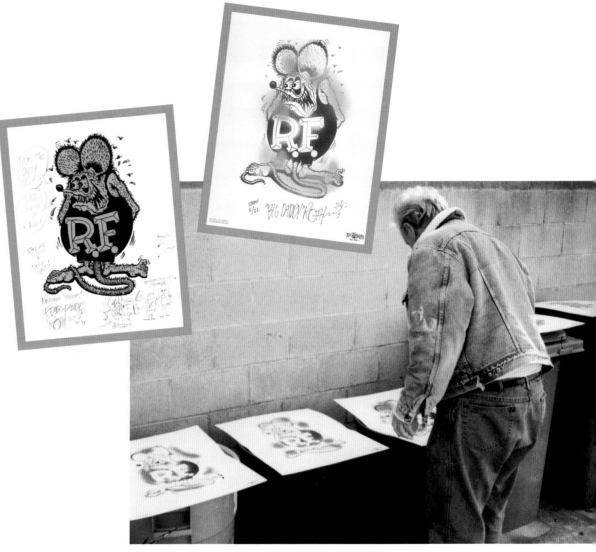

Above Left: Rat Fink: The Diamond Dust Edition *fine art print adorned with Big Daddy's remarques. (courtesy of Copro/Nason)*

Above Right: Rat Fink: The Original *fine art print with T-shirt style spray bombing. This technique was pioneered by Roth in the late '50s. (courtesy of Copro/Nason)*

Below: Big Daddy spray bombs Copro/Nason prints in an assembly line style using trash cans as an easel, 1995. (photo by D. Nason)

he would discourage me from flying or taking a room for the night. He preferred to sleep in his truck or under the stars. He insisted we conduct our business outside, and he would sign all of our fine art prints on the hood of his car. Big Daddy's contracts were inimitable; one mandated that a large anchovy pizza be delivered to him twice a day during his appearance at a swank New York gallery. Roth constantly challenged my ideas and often complained to me that I was "moving too slow." I looked on these idiosyncrasies as though he were simply a prankster who, on occasion, enjoyed throwing a wrench into the works just to see you squirm.

At times, these antics tested my resolve. But in time, I came to understand that, in addition to being extremely creative and innovative in custom-car building, monster designing, T-shirt designing, pinstriping and sign painting, BDR was a do-it-yourself

businessman driven by his underlying ethics and the belief that he would someday have to answer to a higher power. He was a man with a definite vision and was very protective of how Rat Fink and his other monster images were portrayed.

Nevertheless, Roth would always proclaim he was not an artist, which was something I would always refute. The more I learned of Roth, the more diverse his artistry appeared and the more apparent his contribution to popular culture became. Knowing his amazing body of work

needed to be documented, I started collecting and photographing everything I could get my hands on. Escalante and I always told BDR that he was an important artist, and that we were preserving high quality images of his work in order to publish a definitive art book someday. Much had been deservedly written on Roth's cars, but a book that presented him as the versatile, multimedia artist he was had been long overdue.

I would like to thank Big Daddy's beloved wife, Ilene Roth, for entrusting me to present what I believe are BDR's most monumental artistic achievements. Thanks also go to Ron Turner and his company, Last Gasp, for believing in this project and publishing this book; the book's amazingly talented contributors, including Ren Messer (photography, biography, and editing) and C.R. Stecyk III (biography); Doug Harvey (art essay); Rob Fortier (custom car essay); Ed Newton (working with Roth essay); Robert Williams (afterword); Roth's collectors (without whom this book would not have been possible); Tornado Design (the book's designers), and Greg Escalante (co-owner of Copro/Nason Fine Art).

Finally, after spending months reviewing Roth's achievements and contemplating the time I spent with him during the making of this book, I understand why this book was of such personal importance and meaning to me. I realize that Ed "Big Daddy" Roth was not just my childhood hero, he is my adult hero and role model, as well! God Bless you, Big Daddy, for touching our lives and for being a major contributor to contemporary culture.

Artiste, a T-shirt design poking fun at the sophisticated, high-falutin' art world. (courtesy of Bert "The Shirt" Grimm)

Opposite Page: Ed "Big Daddy" Roth finishing some pinstripe designs on the under-side of a toilet seat cover at a 1994 Rat Fink party. (photo by Greg Escalante)

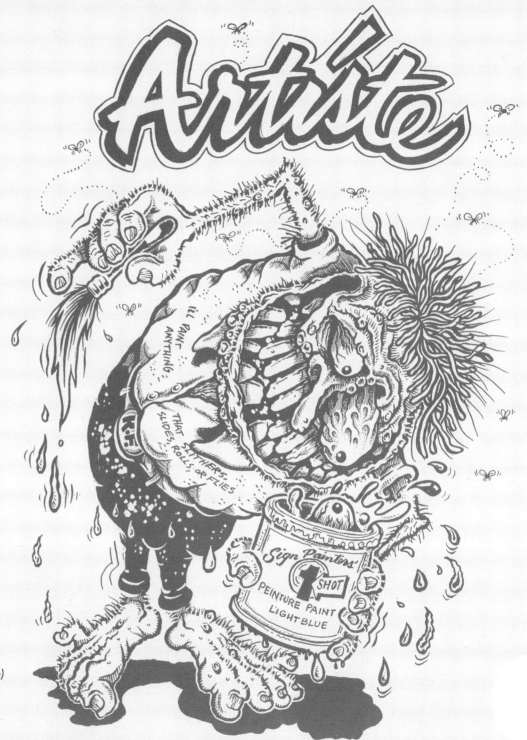

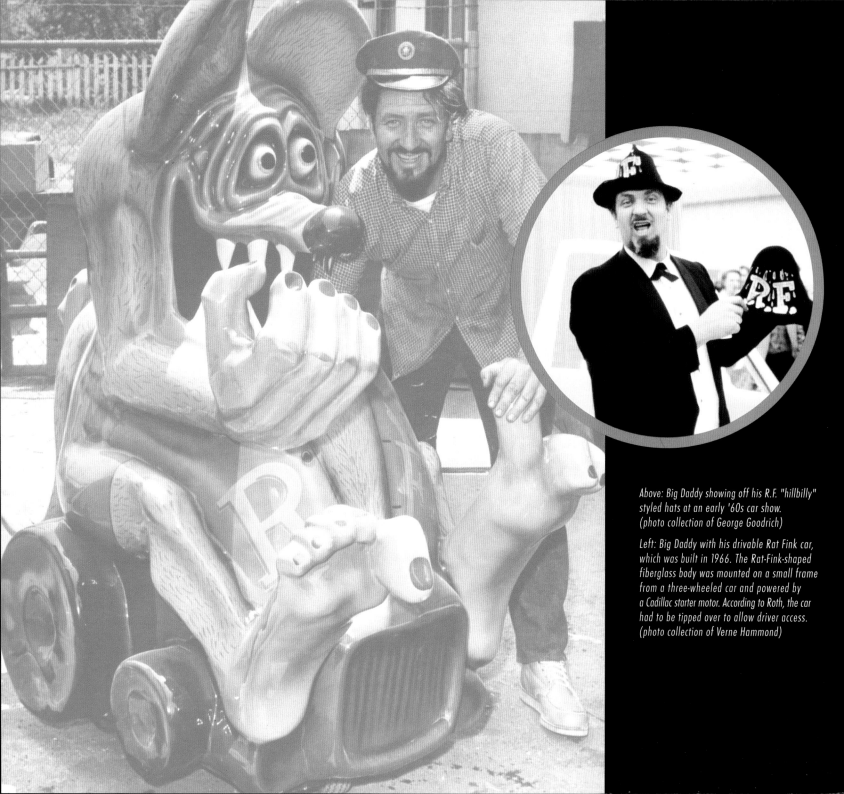

Above: Big Daddy showing off his R.F. "hillbilly" styled hats at an early '60s car show. (photo collection of George Goodrich)

Left: Big Daddy with his drivable Rat Fink car, which was built in 1966. The Rat-Fink-shaped fiberglass body was mounted on a small frame from a three-wheeled car and powered by a Cadillac starter motor. According to Roth, the car had to be tipped over to allow driver access. (photo collection of Verne Hammond)

INTRODUCTION: From Monsters To Mormonism

BY DOUGLAS NASON

Shortly before meeting his beloved wife Ilene, Ed "Big Daddy" Roth attended a singles hootenanny, where one of the gals at the dance inquired about his mode of employ. "I draw monsters for a living!" he responded. The nice lady had no idea what Roth meant, but of course he'd spoken the simple truth, simple being the operative word. What, after all, could be any less complicated than a slobbering, fly-infested, hot-rodding rat? It was part of Big Daddy's raging success that kids got it right away. To them, no explanation was necessary.

Scratch the surface, however, and you quickly discover a whole lot more about Roth. He was a "Renaissance Man," whose varied talents and enormous influence weren't confined to a single realm or medium. Big Daddy was a highly versatile artist with a flair for expressive caricature who could draw, paint, pinstripe, airbrush, and silk-screen. He designed everything from unique signs, to original monster T-shirts, to one-of-a-kind roadsters and even drivable sculptures,

including a fully operational Rat Fink on wheels. Legions of baby boomers adopted Roth's idiosyncratic style of drawing monsters and cars. His impact bridged the yawning divide between low-brow culture and high-society fine art. Many museum-class artists now use the same raw materials he chose to make his cars shimmer and shine.

In its posthumous tribute, printed shortly after Big Daddy's April 4, 2001 demise, the art magazine *Juxtapoz* dubbed Roth "The Greatest Artist of the 20th Century." Writer C.R. Stecyk III stressed the importance of Roth's cross-pollination among the worlds of hot rodding, surfing, skating and art. Roth's gift for merchandising, his do-it-yourself, jack-of-all-trades style, set him apart. His true genius, Stecyk noted, was in packaging. Roth combined his talent for caricature with the tools of custom-car painting to come up with his monster shirts, which he sold at car shows where his motorized creations were on display.

Above: Juxtapoz (Issue #34, September/October 2001) art magazine paid extraordinary tribute to the late Ed Roth by dubbing him the greatest artist of the 20th century. (collection of Greg Escalante)

Left: If I Gotta Explain You Wouldn't Understand! is an oil on canvas painting commissioned by Roth from artist Jean Bastarache. This is a mid-'90s revision of Roth's classic "Brother Rat Fink" image from 1965. Big Daddy would often revise his T-shirt designs simply for the sake of change. (courtesy of David Chodosh)

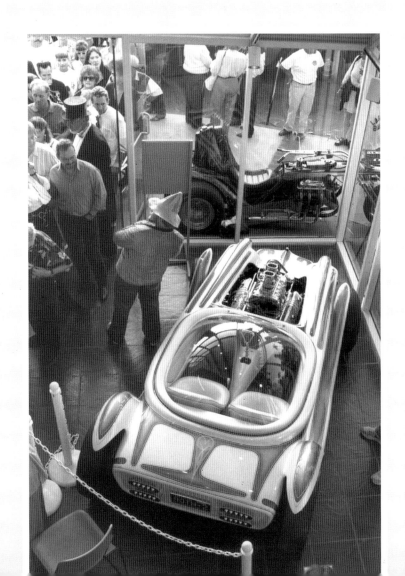

Left: Big Daddy greeting people at the entrance to the Laguna Art Museum, as the doors opened for the Kustom Kulture exhibition in 1993. Roth's Beatnik Bandit, which was built in 1960 and made into a Revell model kit in 1962, was displayed in the museum's foyer. His 1986 trike, Asphalt Angel, stood in front of the museum along with a crowd of people waiting to get in. (photo by Jim Staub)

Centerspread: "Art is What Sells!" is Big Daddy's remarque detail found at the bottom of one of his Rat Fink fine art serigraphs. This succinct statement was Roth's definitive answer to the rhetorical question, "What is good art?" (collection of Junior Sammet)

Roth's T-shirt designs spurred an industry. Prior to Roth's popularity, T-shirts were generic; predominantly white without designs or logos, like the style made famous by James Dean. Roth began making his monster T-shirts at car shows. When demand for his custom airbrushed T-shirts exceeded what he could churn out, Roth figured he could produce a lot more inventory by silk-screening them. The popularity of silk-screened T-shirts quickly spread across the nation.

"What is good art?" BDR asked once. "Good art is what sells!" he answered. Indeed, who is to say what is "better" art — a master oil painting locked away in some plutocrat's vault, or a readily accessible T-shirt with an imposing iconic image that makes a statement about its wearer?

Wherever he made a public appearance, Roth always insisted on setting up a booth, even for bona fide museum exhibitions, like the "Kustom Kulture" show at the Laguna Art Museum in 1993, where he sold his T-shirts, key chains and stickers. Of course, this sort of on-site merchandising annoyed sophisticated patrons, gallery owners and curators to no end. However, BDR had the business philosophy that it was more lucrative to sell low-dollar items all day long than to hold out for one sale of a high-priced, original piece of art. He would insist, "Art work has to be accessible."

Roth continually challenged the Art Establishment. "I've never had the idea that galleries were the way to do these things, they're not normal," he told *Juxtapoz* in its premiere issue. "The rod runs are the museums of the day. Art belongs on the streets, not in some pretentious white box. My stuff is priced so a working guy can afford it. I don't care about people eating cheese and sipping wine

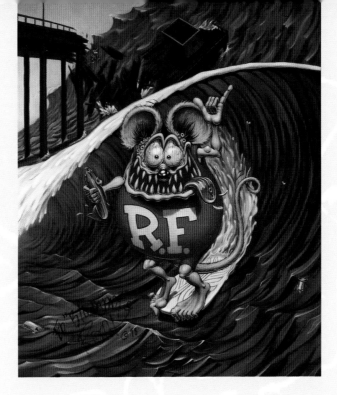

Hang Ten *(1995) is an oil-on-canvas masterpiece conceived by Ed "Big Daddy" Roth and painted by artist Jean Bastarache. (collection of Charlie Miller)*

in tuxedos." Roth was self-taught. His first works were the cars he sketched on his school book covers; he advanced to pinstriping when he got into hot rods. In a 1987 interview, he told Jeffrey Ressner with *Airbrush Action,* "I stay away from people trained in art school, because they draw women and houses and pictures as things are. I draw pictures in my head. Anybody can draw what they see, but my type of art is what you can't see."

Roth rejected the title of "artist" for himself and didn't think much of his draftsmanship. "I can't draw, never have been able to," he once said. "I was just a guy trying whatever wild thought popped into my mind. I never spent any time thinking about art, I just did things. I would go with any concept I understood, based on what was going on around me. The monster stuff was a reflection of the people I knew." However, Big Daddy's sign work,

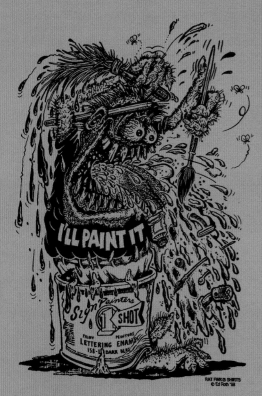

Above: I'll Paint It T-shirt line art.
(courtesy of Bert "The Shirt" Grimm)

Right: The Rat Fink Experience by artist R.K. Sloane (1994).
Along with Rat Fink, this canvas painting includes depictions
of Bad News (1965) and Harley Hound (1965), with two
Von-Dutch-styled flying eyeballs. (courtesy of Copro/Nason)

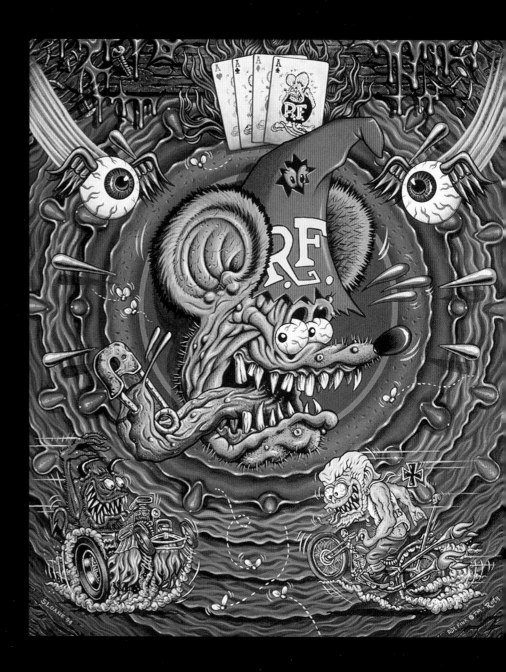

and the intricate illustrations with which he emblazoned his custom cars, bear witness to the fact that Big Daddy was indeed a talented artist capable of producing sophisticated compositions when he took his time.

Roth could be likened to Andy Warhol. Both were considered to be mainly what I call "concept" artists, in that they came up with the ideas but often let others execute them. Warhol had his factory and, in a way, BDR had one too. He collaborated with an arsenal of artists across the country. Some did line work, others did color illustrations or canvas painting; some excelled at cars or monsters, and a few at both. Roth's pop sensibility actually predated Warhol's. During one exhibition of his work, he airbrushed a can of Lucky Lager beer on a car show wall. He said it was a fine replica of a Lucky Lager beer, complete with all the details, the highlights, the seals and the small print — just like a Warhol Campbell's soup can. Only this was the very early Sixties, before Warhol started the trend. To Roth, the ideas were more important than the form, so inventing the concepts was a greater achievement than executing them. Roth felt there would always be someone with better technical skills somewhere, but he thought ideas held the potential to change the world.

"Roth the Rebel" didn't do things like most people, which to me was his true genius. As the ultimate non-conformist,

he was a futurist whose ideas led to many projects that were ahead of their time. He was an out-of-the-box thinker before the term became a mantra for conducting business in the 21st Century. In his book *Out of the Box*, author Mike Vance profiled several people whose creativity has significantly contributed to society. Vance, who was instrumental in the creative culture at Disney and worked with Apple during its early days, spotlighted such forward-thinkers as Thomas Edison, Frank Lloyd Wright and Buckminster Fuller. To this list I would add Roth, who constantly pushed the envelope, changing and improving on everything he created simply for the sake of change.

To Roth, it didn't necessarily matter if the change was an improvement, since the market was dynamic and difficult to predict. Roth felt even failed attempts were progress, because they taught him what didn't work. This is the same philosophy used by today's high-tech corporate think-tanks, which are always striving for new ideas and initiatives.

Above: Share Your Cheese *(1992), an airbrush design by Ed "Big Daddy" Roth. Sharing was a concept Big Daddy always preached. His 20-plus instructional booklets testify to Big Daddy's willingness to share his vast knowledge, most of which he learned through the "school of hard knocks!" (courtesy of L'Imagerie Gallery)*

Above Left: Born Bad *mini poster from the late '90s. (collection of David Chodosh)*

Left: A collection of Big Daddy Roth's instructional books, which he self-published during the 1980s. These booklets were crammed full of valuable information on everything from car and trike building, to pinstriping and sign painting, to lettering and airbrushing. (collection of George Goodrich)

21

Below: Mistakes Schimstakes *(1992), an airbrushed design by Ed "Big Daddy" Roth. Mistakes are inevitably encountered on the road to success. (courtesy of L'Imagerie Gallery)*

Centerspread: Concept illustration for Candy Wagon *(1967) by Ed Newton. Roth eventually built this trike out of a three-wheeled meter maid police bike he picked up at a sheriff's auction. (collection of George Goodrich)*

In 1976, BDR told *Street Rodder* magazine he had one basic philosophy: "There must be a better way to do something. If it's been done before, why should I waste the time?" Indeed, Roth worked to create revolutionary, previously unseen machines such as the *Outlaw* (1959) and the *Beatnik Bandit* (1960). "I realize that there's a lot to be said for building replicas just to get the feel of things," he said in *Hot Rod DeLuxe,* in what was likely his last interview, "but there should be a stage of a person's life where he realizes that copying is not where it's at...take a chance! Fail! Fail! Fail! Then you learn what success is all about."

BDR wasn't interested in dealing with Detroit's constrictions. He continually risked it all in an effort to forward automotive design. Roth embraced radical design and alternative products, and he pioneered their use long before others thought they were cool. He was the first to employ asymmetrical curvilinear design by using fiberglass and Plexiglas to build such infamous cars as the *Mysterion,* and the fiberglass-bodied, three-wheeled motorcycles he called "trikes." Roth initiated the use of Honda, Porsche and even Corvair engines in customized cars. He frequently claimed Japan's Dr. Honda and Germany's Dr. Porsche were his heroes for creating the Honda 600 and the VW engines respectively, even though the hot rod/custom car world disdained them.

"I have a lot of convictions," he said in his 1992 autobiography, *Confessions of a Rat Fink,* "...I'm the first to say I stick by them. That's why I never heeded the call of Detroit." Later in his career he designed cars for ultra-efficient gas mileage; his forward thinking led him to predict that the future would require smaller, lighter, more

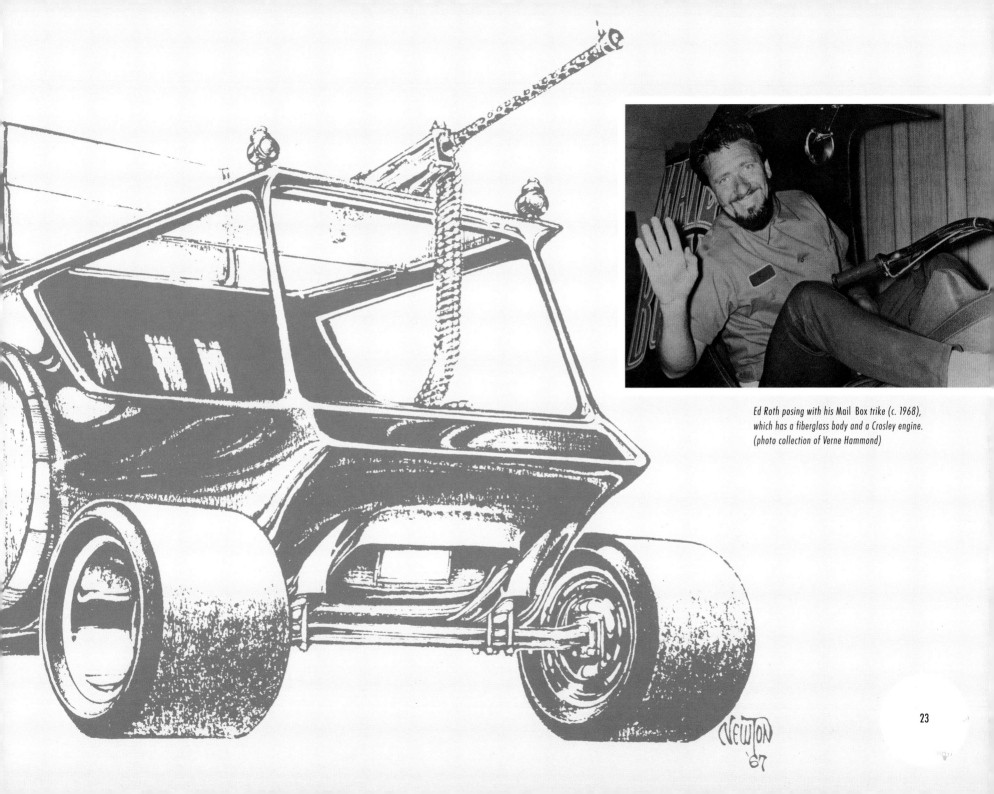

Ed Roth posing with his Mail Box trike (c. 1968),
which has a fiberglass body and a Crosley engine.
(photo collection of Verne Hammond)

fuel-efficient vehicles. These designs included the *Rubber Ducky* (1972), a Honda-powered trike with a 26-gallon fuel tank that he said could travel 2,000 miles on a single fill-up.

Roth thought Harleys were hot long before they were widely accepted as the motorcycle of choice. (It wasn't all that long ago that Harleys were considered "nerd" bikes and European bikes, such as Triumph and Norton, were the rave.) Sticking to his non-conformist guns and maintaining his association with Harley riders got Big Daddy into trouble with Revell. As he relayed in

Confessions, the corporation cancelled his contract because of his association with a band of outlaw bikers. "I never got up enough guts to actually join a bike club, but a few of these lunatics were always ready to ride somewhere...." Roth didn't care for authority of any kind or society's approval. It's part of what made him such an original thinker.

The opinions that mattered most to Roth belonged to children. Always looking ahead, Roth paid attention to what the kids were into. He believed that "kids are the future," as well as the best critics. He advised *Juxtapoz* in its premiere issue, "You can't fake out a kid. Something's either cool or it's not, they either want it or they can't stand it." Roth was a master at figuring out what held shock-value appeal for kids who wanted to freak out their parents. He was convinced that conventionality squelched creativity, as he said in *Confessions.* "Reality is a concept that we try to impose on kids, and sometimes we destroy their ability or desire to fly with thoughts and ideas." Rat Fink was obviously one of the things kids found extremely cool; and Roth's practical nature, in addition to his wild inventiveness, contributed to the creation of the most famous cartoon character in hot rod history. Rat Fink provided Ed with an outlet to express his thoughts, ideas and opinions in a humorous way that people might better be able to relate to. In so doing he became a counter-culture anti-hero.

Rat Fink was a window to Ed's sense of humor, but there was also a serious side to Roth that many don't know about. He was a man of abiding faith. Initially, it seemed to be a faith of his own making. He would always exhibit an unwavering positive belief that it would not rain on a Rat Fink show (which it never did), and an absolute

Below: Roth in Space (1995) by Von Franco. *Needless to say, this airbrush on canvas requires no explanation. (collection of Shawn Attema)*

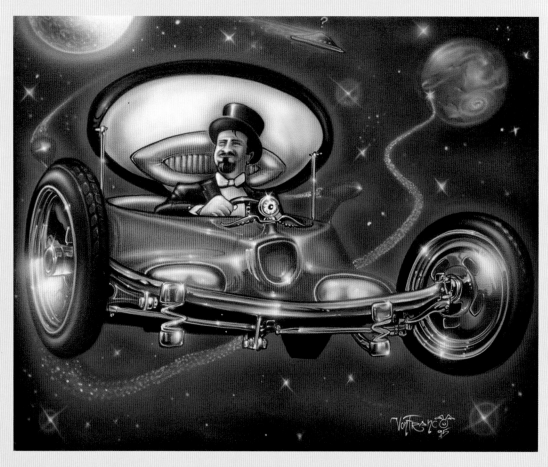

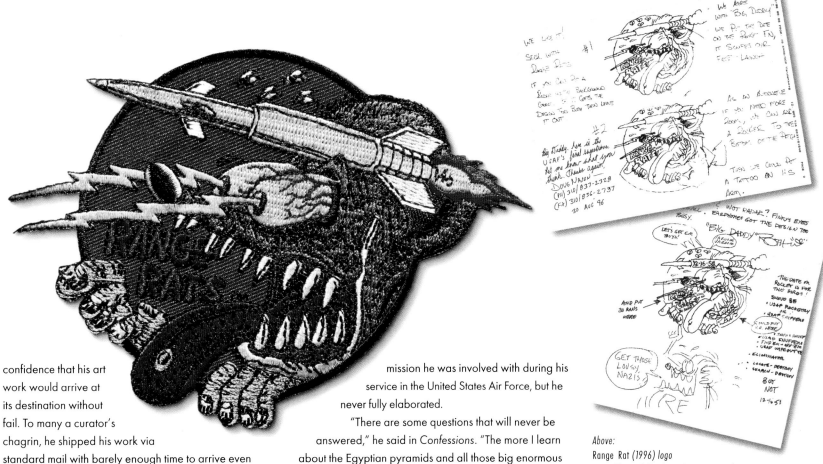

confidence that his art work would arrive at its destination without fail. To many a curator's chagrin, he shipped his work via standard mail with barely enough time to arrive even before big openings.

Roth also seemed to believe in things unseen, UFOs among them. Once, he was creating a uniform logo for a rocket-launching squad of the United States Air Force, and he asked me to negotiate on his behalf: Would they consider trading the logo design for a UFO engine, in lieu of cash? Roth ended up with the money, but could this have been just one more governmental cover-up? I never quite knew if Roth was serious when it came to UFOs. On occasion, he alluded to the top-secret North African

mission he was involved with during his service in the United States Air Force, but he never fully elaborated.

"There are some questions that will never be answered," he said in *Confessions*. "The more I learn about the Egyptian pyramids and all those big enormous stone temples in South America, or any other amazin' phenomena, I realize that we ain't the masters of the universe after all. Who knows who built that stuff? Maybe aliens? Wasn't me, folks! Whoever they were, they were hip and real smart."

Roth's big ideas led him to embrace God through the Mormon Church. It happened around the time that he was hanging out with some outlaw bikers and knew a guy named Frank. "There was this guy next door," he said in *The Rocket* about his early Seventies religious

Above:
Range Rat (1996) logo
created by Roth for the 30th Range Squadron,
United States Air Force. After faxing several concept sketches
back and fourth between Roth, the military squadron and me,
the logo was approved. The final art was executed in pen and ink
by Garry Mizar using BDR's concept sketch. Roth's agreed-to fee
was less than 10 percent of his normal rate for an identity logo.
His explanation: he has "a soft spot in his heart for men in the military."
This logo ultimately became a uniform patch for this rocket-launching
squadron stationed at Vandenberg Air Force Base in central California.
(courtesy of Rudi F. Diamco, 2nd Lt., USAF and Copro/Nason)

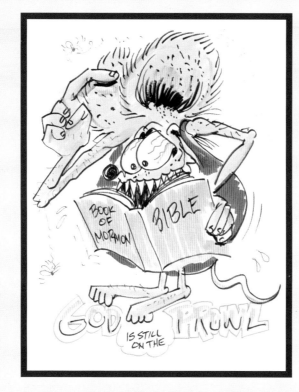

God is Still on the Prowl. *This is one of the 28 Marks-a-Lot illustrations done by Big Daddy in 1995. (courtesy of Copro/Nason)*

Opposite Page: Rat Fink *design (1997), created by Roth himself combining traditional pinstriping with computer technology. (courtesy of Copro/Nason)*

1972 rolled around and got baptized into the Mormon Church in 1974."

Roth had his own way of worshiping, of course. I once attended a church service with him in Manti, Utah, where he lived. We sat in the very back row. He was dressed conservatively in a coat and tie, because he took his faith very seriously. But during the sermon, he pulled out his briefcase, which contained his Bible and a sketchbook. For most of the service he made cartoon-like sketches of people in the church.

After his conversion, Roth said he felt sort of guilty for "contaminating the youth" with "all the monsters and stuff." He decided he wanted to get a job, a new set of friends and go to work for a "family-oriented company." And indeed, for a while, his imagery changed. BDR said in a 1995 interview with Baby Boomer Collectables, "I felt guilty about putting bloodshot eyeballs on characters and monsters. [Parents were saying] 'You're confusing my kids here. You are making them draw weird stuff like this.'"

The change didn't last long, however. Shortly after his baptism, he reclaimed his hot rod attitude, which he said was, "Go for broke, put it all on the line, go fast, go in style." And Rat Fink rose again! He proclaimed that God had put him on earth to accomplish two things: build cars and promote Rat Fink. He went on to say in the Baby Boomer article, "When I stopped, people were still sending in for the Rat Fink decals. After, I figured out for myself that these designs were not detrimental to kids' thinking. I went back into it."

And we shall be forever glad, Big Daddy.

conversion. "We [would be] stripin' bikes in the back of the shop and he'd come over. It was like he was loaded all the time, a happy dude. One night I asked him, 'Frank, what are you getting loaded on? What kind of drugs do you take?' In those days we were smoking dope and taking Seconal and speed. He says, 'Tomorrow I'll tell you.' The next morning I thought, oh boy, Frank's bringing over some of his real neat drugs. So he came over and handed me a Book of Mormon. He said, 'Read Joseph Smith's testimony.' I read it and knew it must be true, because dying men don't usually lie. I hemmed and hawed and finally made my conversion by the time

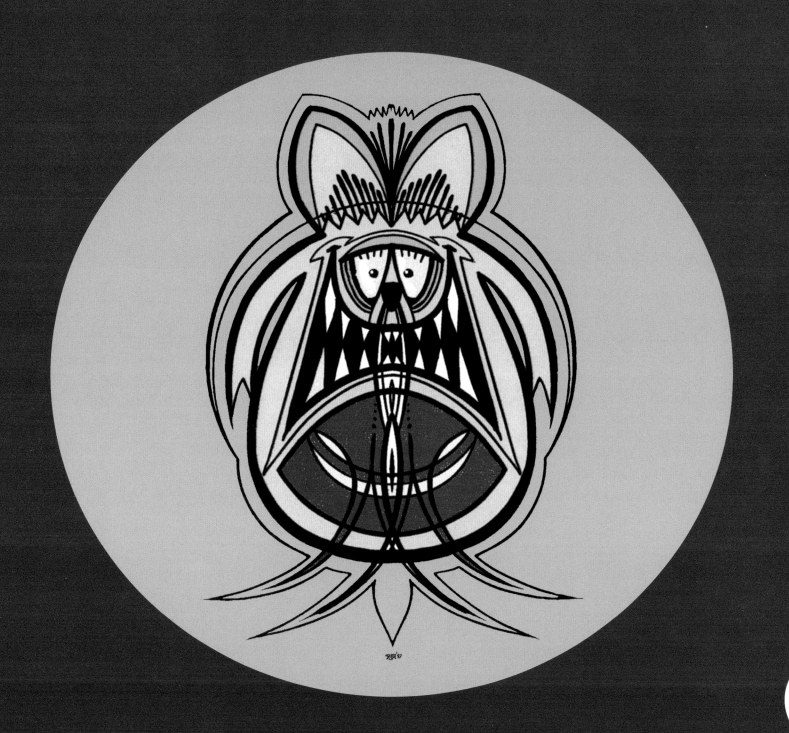

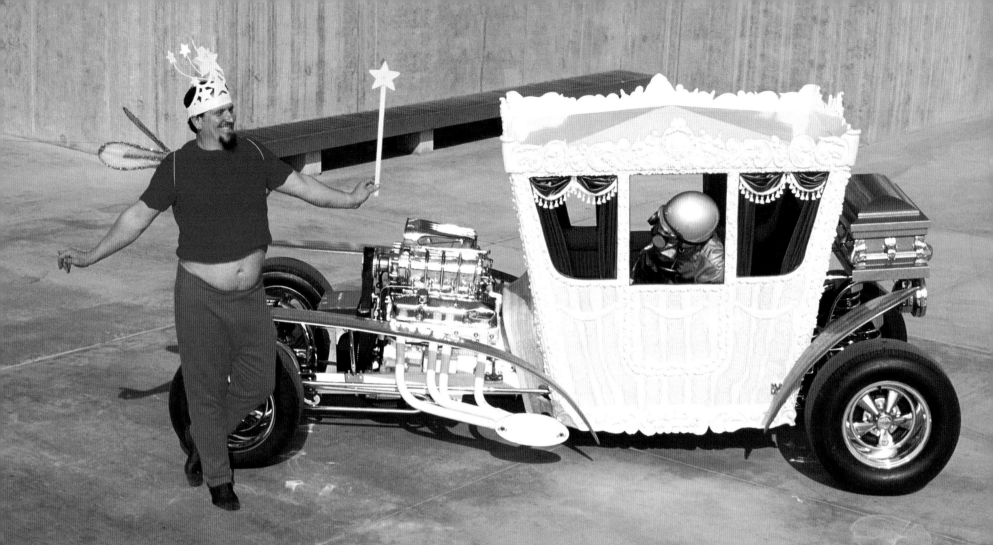

Road To Rumpsville

BY C.R. STECYK III & REN MESSER

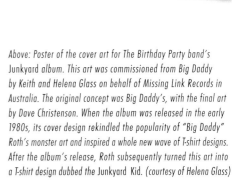

Hot rodding is a compulsion, an obsession, an occupation, an affliction, a fascination, a fate. It is not a hobby. Those who do it, must. Those who don't think it a distant relative of antiquing, a kin to the trophy cabinet, an utter distraction, a waste of time. For Ed Roth, it was a calling.

Los Angeles is known as a city given to speed and transformation. Ed Roth was born there (in the suburb of Beverly Hills) on March 4, 1932, into the conservative German-American home of Henry and Marie Roth. He and his younger brother, Gordon, were reared in a strict German-speaking household full of German military symbols and history books. His father was a first-generation

German immigrant, and it was in school where Ed first learned to speak English. Ed was a good student, but he preferred drawing monsters; early on he began spending most of his class time doing just that. Ed descended from a long line of German-Polish tradesmen of both Christian and Jewish heritage. His father was a cabinet maker who would acclimate the young boys to spending hours on

end tooling around in a workshop. But as Ed developed his skills for design and building, he would become increasingly frustrated at the systematic and precise approach his father insisted on. Although his father's work ethic would become ingrained in Ed, over time he would reject his rigid thinking, laying the foundation for Roth's rebellion socially, mechanically and artistically.

Roth spent his teen years in Bell, another LA suburb, which was burgeoning into the literal epicenter of the California hot rod movement. World War II was in full swing, so new cars were not available. The war prescribed fuel rationing as a way of life; even second-hand junkyard parts were scarce. With California's driving age being just 14, every Southland garage became a veritable clubhouse sanctuary, and auto shop became a standard course in most Southern California high schools. The principal pastime of teens became building cars from whatever parts they could find. Mobility defined freedom, and style anticipated legend. Ed was well on his way.

Ed dreamed and schemed as he sought the perfect combination of engineering skills and junkyard parts. Success was measured in lowered elapsed times. It was 1946 when he turned 14. The war years' need for fuel restraint had passed, and Ed would disregard the notion completely. Ed purchased his first car, a 1934 Ford coupe,

Above: Poster of the cover art for The Birthday Party band's Junkyard album. This art was commissioned from Big Daddy by Keith and Helena Glass on behalf of Missing Link Records in Australia. The original concept was Big Daddy's, with the final art by Dave Christenson. When the album was released in the early 1980s, its cover design rekindled the popularity of "Big Daddy" Roth's monster art and inspired a whole new wave of T-shirt designs. After the album's release, Roth subsequently turned this art into a T-shirt design dubbed the Junkyard Kid. (courtesy of Helena Glass)

Left: Baron Von Roth, also known ominously as The Death Painting because it has a bullet hole going all the way through it. (collection of George Goodrich)

Opposite Page: Ed premieres the Druid Princess at a photo shoot for Pete Millar's Drag Toons, 1967. The technical humor magazine was devoted to the absurdity inherent in America's obsession with the automobile. Roth was a willing pin-up. (photo collection of C.R. Stecyk III)

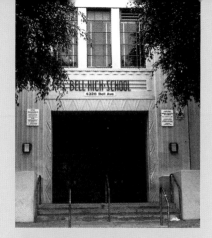

Top: The facade of Roth's alma mater: Bell High School.
(photo by D. Nason)

Middle: The former building and yard of Roth Studios in
Maywood, California. Big Daddy would be proud of all the
great junk still scattered around the site. (photo by D. Nason)

Bottom: Detail of utility box cover which is still mounted to
the exterior of the former Roth Studios. (photo by D. Nason)

Right: Surf's Up, done by artist Jeff Gaither under the
direction of Ed Roth. From such prescient images as Surfink!,
Hunter, and Rat Fink, to vehicles like the beach-going Surfite,
Roth seemed to identify with the freestyle variation of
the surfing lifestyle. Was he the first artist to hook up
the surf/street matrix in popular culture? The Beach Boys
might have a weak claim, but Ed Roth is an originator,
a progenitor of style. (collection of George Goodrich)

a few months after his birthday. Days were devoted to
wrenching and nights centered on driving. As he modified
his old Ford he would repeatedly have to convince his
stern father that the additions were in the name of
safety and practicality. Despite his rejection of certain
notions of his father's, these two ideals would become
ingrained in Ed's mechanical designs, even given their
fantastic stylizations.

He graduated from Bell High in 1949 with speed on
his mind. He continued his education at East Los Angeles
Junior College, where he earned an Associate Degree
in mechanical engineering before joining the armed
forces. Back then, the military was one of the few places
where real value was placed on the mechanical skills
of young hot rodders. Like many of his hot roddin' pals,
Ed was recruited and decided to join up. In 1951, he
left the motoring Mecca of Bell for the United States Air
Force. He headed first to Denver, where he trained in
cartography before being sent to North Africa to test
his skills. His unit's top-secret mission, he would allege,
was to document UFOs.

During those years in military exile, Ed drew cartoons,
lettered signs and plotted his return to the world of rods.
It was while serving in the Air Force that he would draw
his first rudimentary sketches of the Outlaw, a design
that was, at the time, impossible to realize with the tools
and materials used to build cars. He later transferred
to South Carolina, where he was married in 1952.
It was sometime in early 1953 that he saw his first issue
of Honk! magazine, a Petersen publication that would
later become Car Craft. Upon his honorable discharge
in 1955, Ed would pursue the dreams cultivated
from those pages.

His return to El Lay was greeted by a booming scene
of hot rodders, surfers and greasers. Hot rods dominated
as the transport mode of choice. Youth culture was taking
over Southern California, and it was a mobile rebellion
that was as intimidating to most adults as it was liberating
to teens. Just how big was the movement? In 1962 there
were some 45,000 car clubs reported in the U.S. and
some 4 million hot rodders. The numbers prompted
a national over-reaction, as national agencies and
publications responded in an
effort to rein it in. The California
legislature passed a law
prohibiting the lowering of
any part of the car body
below the wheel rims.
Sports Illustrated quoted
The National Safety
Council as speaking out
against racing, "on the
grounds that speed itself
was bad." The magazine went on to explain that,
"Some educators went so far as to deplore ownership
of any car, by any student," after a published study
found that not a single straight-A student owned a car,
but that 83 percent of those failing did. Sociologists
and psychologists published reports around the country
stating hot rodding masked deep psychological needs
for attention, masculine recognition and power.

To guys like Ed, it went even deeper. Racing to them
was tantamount to dreaming. In their minds it wasn't the
car traveling upwards of 200 mph — it was the driver.
The thrills and feeling of freedom rodding provided far
outweighed parental or societal disapproval. By that time

Roth already had five young
sons and several vehicles.
His bills were growing
proportionally with his family.
During the day Ed labored in
the display department at Sears;
at night he worked to further
his artistry by pinstriping cars,
touching them up with 1/64 stripes
of paint that expanded into flames
and eyeballs. Eventually the work
at Sears gave way to a full-on hot
rod customizing business.

In 1958 he went into business
with Oscar "The Baron" Crozier, a
former Studebaker assemblyman who
had garnered a reputation, along with Roth, of being
among "the best pinstripers in the business." Together
they opened a customizing parlor on Atlantic Avenue
in Southgate, in a former realty storefront. Along with
customizer Tom Kelly they were known as "The Crazy
Painters." The shop was to become a regular stop for
nightly cruisers in the Southland.

It was there that Roth, striving for the ultimate power-
to-weight ratio, began using a new high-tech material to
build his dream cars. Through his designs he helped to
pioneer the use of meltable, moldable silica cloth and
resin, formerly a plumbing and insulation material, into
a versatile alternative to costly sheetmetal. This was the
material that allowed Ed to realize the smooth, sleek
lines of the *Outlaw*.

Roth was first hipped to this lightweight, high strength
method of building through a photograph he saw of

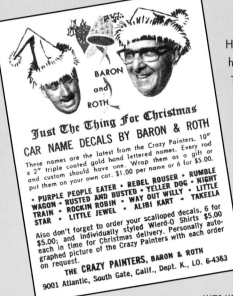

Just The Thing For Christmas
CAR NAME DECALS BY BARON & ROTH

These names are the latest from the Crazy Painters. 10"
x 2" triple coated gold hand lettered names. Every rod
and custom should have one. Wrap them as a gift or
put them on your own car. $1.00 per name or 6 for $5.00.

• PURPLE PEOPLE EATER • REBEL ROUSER • RUMBLE
WAGON • RUSTED AND BUSTED • YELLER DOG • NIGHT
TRAIN • ROCKIN ROBIN • WAY OUT WILLY • LITTLE
STAR • LITTLE JEWEL • ALIBI KART • TAKEELA

Also don't forget to order your scalloped decals, 6 for
$5.00; and individually styled Wierd-O Shirts $5.00
each in time for Christmas delivery. Personally auto-
graphed picture of the Crazy Painters with each order
on request.

THE CRAZY PAINTERS, BARON & ROTH
9001 Atlantic, South Gate, Calif., Dept. K., LO. 6-4363

Henry Ford swinging a sledge
hammer at the deck of a car.
The photographer's caption said
the lid was made of something
called "Fiberglass." Roth made
a mental note. Later, while surfing
at the Huntington Beach Pier,
Ed noticed a strange new
waterproof covering on the
surfers' wooden boards. He
was told that it was "this mysto
glass stuff." Soon after, Big
Daddy heard about a hot
rodder named Shadoff who
was using the then virtually unknown
substance on his Bonneville speedster. Ed was intrigued,
and within days he was hunkered down in his garage
mixing mounds of the strange, sticky goop.

In 1959, following an extensive R and D curve,
Roth unveiled the *Outlaw*, a hand-built roadster
with a radically sculptured fiberglass body
powered by a Cadillac engine. Roth had
accomplished the inconceivable.
Working alone with limited
resources, he had gone
against the global
manufacturing
giants and beaten
them. One man
in a garage
had fended
off the legions
of employees

Left : An early ad for The Crazy Painters, which ran in car
magazines in December, 1958. The Crazy Painters, better
known as Baron, Roth and Kelly, had a customizing shop
on Atlantic Avenue that was an infamous cruising stop.
(collection of Verne Hammond)

Below: The Outlaw was first exhibited at the Los Angeles Sports
Arena in 1959. However, it was first conceptualized by Roth
before he discovered the materials and means to create this
highly stylized T-bucket roadster. He reportedly first began
sketching the vehicle he initially called the Excalibur while
stationed in North Africa during his unit's 1951 tour of duty
for the USAF, where his unit's top secret mission was allegedly
to document UFOs. Exactly where did the inspiration come from
for this groundbreaking curvilinear design? Was it influenced
by UFOs? Some think so. Roth ended up hand-building this
fiberglass bodied vehicle from "bailing wire and spit."
(photo collection of Verne Hammond)

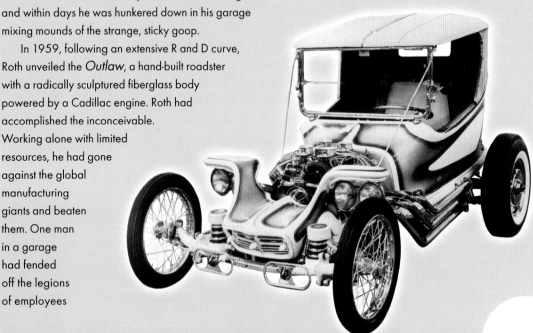

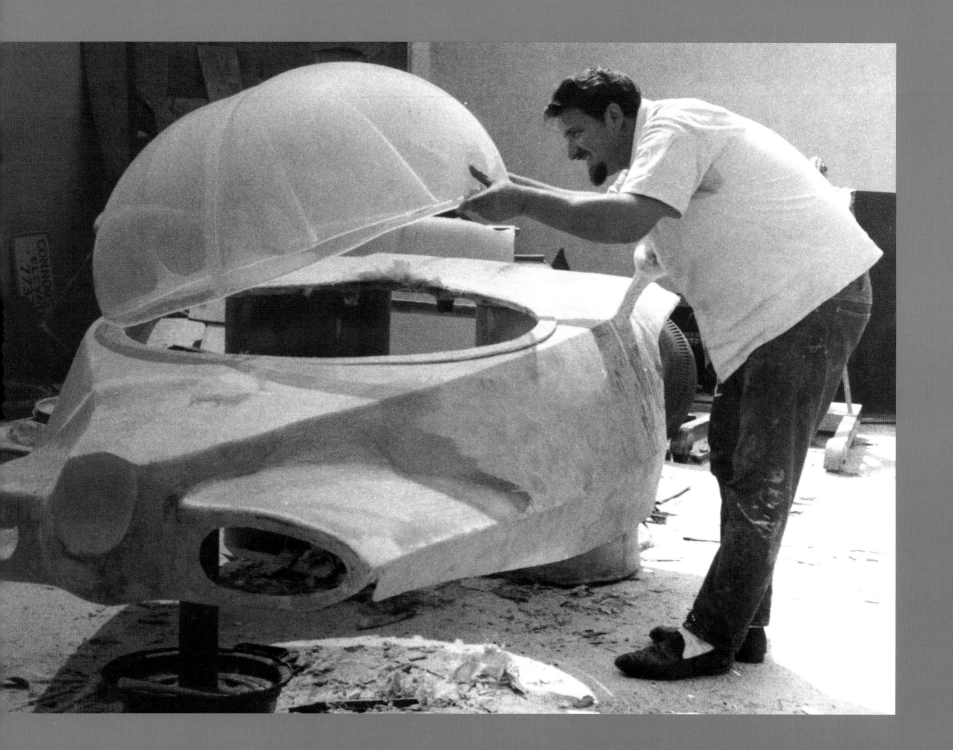

laboring in industrial complexes with their billions of dollars worth of machinery and technical support.

Roth became the toast of the hot rod world. Eventually the prestigious Stanford Design Conference would invite him to speak. But as Ed said, "All I know about design is what works.... In America, we produce engineers and designers who all draw well, but they can't build anything practical. The average hot rodder builds it and bashes it 'til he breaks it, and then he rebuilds it again better."

But Ed was not your average hot rodder. Rather than restyling the pre-existing forms of Detroit cars, as his contemporaries were doing, Ed sculpted unique shapes from plaster and then molded them in fiberglass. Suddenly cars were being built from scratch. America was coming to terms with this new mobile rebellion, and Ed Roth was one of the most-well known faces of the movement.

It was also in 1959 that he got into the monster business. A local hot rod club asked him to design an emblem, and he turned out monstrous caricatures of each member. The images were printed on T-shirts, and soon other clubs throughout Southern California were asking for them. He would sell them on weekends at the Salt Flats, where hot rodders were taking it to the edge and back at speeds well over 200 mph. Within months Roth was drawing these shirts by hand, silk-screening them by the thousands and selling a generous number via *Hot Rod* and *Car Craft* magazines.

These shirts were seen as vulgar and threatening to much of mainstream America, and the lifestyle as derelict. Ed saw them as a means to finance his car creations. "The shirts sell because they are secret little weapons each

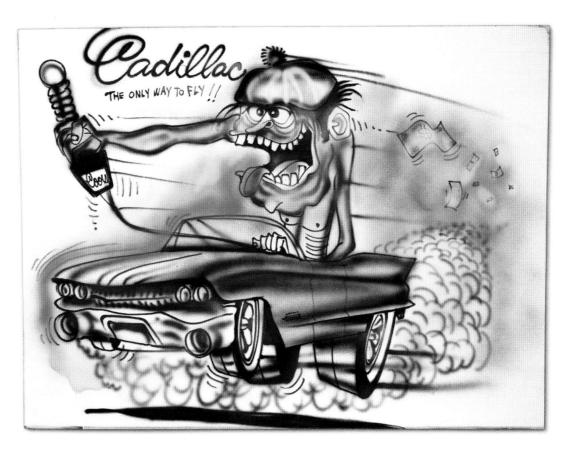

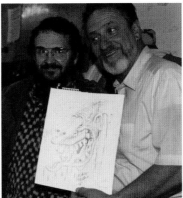

Above: Cadillac The Only Way to Fly!! Airbrush on Illustration board. (photo by C.R. Stecyk III; collection of Jim and Danny Brucker)

Left: Stanley Mouse with Ed "Big Daddy" Roth, at the 1991 Rat Fink Reunion Party in Fullerton, California. Mouse, who hailed from Detroit, also did hot rod monster T-shirt art and, like Roth, set up booths at car shows and had crazy magazine advertisements during the early 1960s. Mouse gave Roth some serious competition until he moved to San Francisco, where he went on to produce the most famous of the late-1960s rock art posters and the Grateful Dead's classic skull-and-roses logo. (photo by Von Franco)

Opposite: Roth deep in the build-up of the Road Agent. (photo collection of George Goodrich)

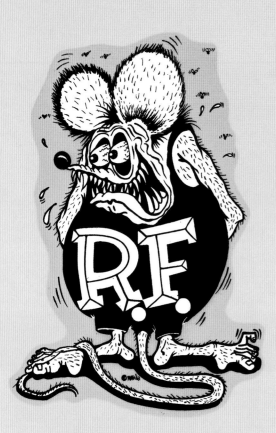

juvenile uses to terrorize his parents and his environment," said Roth. The shirts were considered cultural calling cards signifying a devotion to a lifestyle that was not just a cultural movement but a sort of religion. Ed's monster shirts were part of the uniform for a new youth army.

Around the same time, Roth discovered his pictorial signature while arguing over the origins of Disney's Mickey Mouse at a lunch counter in Maywood. He drew Mickey first as a stick figure and then roughed in an image of one of Mickey's primordial ancestors: a big-bellied rodent wearing overalls. Roth capped him off with the initials "R.F." for "Rat Fink." In racing terms a "fink" was a cheater. Ed recalled that first Rat Fink saying, "It had a strange power over me. Whenever I looked at the drawing, I felt I was looking for the first time at my reality. The world that my parents, teachers, and responsible type people all around me belonged to wasn't my world. Why did I have to be like them? Live like them? I didn't, and Rat Fink helped me to realize that."

It was 1962 when Revell saw opportunity in Ed and quickly contracted with him to turn his car creations into model kits. To better market him they felt he needed a nickname; they decided to exploit his beatnik image and granted him the moniker "Big Daddy." They paid him a two-cent royalty for each model sold. In 1963 alone, 3,200,000 were sold at a price of $1.98.

These injection-molded, plastic, 1/25th-scale icons can be viewed in retrospect as the birth of the counter-cultural toy. Revell followed suit with a series of build-it-yourself monster kits. They included: *Rat Fink*, *Surfink!*, *Angel Fink*, *Fink Eliminator*, *Super Fink*, *Brother Rat Fink*, *Scuz Fink*, *Drag Nut*, *Mother's Worry*, *Robin Hood Fink* and *Mr. Gasser*. Roth's car kits included the *Beatnik Bandit*, *Tweedy Pie*, *Outlaw*, *Surfite*, *Mysterion* and the *Road Agent*, which included a scale model of Big Daddy himself. One other kit never found its way into mainstream America after an accident tainted its release. *Rotar* (for Roth Air Car) was meant to rival George Barris' *X-PAC 100*. At an exhibition at Cobo Hall in Detroit, the *Rotar* broke a crank, sending a propeller into the crowd and injuring a young woman. She survived, *Rotar* didn't. This model kit remains a valued collectible because of its rarity.

A multi-media artist by nature, Ed was adept at all sorts of skills, so the proliferation of diverse enterprises that he developed in his Maywood shop was logical. Roth was all about packaging. He began with an idea that would grow to include every conceivable accessory. He often included

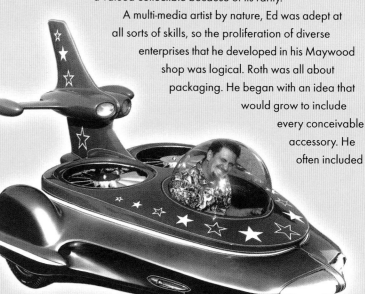

Rat Fink decal. Rat Fink was said to be Ed's alter ego, the counter-culture answer to Mickey Mouse, and hot rodding's first icon. First drawn on a napkin then later on a refrigerator door, Finky would become Ed's emblematic signature, appearing on T-shirts, decals and models. The Finkster later found his way to cell phones, animation and even...fine art prints. (collection of Aaron Kahan)

Right: A compressed Big Daddy under the bubble-topped Rotar, a.k.a. the Roth Air Car. (photo collection of Verne Hammond)

plastic Wehrmacht helmets with his roadster bodies. In addition to T-shirts, fantasy cars and model kits, he began writing columns in a number of car and hobby magazines. Roth was also put on the art staff of *CARtoons*, Petersen Publishing's answer to *MAD* magazine. Other publications included *Choppers*, the first modified cycle magazine; and how-to books and videos on sign-painting, car customizing, monster drawing, pinstriping and custom motorcycles. Eccentrically illustrated catalogs and coloring books followed suit. In 1962 he was featured in his own comic magazine, self-titled *Roth*.

America at large began to marvel at his many accomplishments. *Time* magazine, *Sports Illustrated* and *Life* chronicled Ed's place in the hierarchy of motor mania. Just as certainly as he was maligned for subverting the values of a generation of teenagers, it was well-accepted that he had put Detroit on notice. Ever the prankster, Ed played on his new-found notoriety and wielded it to further his cause. To promote the release of a monster model kit that became known as *Scuz Fink*, Revell held a contest to name it in the car and hobby magazines. The winner was a 12-year-old girl from Saddlebrook, New Jersey, who got the honor of having Big Daddy and his entourage spend the weekend at her

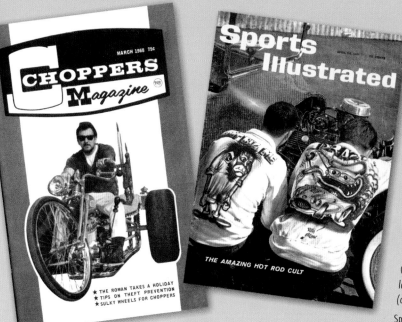

Seen here are some of the many examples of Roth's influence and presence in mainstream media. He had a self-named magazine Roth, began Choppers magazine (the first custom bike magazine), and even appeared in Sports Illustrated, which marveled at the size of the "teenage mobile rebellion" and acknowledged Roth as among the leaders of the movement.

Pete Millar Presents Big Daddy Roth magazine (Issue #2 from Dec./Jan. 1964/65). (collection of Shawn Attema)

Choppers magazine March 1968, logo and layout by Suzanne Williams. (collection of Aaron Kahan)

Sports Illustrated April 24, 1961. (collection of Aaron Kahan)

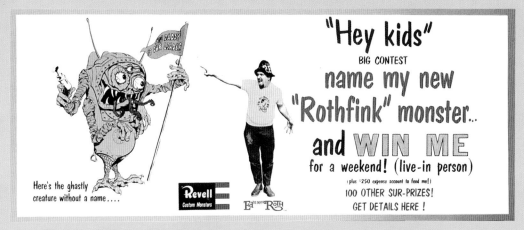

Roth was said by many to have spent his life entertaining children. His "Name the Fink" contest was one example. The Fink would eventually be named "Skuz Fink," and the naming contest's winner, a 12-year-old girl from Saddlebrook, New Jersey, earned a weekend visit from Roth and his entourage at her home, much to the dismay of her entire family and the delight of the pre-teen Fink fan. An expense account of $250 was said to have been provided to feed Big Daddy. (collection of Shawn Attema)

35

RODS n' RATFINKS

FEATURING **THE WEIRDOS**
AND THE VOICE OF **MR. GASSER**

THREE KATS IN A TUB □ THE COOL, COOL ROD □ HEARSE WITH A CURSE □ CHERRY-TOP CHARLIE □ HEY, RAT FINK □ T.J.T.
1947 AVANTI □ FINK ROD, 409 □ THE LONELY STOCKER □ THE WALTZ OF THE RAT FINKS □ THE BALLAD OF EEFIN FINK

Capitol RECORDS
HIGH FIDELITY

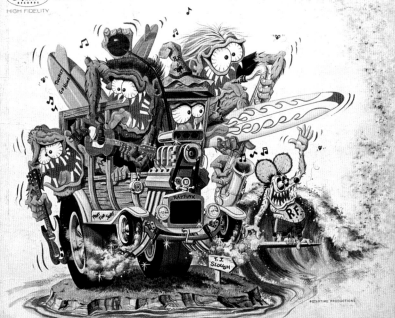

© STARTIME PRODUCTIONS

SURFINK!

FEATURING **MR. GASSER AND THE WEIRDOS**

Capitol RECORDS
HIGH FIDELITY

PLUS THIS FREE BONUS RECORD!

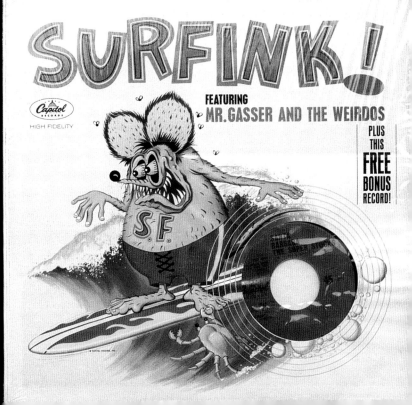

home. Ed took great delight in the controversy surrounding the contest, saying, "The kids idolize me because I look like someone their parents wouldn't like."

Capitol records looked to cash in on the hot rod mania and signed Ed to produce a series of albums. A band was formed by Gary Usher, made up of Phil Spector's Wrecking Crew, and included Leon Russell, Glen Campbell, Hal Blaine, Billy Strange, Jimmy Bond, Tommy Tedesco, Carol Kaye, Steve Douglas, David Gates, Ray Pohlman, Barney Kessel and Jerry Cole. It was called Mr. Gasser and the Weirdos, featuring Ed Roth. The albums had titles like *Hot Rod Hootenanny*, *Rods n' RatFinks* and *Surfink! Car Craft* editor Dick Day teamed with Roth to write lyrics to songs with names like, "Eefen it don't go – chrome it," "Termites in My Woody," and "The Fastest Shift Alive."

Rat Fink comics, decals, patches and skateboards followed the albums. In time there were even action figures, cell phone straps, air fresheners, bendable dolls, wind-up toys, refrigerator magnets, clocks, toilet seats and a film on the fabled artist Von Dutch. Fine art publishing and poster printing came later. Roth's studio in Maywood was a melting pot of artists, hot rodders, bikers and movie stars. His studios boasted a staff of 25 artists, among them Robert Williams, who would create ground-breaking ads for Roth merchandise before going on to become one of most singularly important artists in

Capitol Records jumped on the Ed Roth bandwagon and released a series of albums inspired by the hot rod craze, including three albums featuring Mr. Gasser and the Weirdos: Rods n' Rat Finks, Surfink! and Hot Rod Hootenanny in 1965. (collection of Verne Hammond)

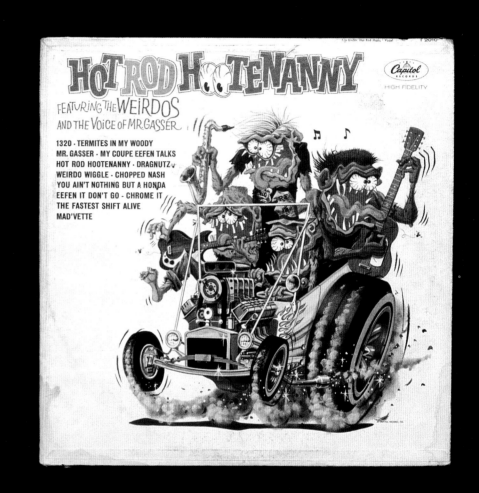

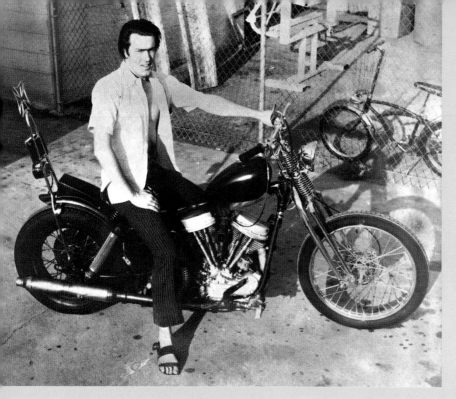

Above: A young Robert Williams (c. 1966 at Roth Studios) on Roth's then in progress Oink chopper, which was made from a beat-up police Harley that Roth picked up at a sheriff's auction. Roth added a brand new '66 Shovelhead engine, peanut-style gas tank and sissy bar surmounted with an iron cross. Oink would later sport a chromed rear wheel and custom exhaust system. Seen in the background is a modified Schwinn Sting-Ray replete with extended goose neck and straight T-grip handle bars and chrome fenders. When Roth hired Williams he didn't know that Williams would eventually produce what he called "mind-bending ads in Hot Rod and Car Craft magazines." Said Roth, "Those ads are still milestones today. Collector's items. They set a whole new standard of advertising." (photo collection of C.R. Stecyk III)

Opposite Page: Car Craft magazine cover, June 1965, which featured the And Proud Of It!!! Roth Studios ad. Shown here is the original inking/paste-up, while on the right is the final ad as it appeared in the magazine. (magazine collection of Aaron Kahan; original art collection of Lynn Coleman)

the Kustom Kulture scene and lowbrow art movement. Big Daddy had achieved true pop-art crossover stardom at a time when "pop artists" were still struggling to hustle shows in galleries and museums. Before Warhol's Factory was Ed's garage.

But like all popular icons, America builds them up and tears them down. Ed had been uncompromising in his pursuits. Big Daddy dared to be an outlaw and social critic when people in power still took exception to such things. In his day, outsider status was not yet chic. *Time* maligned him as being "the supply sergeant to the Hell's Angels." *Life* probed the troubled nature of his relationship with his father. An alphabet load of governmental agents routinely surveilled the groups Ed rode with, including the Hell's Angels. Hot rod and motorcycle journals began refusing to run his advertisements, deeming them "too controversial." At first Ed saw each barb and rejection as a tribute to be marveled at and cherished.

In time, Ed's rebelliousness took its toll personally. *Surfer* magazine came out with an article called "Sign of the Kook," accusing him of being a neo-Nazi for the

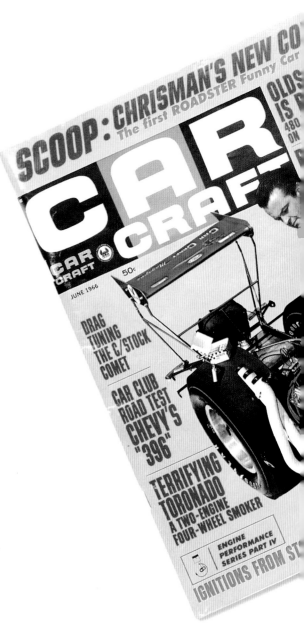

SCOOP: CHRISMAN'S NEW CO
The first ROADSTER Funny Car

OLDS
IS F
480
ON

CAR CRAFT

CAR CRAFT

JUNE 1966

50¢

DRAG TUNING THE C/STOCK COMET

CAR CLUB ROAD TEST CHEVY'S "396"

TERRIFYING TORONADO A TWO-ENGINE FOUR-WHEEL SMOKER

ENGINE PERFORMANCE SERIES PART IV

IGNITIONS FROM ST

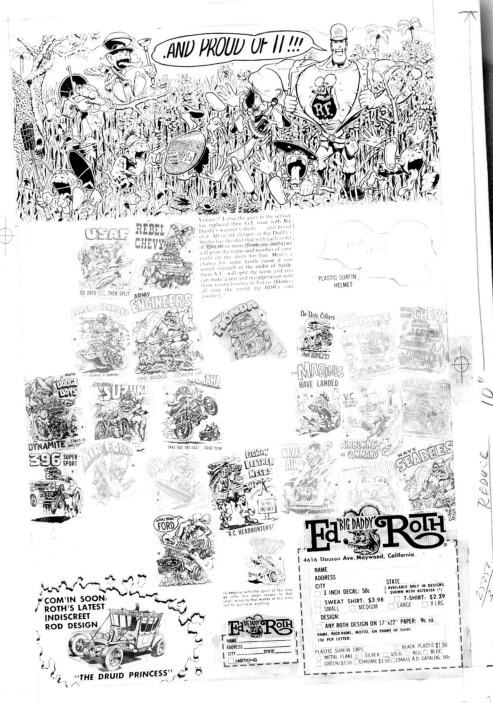

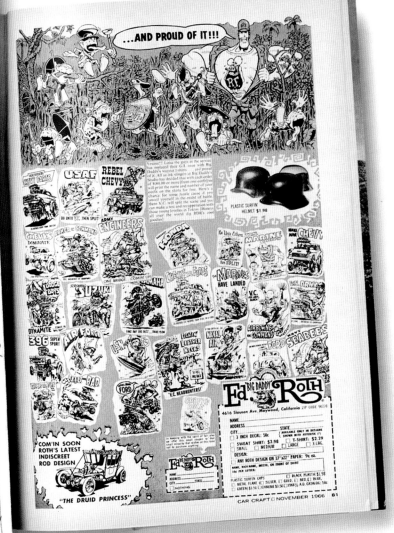

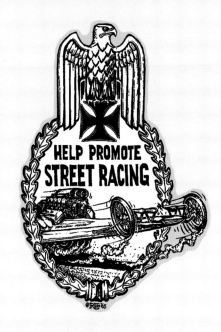

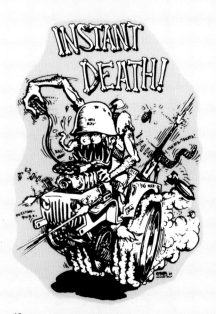

German helmets and iron crosses he sold while billing them as "surfer's helmets" and "surfer's crosses." He found the accusation unbelievable and defended both symbols for their design, explaining he was in no way a Nazi. He further added that he didn't like Hitler's shiny suits. The association to the Nazi party would follow him for a time, even though the writer of *Surfer's* highly suspect propaganda piece would turn out to be an FBI agent who'd later pen a book called *Inside the FBI*.

Ed was, in fact, fiercely patriotic. A large portion of the shirts he made were for young hot rodders headed off to fight in Vietnam. His pro-Vietnam War merchandise defied political correctness with slogans like "VC: Breakfast of Champions" and images of surly U.S. soldiers kicking Vietcong fighters in the face.

The negative press grew around Ed's larger-than-life persona. Revell got nervous and dropped him after he refused to give up his support for modified motorcycles and their association to motorcycle gangs. The car customizing magazines began to shun Roth, dismissing many of his evolving designs outright, especially his trikes. They refused to run his ads, limiting much of his mail-order sales. Some of the motorcycle gangs he was alleged to have run with took exception to Ed's growing celebrity. Though a few appreciated his work, a large percentage

Left: Some early controversial Roth decal images. Roth was an opinionated man and was not one to worry about political correctness. He defended his use of swastikas and iron crosses for their design and scoffed at the association with Nazism. Roth was in actuality fiercely patriotic, as seen here and in the hundreds of pro-military decals, patches, T-shirts and insignias he designed over the years.

Decals: Help Promote Street Racing (1965) (collection of D. Nason) and Instant Death! (1964). (collection of Aaron Kahan)

felt exploited. Allegedly some of those gangs began extorting money from Ed. His ultimate refusal to continue paying them off led to a violent backlash. In 1970, the Roth studios were literally swept clean of everything, including the guard dogs, in a burglary. Ed walked away from it all, closing down his Maywood shop.

It was a move that was received with amazement and frustration by those in the Kustom Kulture scene. The shop had long been a hangout and regular stop for rodders and bikers, so much so that they challenged its closing in what has become a much exaggerated account of Ed sitting on the roof of his studio in a gun battle with a gang of outlaw bikers. Legend has it that Ed won the standoff. The shop closed and the Bruckers took possession of it in its entirety. In rapid succession his studio was disbanded, his original art and cars sold off and his marriage dissolved, with his ex-wife getting the T-shirt company. To some, Ed Roth's fall from grace served as an object lesson in the unraveling of the American Dream.

His five children, now grown, had at times embraced his lifestyle and obsessions and at times struggled under their father's fame. Ed had said many times he was never happier than when on the road with his sons, making appearances as a united family. But those times were never lasting. He longed for some change. He regretted many past images that he had created, stating that he saw, in retrospect, that many of them were potentially negative images for children. He revisited works and modified them to fit his new image of himself and the world. For example, he replaced the hatchet on *Wild Child* with an ice cream cone. He spent countless hours working with groups like the Boy Scouts of America and participating in remarkable philanthropy for the

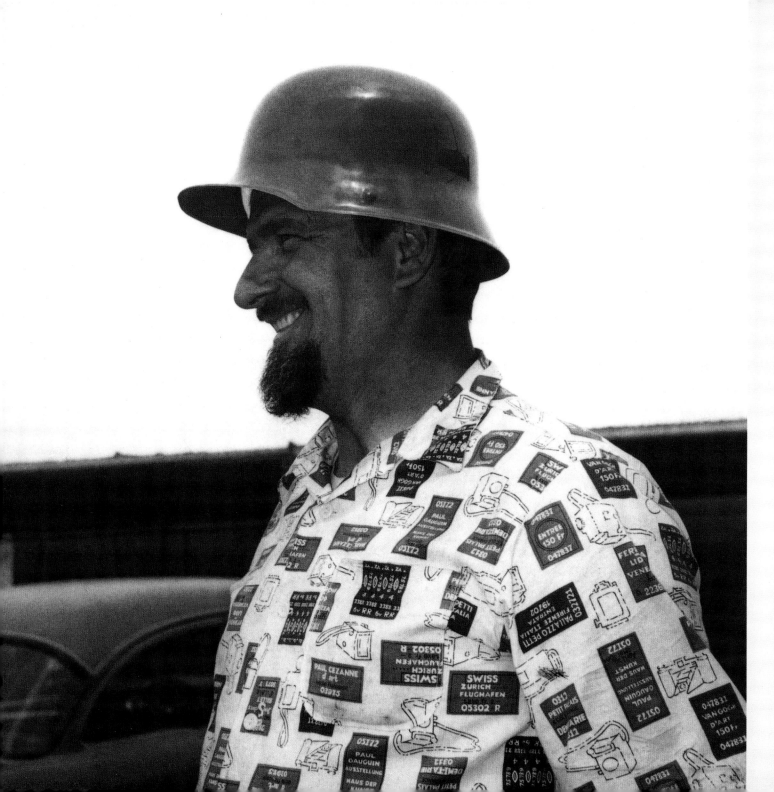

Left: Roth in a Wehrmacht helmet, which he
would later market along with Iron Crosses
as "Surfer's Helmets" and "Surfer's Crosses."
(photo collection of C.R. Stecyk III)

41

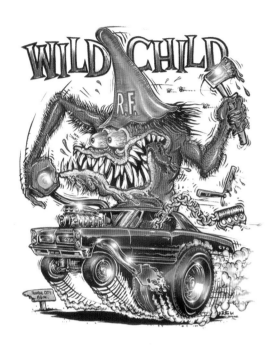

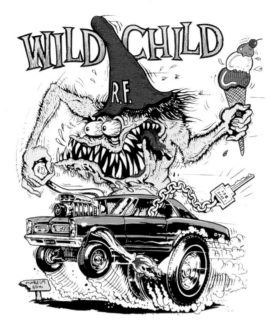

Behold the transformation: Seen left is the Wild Child, a classic unaltered BDR image from 1964. The black line-art was screen printed by Jeff Wasserman, and the airbrushing was by Von Franco. This fine art serigraph is part of the Rat Fink Portfolio published by Copro/Nason. (collection of B. E. Baldwin)

To the right is the Wild Child revised sometime during the 1980s by Roth to omit the violent overtures. This is emblematic of Roth's conversion to Mormonism and desire to take back many of the violent or offensive images of his earlier years. This fine art serigraph was published by L'Imagerie Gallery. (courtesy of Debi Jacobson)

community. His focus became a world view meant to support and encourage children in all forms of mechanical, educational and artistic pursuits.

Ed attempted to separate himself from his monster-making, car-building and bike-riding ways by joining the Mormon Church in 1974. He remarried and began teaching Sunday school. He got a job painting signs at the Knott's Berry Farm amusement park, where for the next 10 years he pinstriped stage coaches, lettered signs and built flying saucers and biplanes for the Knott family enterprise.

In 1984 he would rethink his exodus from monster making and return to his mail-order business, although his images remained sanitized. Ed had said, "Everything started to center around rock-n-roll. Kids quit spending money on cars and started buying guitars. Drugs were coming on strong, and I started to think maybe Rat Fink

wasn't that bad of a dude." In time he would move to Manti, Utah, where he would live out his days in his workshop, work as a contributing editor for *DRIVE!* magazine, and most importantly meet and marry the love of his life, Ilene, and form his first and last truly stable home life. His final years were devoted to his marriage, family, church and never-ending tour of car shows across the country.

Beneath Revell's manufactured hot rod persona was a conservative mind tempered by Mormon values. Ed Roth was a man of multiple contradictions. Considered by those who knew him to be a truly honest and generous spirit, he was also unabashedly rigid in his views of a woman's place. He was blindly patriotic and at times outspoken in his belief that the government had overstepped its bounds and was maintaining surveillance on his associations with motorcycle gangs. Contrary to his wild image, he was a Scoutmaster and Sunday School teacher. Like his father before him, he thought it disrespectful when cartoon character Bart Simpson called his dad "Homer." Ed Roth may have been a beatnik and counter-culture hero, but he never completely endorsed the redneck sensibility his monster images came to symbolize.

Based on overall influence, Roth was perhaps the best-known American artist. He remains a paramount force in street aesthetics, in the salons of industrial design and in the cloistered fine art world. Decades ago Roth pissed joyfully upon the shrines of high society and its officially sanctioned and sanitized art. His uninhibited masterpieces of mechanical function and form were years ahead of their eventual adaptation by the automotive manufacturing industrial complex. No one had ever

dared take on Detroit in such a manner. He defined hot-rodding subculture's iconography and transgressed its style. His grotesquely rude, defiantly abrasive, socially critical characters were fundamentally anti-establishment.

His monsters remain potent forces today. Rat Fink's influence is present in underground comics, the protest T-shirt, *The Simpsons*, the surly kids of *South Park*, *Ren and Stimpy*, and the efforts of innumerable artists. Big Daddy lived to defy expectation. He did so across media, delivering a creative sucker punch into the belly of 1960's America. He was an anarchist to form and a muse to function. He lived to set himself apart and define what would be considered the furthest of the out, the proverbial one-percenter, the most diabolical of the radical fringe.

The great man passed on April 4, 2001, in his garage working on yet another fantastic car creation. It's been said that car culture and hot rodding are about going to the limits of freedom and beyond, and on that day Ed was no doubt en route to the proverbial hot rod Elysian Fields known as Rumpsville. Said Ed, "My garage is my world. My path to sanity. A place where God (sometimes even the devil) unleashes ideas and concepts so wild that when I think back on 'em years later, I can hardly even remember thinkin' em....A place of solitude. Amen!"

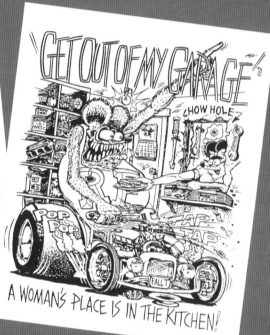

Left: Garage Punk. *Original pen and ink illustration. (collection of George Goodrich)*

Below: Chow Hole. *Concept inking for a T-shirt design. (courtesy of Copro/Nason)*

Background: Tombstone that Roth used to carry with him. Detail from a Movie World postcard. (courtesy of Jim and Danny Brucker)

43

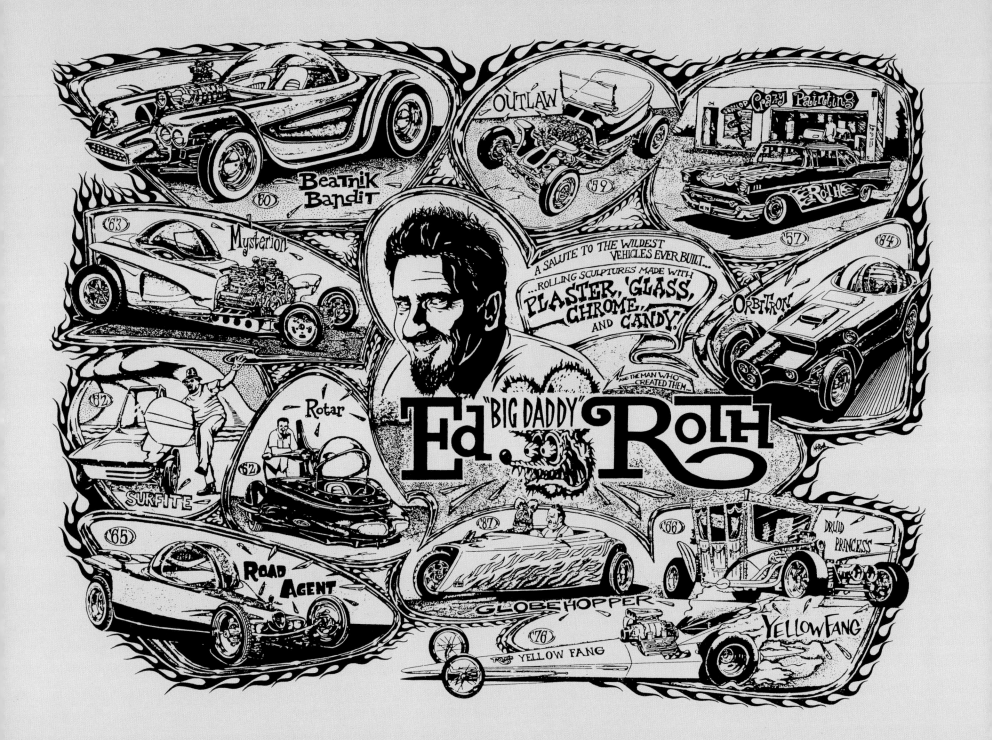

Anti-Detroit:

BY ROB FORTIER

THE BIG THREE DESIGNED CARS OUT OF PRACTICALITY; ROTH DESIGNED OUT OF OBSCURITY

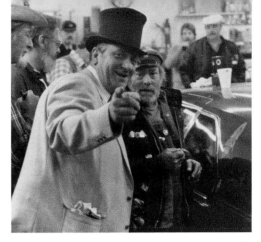

Big Daddy with his friend, the legendary Von Dutch, at a mid-'80s Rat Fink Reunion party. (Among the onlookers in the background is pinstriper Shaky Jake with the white beard; Bob Burns, in the white hat, who holds the flying eyeball copyright; and author Nason, tossing back a cold one.) Although the late Kenneth Howard, a.k.a. Von Dutch, is best remembered as the "originator of modern pinstriping," he was also a phenomenal metal fabricator, gunsmith and all around supreme craftsman. Roth had tremendous respect for, and drew much inspiration from, Von Dutch, who was three years his senior. Big Daddy was deeply saddened when Von Dutch passed away in 1992. (photo by Pat Ganahl)

While the average Joe will remember or associate Ed "Big Daddy" Roth with his trademark Rat Fink, others find themselves influenced by Roth's numerous mechanical designs, from the *Beatnik Bandit* to *Mysterion, Outlaw* to *Orbitron*, and on and on. To say Ed was a creative genius is an understatement, but rarely were his cars designed with any purpose in mind other than to amaze onlookers. Like an original painting, Roth's cars were meant to be admired for their artistic beauty. Practicality or roadworthiness were lower on the priority list.

Ed was a pre-WWII product, which meant he was a teen in the prime of alter-automotive-ego development in the late Forties. Not surprisingly, his first car, a '34 Ford five-window coupe, would eventually turn into a hot rod (the emphasis on "hot" more because of the temperature it constantly ran). To his parents' dismay, none of his cars remained "as-is," whether that meant stripping off fenders or hopping up an engine. Street racing and cruisin' followed. By the early Fifties, Ed was self-versed in body mods and, more importantly for the future that lay ahead of him, custom painting.

Left: Salute to the Wildest Vehicles Ever Built by artist Dennis McPhail. This pen-and-ink illustration was purchased at a 1996 Rat Fink Party at Mooneyes in Santa Fe Springs, California. (collection of Fausto Vitello)

A stint in the Air Force would have put things on hold for most average folk, but not for Roth. Ed served as a bombsight mechanic and cartographer, but found time to fiddle with car projects on off-duty hours. Back to "normie" life in '55, the freelance striping and flaming gig suited Ed to a T, and it was about this time that his creative juices really began to flow.

Ed took the experience he gained in the service and added the street styling inspiration from another brush man whose career was in its infancy, Ken "Von Dutch" Howard. From there, Roth teamed with Bud "The Baron" Crozier and Tom Kelly, forming "The Crazy Painters," better known as Baron, Roth and Kelly. As you can imagine, scalloping,

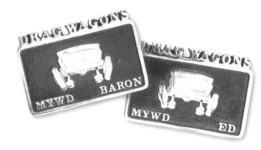

Above: Baron and Roth were members of the Drag Wagons car club. Shown above are their club plaques. (collection of Stan Chersky)

Left: Baron, Roth and Kelly, "The Crazy Painters," business card from the late '50s. Roth joined up with Bud "The Baron" Crozier and his grandson, Tom Kelly, in 1957. In their shop in Southgate, California, the three of them cranked out as many as 40 hand-painted T-shirts a day, while at the same time painting customer's cars with flames, scallops, pinstriping and lettering. Roth and The Baron parted ways in 1959; not too long after, "The Baron" passed away in 1962 at the age of 67. (collection of Stan Chersky)

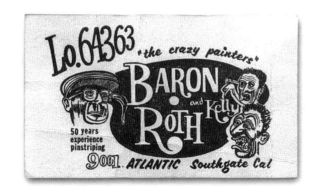

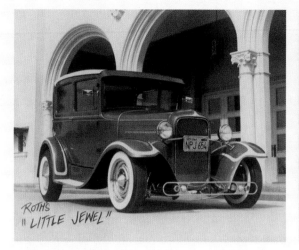

ROTH'S "LITTLE JEWEL"

flaming and striping all those cars fueled Ed's desire to expand on the "unique" thoughts floating around in his enigmatic head.

Towards the tail end of his partnership with Baron and Kelly, Ed began working on his first scratch-built car, the *Outlaw*. Many may remember Roth's *Little Jewel* Model A sedan, his striped-roof '57 Chevy hardtop, or even his early shop truck, but it would be the *Outlaw* that etched Roth's name in the custom car builder's hall of fame.

The *Outlaw*, originally named *Excaliber*, was Ed's very first fiberglass car. Now remember, this was the late Fifties, and except for the Detroit designers who were using clay to build mock-ups of their designs, most rodders were simply restyling existing cars by building off their basic designs. In Ed's process, there was nothing at all from the get-go but a vision in his head. His ideas were completely original and never before attempted or tested.

The *Outlaw*'s body was created atop a reworked Model A chassis complete with a coil-sprung V8-60 axle and a tired Cadillac engine. It was modeled by using basic plaster, which he shaped and sanded until he achieved his desired curves. The *Outlaw* wasn't just a design innovation, it rewrote the rules of car design completely.

Left: The Little Jewel was a 1930 Ford Model A two-door sedan with an Oldsmobile overhead-valve V-8. It was customized by Roth in 1955, when he returned from the service, for the show car circuit. He sold the Little Jewel in 1958 to pay for the chrome plating, fiberglass and tires he needed to finish the Outlaw. Gerald Twamley with the Renegades Car Club of Long Beach took the top two photos. (photo collection of Sheridan Attema)

Right: Three extraordinary T-buckets at a 1959 car show at Veterans Stadium in Long Beach. The Excaliber, before Roth changed the front wheels to dragster style spokes and renamed it the Outlaw, is positioned in the foreground. Roth's Tweedy Pie is situated in the middle ground, and Norm Grabowski's Kookie Kar from the television show 77 Sunset Strip is in the background. After meeting photographer Joe Barnett a couple of years ago, Jim Aust discovered Barnett had photos he shot in the '50s and '60s that had not seen the light of day for at least 30 years. This vintage photo (along with the lower-left photo of the Little Jewel) is an example from Aust's rare find. (photos by Joe Barnett; photo collection of Jim Aust)

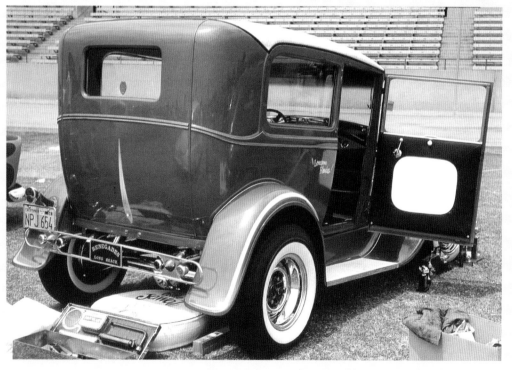

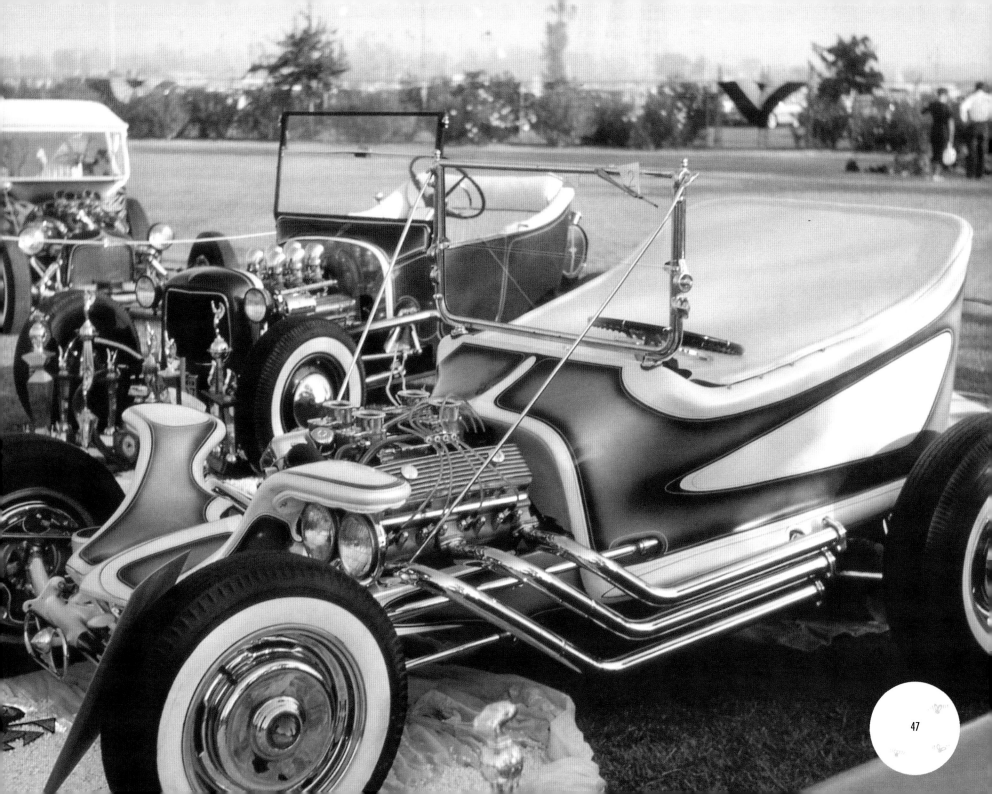

Roth himself was a wonder to behold as he shaped his miraculous forms. Never known to be a big proponent of good hygiene practices, Ed used his bare hands to do everything, including mixing plaster, resin and paint. His clothes were his shop rags. You can imagine the looks of astonishment he received while working furiously on any of a number of designs in front of his shop on Slauson Street in Maywood. Once the basic shape was finished in plaster he would drench the entire assemblage, including himself and the ground below, in fiberglass resin and mat. With the fiberglass cured to his liking, the plaster was chipped from inside, leaving Ed with a mold for his future body. Two bodies would be popped from the mold for the

Outlaw; the second body became an unusual bucket T hot rod, and Robert Williams ultimately ended up with the halved mold. *Outlaw*'s chassis was welded together at a local trailer shop, then completely chrome plated, and was paid for by selling off *Little Jewel*.

The Caddy mill was tidied up with a quartet of Scott-topped Stromberg carbs, Cal Custom finned valve covers and a set of lengthy, sweeping zoomie headers. Chromed Merc wheels with bulleted caps and wide whites set the foundation a roll. The body, with its swept-out rear deck, was painted pearl white with fogged candy green panels. The interior was done in a stylish and effective Naugahyde tuck-n-roll, complete with sword handle shifter that gave the car its original moniker.

Above: The Outlaw at an indoor car show. Built in 1958, it featured Roth's first fiberglass body and a '55 Cadillac engine built by Fritz Voight, who built many of the engines in Roth's custom cars. The Outlaw was originally named Excaliber (Roth's spelling) because it had a gearshift fashioned from a chopped down old English sword, a Roth family heirloom. After replacing the stock front rims with dragster spokes, Roth renamed the car Outlaw as he figured people didn't know the meaning of Excaliber. (photo collection of Sheridan Attema)

Right: T-shirt line art of Tweedy Pie, a 1920 Ford T-bucket hot rod originally built by Bob Johnston, a car show acquaintance of Roth's. Big Daddy further customized the vehicle into this show car. (courtesy of Bert "The Shirt" Grimm)

Bottom right: Roth's debut of Tweedy Pie on the cover of Rod & Custom in 1962. (collection of Sheridan Attema)

Below: A mold of the Outlaw's body was recently produced by pinstriper extraordinaire Jimmy C from the original mold that Robert and Suzanne Williams had saved from the '60s. (photo by D. Nason; courtesy of Jimmy C)

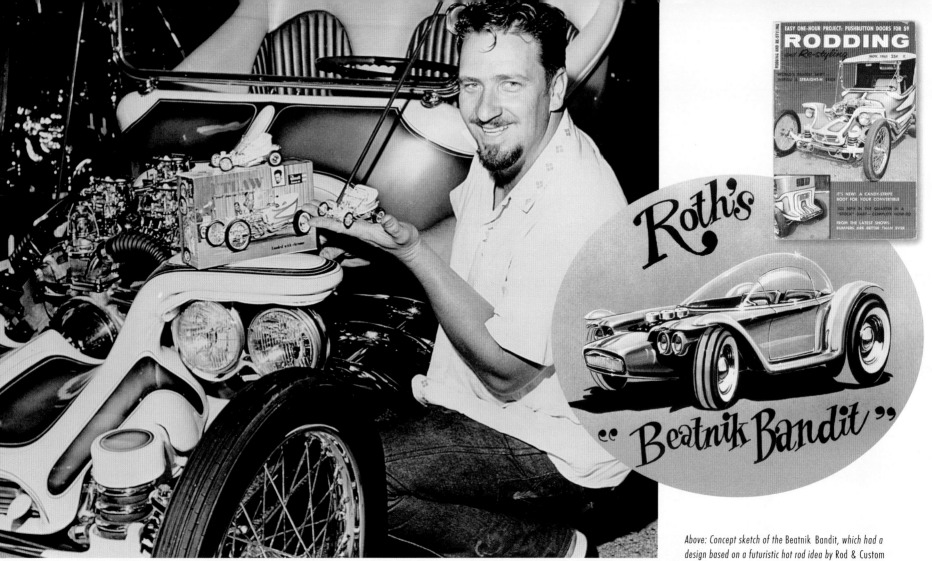

RODDING and Re-styling
EASY ONE-HOUR PROJECT: PUSHBUTTON DOORS FOR $9
NOV. 1961 25¢
WORLD'S FASTEST SHIP
INSTALL A STRAIGHT-H STICK
IT'S NEW! A CANDY-STRIPE BOOT FOR YOUR CONVERTIBLE
100 MPH IN THE QUARTER IN A 'STOCK' DART...COMPLETE HOW-TO
FROM THE LATEST SHOWS: BUMPERS ARE BETTER THAN EVER

Roth's

"Beatnik Bandit"

Above: Concept sketch of the Beatnik Bandit, which had a design based on a futuristic hot rod idea by Rod & Custom magazine staffer Joe Henning, an artist Roth much admired. (photo collection of Verne Hammond)

Left: Roth proudly displays the Outlaw model kit issues by Revell in 1962, alongside the real Outlaw. (photo collection of Verne Hammond)

Top Right: The Outlaw on the cover of Rodding and Re-styling magazine from November of 1961. Note the center-hinged top that later blew off while the Outlaw was in tow. (collection of Von Franco)

Ed knocked 'em dead at the car shows with *Outlaw* (a lot of credit going to the chrome chassis), so much so, in fact, that it sparked the interest of Revell, which wanted to make a model kit based on the car.

The *Outlaw* showed the world that Ed "Big Daddy" Roth was for real. His next project, the *Beatnik Bandit*, was a design based on a futuristic hot rod idea by *Rod & Custom* magazine staffer Joe Henning. The *Beatnik Bandit* would become a landmark car and would mark a number of milestones — among them the birth of the bubbletop and Roth's first collaboration with "Dirty Doug" Kinney.

Unlike the *Outlaw*, the *Beatnik Bandit* was based on an entire, though completely chopped up, chassis combo from one car, a '55 Oldsmobile. The body was built in the

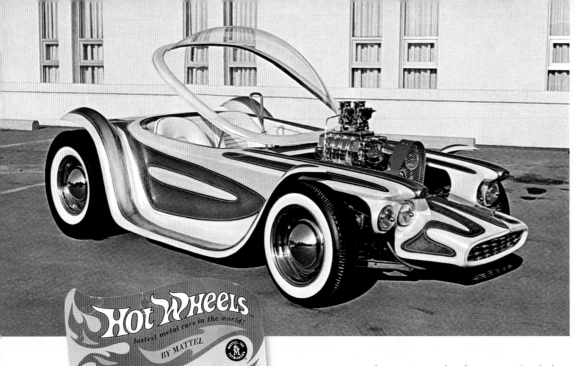

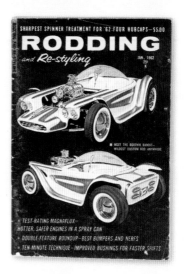

Above: Hot Wheels miniature replica of Roth's Beatnik Bandit by the Mattel Corporation. (photo by Aaron Kahan; collection of Verne Hammond)

Top: The Beatnik Bandit (1960), arguably the most famous vehicle Roth ever built, featured a supercharged mill, whitewall slicks and chrome-reverse wheels with baby moons. Roth made the futuristic bubble dome top by softening some Plexiglas in a pizza oven, then blowing it into shape. The vehicle was maneuvered by a single joystick that controlled the steering, accelerator and brakes. Keeping with the Outlaw motif, this car was originally named the Bandit, but when Roth saw the term "Beatnik Bandit" in a newspaper headline in reference to a crime, he was inspired to rename the car. (collection of Sheridan Attema)

same crude, messy way, but the top was "a whole nuther story," as Ed would so eloquently say. Henning's original sketches called for a Model-T-type square roof, but Roth decided he wanted a bubble top after seeing Bobby Darrin's *Mac the Knife* dream car. To create the bubble, Roth put clear Plexiglas (a new "space age" material at the time) in a pizza oven, then blew it into shape.

The *Bandit*'s supercharged mill, whitewall slicks and chrome-reverse wheels with baby moons were inspired by cars Ed saw while peddling his shirts at Lion's Drag Strip. The most interesting thing about the cockpit was its single joystick-like steering control, which was an accelerator and brake all in one!

All of these elements came together into what to this day is one of the most amazing show cars ever built, despite its impracticalities. Along with Revell, Roth was approached by the Mattel Corporation to create a Hot Wheels replica of the *Beatnik Bandit*. That particular little toy got as much, if not more, recognition as the full-size version. The *Outlaw* is now

owned by the Petersen Automotive Museum, and the *Beatnik Bandit* is part of a Roth collection at the National Automobile Museum (formerly the Harrah Museum) near Reno, Nevada.

As if those cars weren't wacky enough, Roth moved on to such projects as *Rotar*, an air vehicle powered by a pair of Triumph 650cc motorcycle engines. The ill-fated project was built in response to George Barris' *X-PAC 100*, and both looked liked they belonged in front of grocery stores as coin-operated kiddie rides. Each did their job of attracting spectators to the large indoor car shows. Problems would besiege the patriotic-colored creation, and luckily, Ed moved on to other "internal combustion" projects.

More drag strip idea borrowing was the premise for another bubbletop car that would one day eerily reflect its odd name, *Mysterion*. With inspiration from "TV" Tommy Ivo's multi-engine dragsters, *Mysterion* featured twin Thunderbird 390 V-8s mounted side-by-side with two early banjo rear ends welded together and set up so that one or

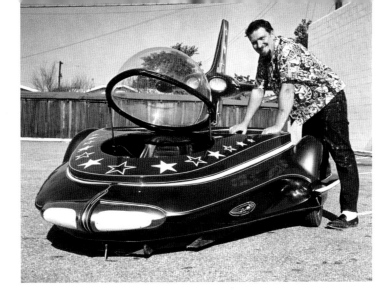

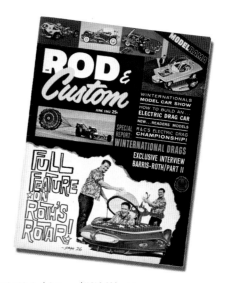

Above Left: Rear view of Rotar with primer ready for paint. (photo collection of George Goodrich)

Above: Rotar, a.k.a. the Roth Air Car, was built by Roth in 1962 in response to George Barris' X-PAC 100. Both Rotar and X-PAC 100 were designed like hydrofoils in that they rode on a cushion of air. Rotar was powered by two propellers, each driven by a sideways-mounted Triumph 650cc motorcycle engine. Unfortunately, Rotar blew up during a demonstration at a Cobo Hall car show in Detroit in 1964 and injured some onlookers. Feeling bad over this tragic occurrence, Big Daddy admitted Barris won the battle of the air cars. (photo collection of George Goodrich)

Above Far Right: Cover of Rod & Custom which featured a cover story on Roth's Rotar. (collection of George Goodrich)

Below: Line art for T-shirt design of the Mysterion by artist Adam Cruz with House Industries. The Mysterion was built in 1963 and was powered by two parallel Ford V-8 engines, each with its own driveshaft. This yellow space-age creation featured Roth's signature bubble domed Plexiglas top, but it was the unprecedented asymmetrical styling of the nose piece that aroused the attention of designers across the globe. Befitting its name, the whereabouts of this vehicle is a mystery. (courtesy of House Industries)

both engines could be run at a time. The chassis, the car's ultimate weak spot, was built based on chromed and drilled steel channel stock.

The body was fashioned in the same messy manner Roth was accustomed to, as was the tinted top; but this time he trimmed in a clear windshield section for better visibility. Larry Watson, who painted many of Ed's cars, coated *Mysterion* in candy yellow, while the interior got a real "spacey" theme with a single, pearl silver pleated seat and a UFO-like headrest pod that mimicked the Cyclops headlight/grille treatment. Angel hair upholstery that created a floating illusion completed the look. Racing slicks were also used, this time mounted on chrome Radir five-spoke mags, with skinny, chrome slotted wheels up front hung on an I-beam axle that was welded solid. *Mysterion's* brittle chassis would eventually break, forcing promoter Bob Larivee, Sr., who was touring the car for Roth, to disassemble it and part out the pieces Roth didn't want. To this day nothing has surfaced from the *Mysterion*.

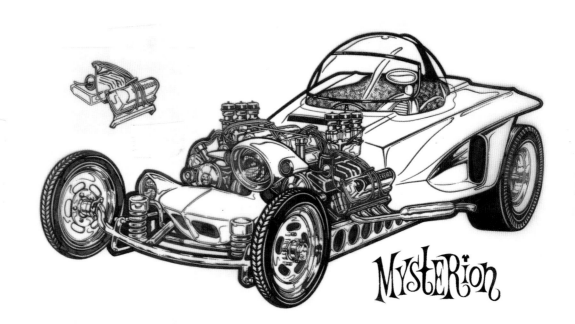

MYSTERiON

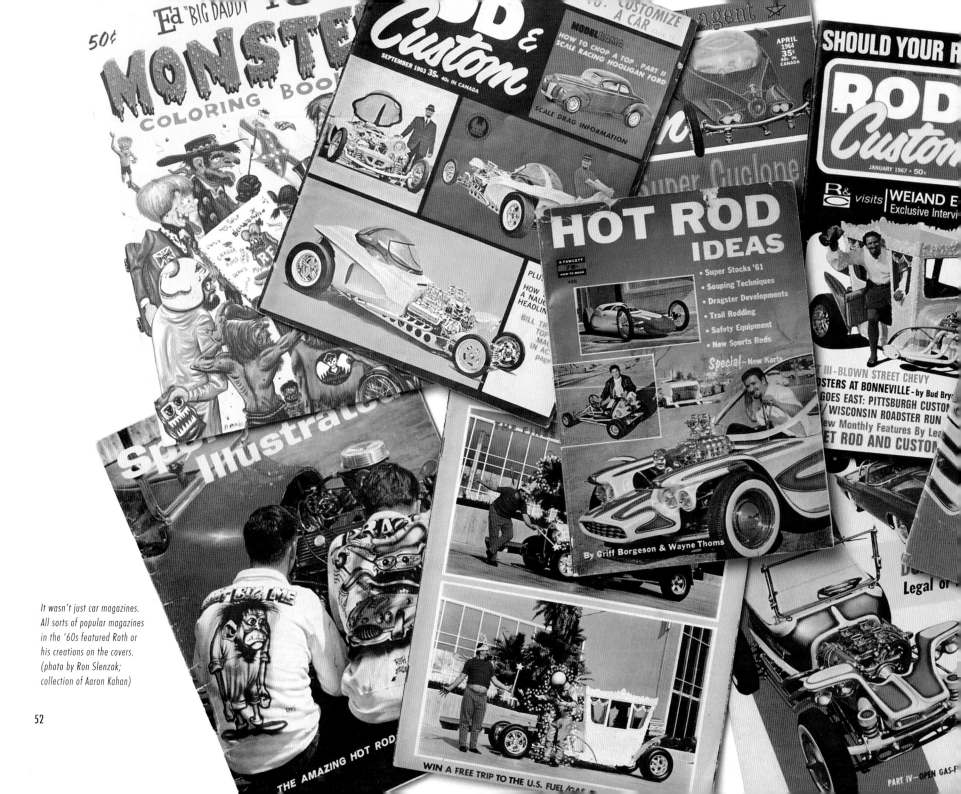

It wasn't just car magazines. All sorts of popular magazines in the '60s featured Roth or his creations on the covers. (photo by Ron Slenzak; collection of Aaron Kahan)

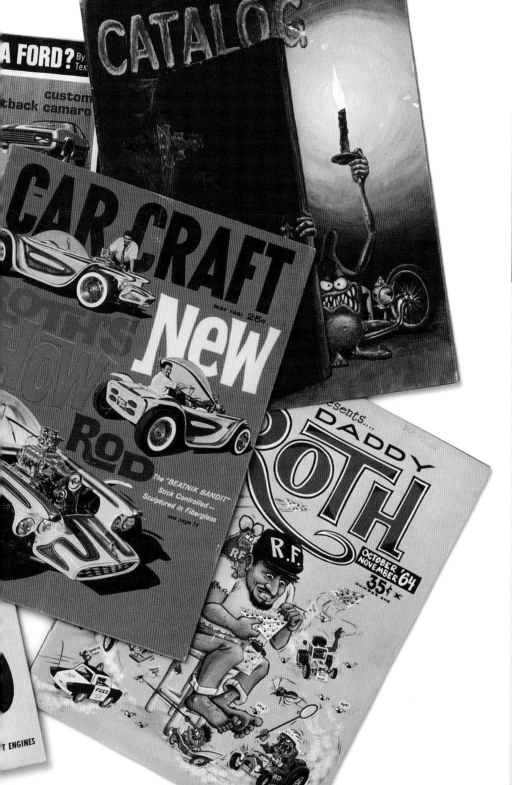

Above: Roth with the most famous of his bubble-topped futuristic rods — the Orbitron,
Road Agent and Beatnik Bandit — at Lyons Drag Strip in Long Beach, California.
(photo collection of David Chodosh)

Below: Roth's Old Pro was a 1929 Model A with a Chevrolet engine.
This is the little pickup Roth acquired and customized in 1962.
He used it mostly to haul stuff to car shows.
(photo collection of Verne Hammond)

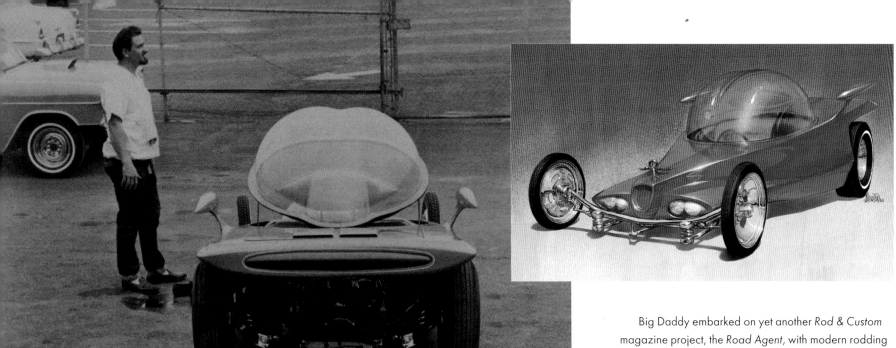

Big Daddy embarked on yet another *Rod & Custom* magazine project, the *Road Agent*, with modern rodding in mind. Again working with Henning, the two decided that this car would get rear-engined Corvair power. Perhaps out of fear of another *Mysterion* catastrophe, Roth used a chromoly tube chassis built by Dick Cook. Like its predecessors *Mysterion* and *Outlaw* before it, *Road Agent* would utilize pocketed coil springs on a transverse front axle, but this one used a single Volkswagen torsion rod as well. The top would be another bubble, but tinted (pink) with detail lines, beneath which a puckered-lip-shaped, pearl Naugahyde headrest loomed. The hand-formed body, with its teardrop side pods, was painted candy pink by Watson.

Other cars, such as *Orbitron*, *Surfite*, *Wishbone*, and even an actual dragster, the Tom Hanna-bodied *Yellow Fang*, would follow, but it wouldn't be long before Ed migrated into fewer-wheeled projects: choppers and trikes. These creations were disdained by the majority of rodders, but Ed loved 'em. He built some cool Harley-powered choppers and moved up to three-wheeled

Above: Ed "Big Daddy" Roth patiently waiting for Revell to measure the Road Agent so as to manufacture it as a 1/25 th-scale plastic model kit. This early '60s photograph was captured in the Revell parking lot in Venice, California, and includes a partial view of the front of Roth's 1955 Chevy daily driver. (photo collection of George Goodrich)

Above right: Road Agent by Ed "Big Daddy" Roth as rendered by Ed Newton in 1964. For some reason, Revell did not use this illustration on the original model kit box; however, it was used as the box art for Revell's reissue of the Road Agent model in 1997. (courtesy of Ed Newton)

Right: Orbitron illustration by Adam Cruz. Built in 1964, the Orbitron featured an asymmetrical body design with an unusual off-set headlight configuration. With paint by Larry Watson and upholstery by Joe Perez, this car was powered by a Chevrolet small-block V-8 engine. Although Ed Newton's original design sketches of the car looked good, Roth claimed he was not happy with the finished vehicle and ended up selling it to a collector in 1969 from whence it has disappeared. (courtesy of House Industries)

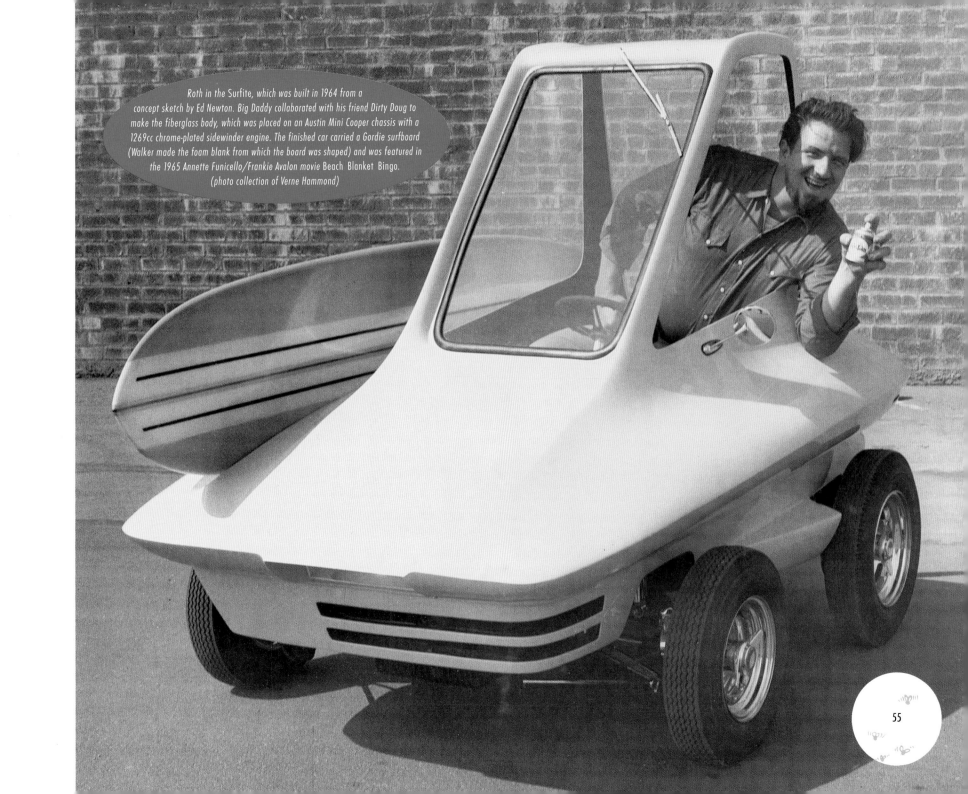

Roth in the Surfite, which was built in 1964 from a concept sketch by Ed Newton. Big Daddy collaborated with his friend Dirty Doug to make the fiberglass body, which was placed on an Austin Mini Cooper chassis with a 1269cc chrome-plated sidewinder engine. The finished car carried a Gordie surfboard (Walker made the foam blank from which the board was shaped) and was featured in the 1965 Annette Funicello/Frankie Avalon movie Beach Blanket Bingo. (photo collection of Verne Hammond)

To Verne a real gone Gasser... Roth

Choppers magazine
a Roth publication

Roth's California Cruiser

Above: Ed "Big Daddy" Roth's Yellow Fang dragster at Lyons Drag Strip in Long Beach, California. Roth built the Yellow Fang in 1966 based on a design by Steve Swaja. This rail featured an aluminum body by Tom Hanna, a chassis by Jim Davis and a blown Chrysler Hemi engine. Running a 7.3-second quarter mile at over 200 MPH cost so much that Roth elected to give up the drags. (photo by Jere Alhadeff; photo collection of Verne Hammond)

Above Right: Choppers Magazine, December 1969, cover, as laid out by Suzanne Williams, depicting Roth on his California Cruiser. In 1966, Roth attended a police auction, picked up some used Harleys, and soon was immersed in the chopper scene. Noticing that choppers were shunned by car and motorcycle magazines alike, Roth started Choppers Magazine. The inspiration for the California Cruiser hit Roth one day after a new '66 Mustang passed his Harley "like I was standin' still." In response, Roth dropped a Buick F-85 engine and transmission, linked to a narrowed "dragster" styled rearend, into a home-welded frame with Harley forks, and created his first V-8-powered trike. (photo collection of Coby Gewertz)

Right: Wishbone by Ed Roth. The Wishbone is a car Big Daddy was so unhappy with that he ended up cutting it up into pieces and discarding it into the garbage can. To Roth's dismay, Dirty Doug ended up retrieving these pieces, and amazingly the Wishbone resurfaced again. (photo collection of Verne Hammond)

motorcycles — the trikes — that had Buick and Mustang engines driving the rear wheels. When he tried, and failed, to get these bikes into the rod mags that had been his partners in the past, he launched his own magazine, Choppers, and ran it for three years.

Probably one of the last great creations to come from Roth's hands during the Sixties was the Druid Princess. With help from Dirty Doug, Jim "Jake" Jacobs, and even Dan Woods, the Princess was originally built on the premise of being a show car for the Addams Family television series, though the series was cancelled before the Princess was completed. With its blown Dodge engine and creepy wedding cake-like attire, the car did the show car circuit, and was eventually restored by Ed's son Darryl.

As the years went by, and Ed's personal outlook changed, so did his cars. Rubber Ducky, Globe Hopper and others not only reflected the times (the Seventies and Eighties) but also Ed's way toned-down character. His focus now added practicality to his design principles, and he foresaw a future that would require smaller, more fuel-efficient cars.

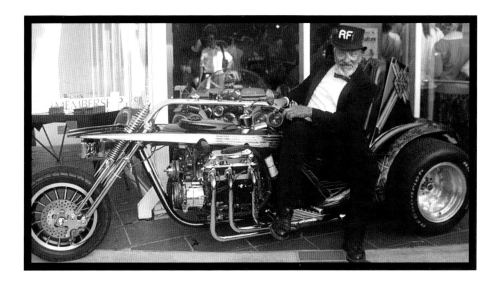

Above: Ed "Big Daddy" Roth posing with his Asphalt Angel in front of the Laguna Art Museum at the opening of the Kustom Kulture exhibit. Roth built the Asphalt Angel in 1986 with a Buick V-6 engine. After riding it across country all the way to the Street Rod Nationals in St. Paul, Minnesota, Roth was denied entry. This body mold was used for many three-wheeler kits from the early 1970s. At that time, these three-wheelers were death traps with their big V-8s and weak front ends and wheels, but what a fun ride they were! (photo by Z. Diane Sopher; courtesy of Downtown Willy)

Right: Ed Roth in the process of building the Globe Hopper.
(photo collection of George Goodrich)

Above: Rubber Ducky with a bikini-clad model at the Movie World: Cars of the Stars museum in Buena Park, California. Rubber Ducky was a fuel-efficient trike Roth built in 1977 in response to the gasoline shortage. Powered by a 600cc Honda engine and weighing only 325 pounds, its Kevlar unibody construction housed a 26-gallon gasoline tank that enabled Roth to drive it from Los Angeles to Salt Lake City and halfway back on a single tank of gas. (photo collection of George Goodrich)

Right: Line art for Roth's Mail Box trike. Big Daddy got the idea for this creation from a drawing Ed Newton made of a trike called Mail Box (originally called the Booze Wagon) for the letters page of Choppers Magazine. Jim "Jake" Jacobs built the frame and spring forks with a four-cylinder Crosley engine, transmission and axle. Big Daddy created the fiberglass body. (courtesy of Bert "The Shirt" Grimm)

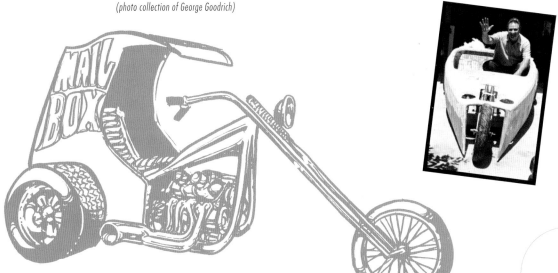

Roth with his Fink Mobile which has five wheels and is powered by a Honda Elite engine. This picture was taken at the Laguna Beach opening of the Kustom Kulture exhibit. (photo by Z. Diane Sopher; courtesy of Downtown Willy)

Then he side-stepped again in the mid-'90s, as it appeared the old Roth fire had been rekindled. Born was *Beatnik Bandit II* (originally named *Beatnik Bomber*). Reminiscent of its predecessor, *BBII* was indeed a modern version of the over-30-year-old original, but its execution and raw Roth flair made it more than just a remake. The public's reception of the new car was overwhelming, and Ed embarked on yet another nationwide tour with it and all his Rat Fink wares. Even though the custom car world was either building contemporary cars or period-style recreations, Roth was able to successfully fuse two eras of design concepts with the new car. Who would have ever imagined that modern-day fuel-injection and bubbletop would be used in the same sentence?

And just when you thought the old Roth had surfaced, along came *Stealth 99* (or pick any other name, as it had many). Based around Ed's timeless, bare-hand-built method, this car was to be his last. Using a Geo Metro engine, *Stealth* was one of Ed's smaller creations, and its mix of styling cues was quite odd. Nonetheless, it encompassed the large father's pension for translating thoughts, as wacky as they may have been, into rolling reality. Fortunately, Ed was able to complete this final car project before his untimely passing. What is not so fortunate (and this is a very touchy subject, one this author prefers not to engage in), is that *Stealth* started out as a father-and-son collaboration between he and Dennis, but ended as a solo project under Ed's direction due to personal differences.

However, no matter how Ed's personal life unraveled, he will always be remembered for his outlandish, yet ultimately cool cars. He may not have been the best at engineering or fabricating, but he could produce rolling art that served its purpose: It wowed the public and caused the world to rethink and reconceive the automobile. Drivable or not, Ed "Big Daddy" Roth's cars will go down in history as some of the most unique, often trend-setting, creations ever built.

Beatnik Bandit II was Roth's new and improved Beatnik Bandit. BBII has a futuristic Rat Fink emblazoned on its side panels and is powered by a 350-inch Chevrolet engine. Roth built this car in 1995 with his son Dennis at the Snow College near his home in central Utah. (photo by Greg Escalante)

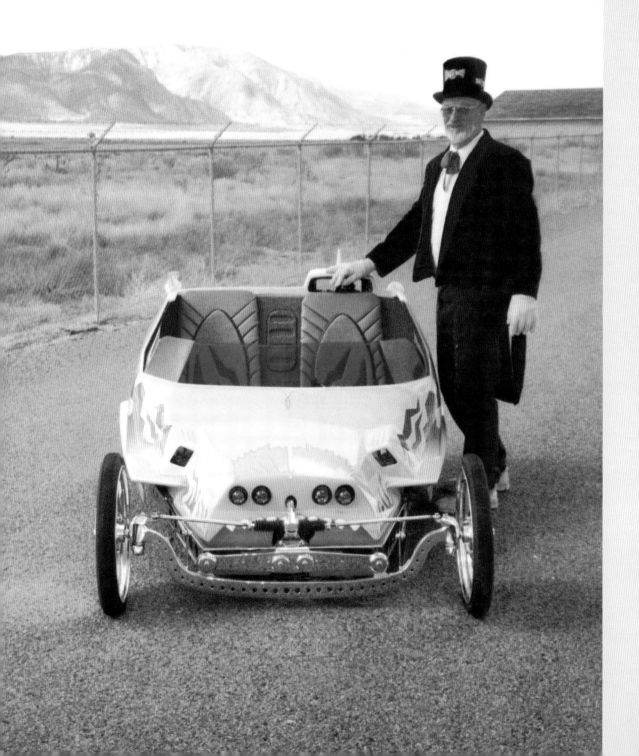

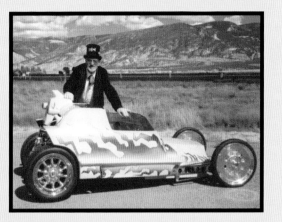

Left and Top: Roth proudly posing with the Stealth 99 in the open country of central Utah. Stealth was the last car he would build. (photo courtesy of Ilene Roth)

Above: Rat Boy was Roth's last trike; he was working on it when he died. (photo courtesy of Mike Calamusa with DRIVE! Magazine)

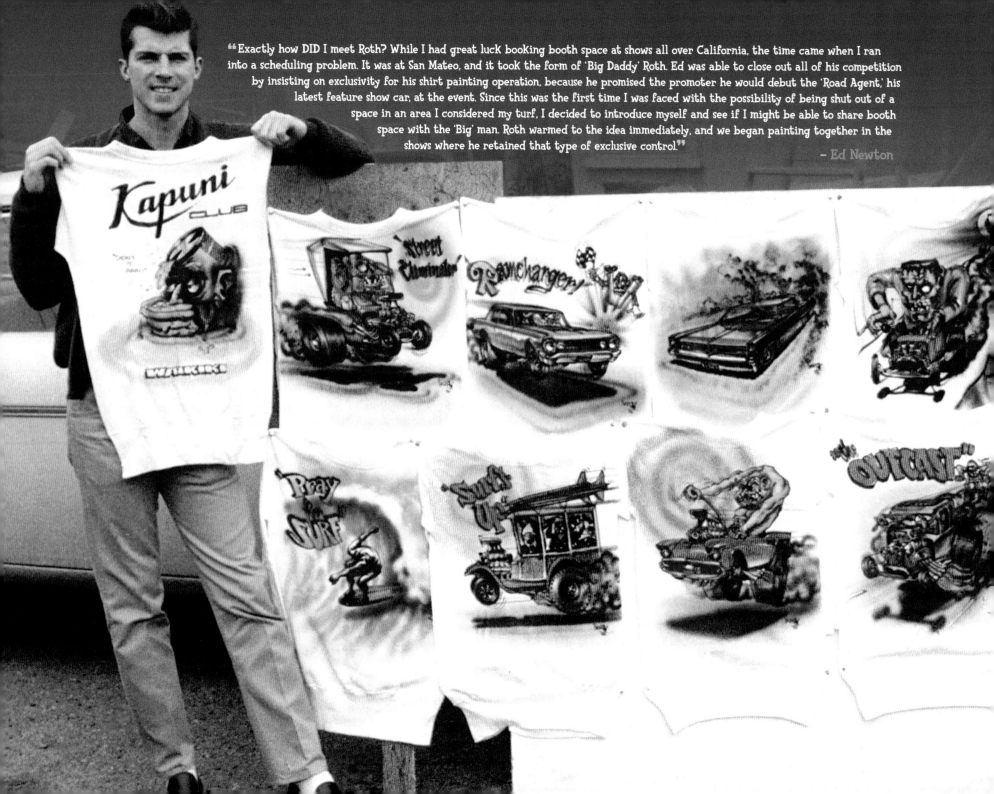

"Exactly how DID I meet Roth? While I had great luck booking booth space at shows all over California, the time came when I ran into a scheduling problem. It was at San Mateo, and it took the form of 'Big Daddy' Roth. Ed was able to close out all of his competition by insisting on exclusivity for his shirt painting operation, because he promised the promoter he would debut the 'Road Agent,' his latest feature show car, at the event. Since this was the first time I was faced with the possibility of being shut out of a space in an area I considered my turf, I decided to introduce myself and see if I might be able to share booth space with the 'Big' man. Roth warmed to the idea immediately, and we began painting together in the shows where he retained that type of exclusive control."

– Ed Newton

Roth Studios

BY ED NEWTON

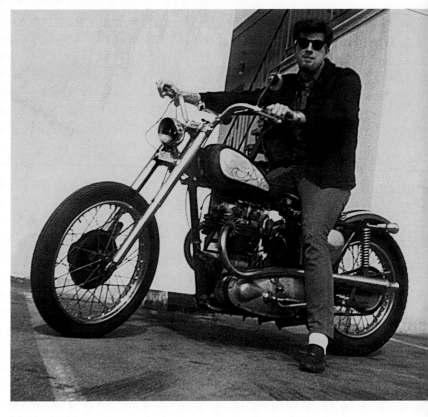

Ever wonder how many kids today would have enjoyed working with the flamboyant Ed "Big Daddy" Roth, drawing cars and monsters for a living? My experience at Roth Studios during the early Sixties was indeed varied and colorful, but it certainly happened by chance, not by design. One may say that it happened because "necessity is a mother."

When I was a teenager, in order to pay my way through art school, I gambled on a quick moneymaking scheme — airbrushing T-shirts. This "crazy painting" thing was in its absolute infancy when Rick Ralston, an Art Center School of Design classmate, talked me into painting shirts with him in Hawaii. I was aware of Big Daddy's efforts in this field only because of his exposure in the popular car magazines. But during my summer vacation in 1962, I found I could not only make enough money to pay my yearly tuition, but make more than I might earn as a fledgling automotive designer in the corporate world (which had been my professional goal). So after an earlier two years at UCLA, and two at the Art Center, I left school to pursue this new, provocative business full time.

After meeting at a car show in 1963, Ed Roth and I began painting shirts together at various show venues throughout California. During these sessions, Ed tried to convince me to abandon my own shirt painting business and go to work with him in the Southland. If I turned him down, he'd just up the ante during our next event together. Soon it became such a lucrative deal, I accepted the position and moved to Maywood to join those crazies lurking at Roth Studios.

Strangely enough, when I first arrived at Roth's for my full-time assignments, they did not include the task of creating any shirt designs. Ed promised I'd stay plenty busy just taking care of his advertising and show car designs, and that he had the "shirt thing" covered. After just a few days at Roth's, I became familiar with his flat-file full of shirt artwork, but I found there was a piece missing. One afternoon, I asked him where the original art was for his most famous design of all time, the Rat Fink. He launched into a colorful description of how he had drawn Rat Fink on a napkin, but was forced to render the final version on the shop

Above: Ed Newton on his customized Triumph motorcycle in 1964. Newton bought this 1957 Triumph already customized with 1951 forks and a Mustang "peanut" (smaller than stock) gas tank and used it for his daily commute to and from Roth Studios. (photo courtesy of Ed Newton)

Above Left: Ed Roth c. early '60s. (photo collection of George Goodrich)

Opposite page: Ed Newton with some of his original airbrush T-shirts in 1963. This photo was taken just prior to Newton meeting and going to work for Ed "Big Daddy" Roth. (photo courtesy Ed Newton)

Right: The Chislers with Big Daddy and The Pizz at a late 1980s Rat Fink Reunion party at Kim Dedic's sign painting shop in Fullerton, California. The Chislers were a young Southern California-based car and motorcycle club that transformed into the Burbank-based Choppers Hot Rod and Custom car club in the late 1990s. The Chislers from left to right: Charly Jansen, Meli, Darv, Brian Story, Jon "Fish" Fisher, Kenny Sylvester, Jamie Fleming, Sandy Wachs and Michelle Cicero. (photo collection of David Teare)

Above: 1986 Rat Fink Reunion invitation by R.K. Sloane. (collection of D. Nason)

refrigerator door. Many years later, during a bull session at the first Rat Fink Revival (a.k.a. "Reunion"), someone asked Roth the same question. When he hesitated, I piped up and said, "Don't you remember, Ed, the story went like this...." And I proceeded to relay the facts as he had originally told me 15 or so years previous. After I finished the tale, Roth leaned over toward me and said, "Hey, Newt, that was really great. Do you mind if I use that story?"

During those early days at Roth's, Big Daddy and I would still paint shirts at weekend car shows, and sometimes I'd work alone under the "Roth Studios" banner. During one of these "solo" car shows, I had a little time to myself, so I air-brushed a shirt that I later showed to Roth. I had to

promise that I would "eat the design" if he didn't like my camera-ready version of the art before he would agree to let me give it a shot. After delivering the inked version of "Killer Plymouth," Roth asked me to add all his future shirt designing to my work load.

Ed "Big Daddy" Roth had firmly established himself as an incredible innovator and forward-thinking custom rod builder before I ever started creating vehicle designs with him. Although my Art Center background was similar to those stylists hired to work in Detroit, I learned a lot from Ed when it came to creating a popular feature show car, truck or trike. Something they used to shy away from in Detroit (but not anymore) was the tip Roth gave me concerning engineering features. He told me, "Newt, when a guy looks at a car in a show, he gets tired of looking at just some swoopy bodywork or bitchin' paint job. He needs to see the nuts and bolts...the things that

make it go. Otherwise, he gets bored." So, after wrapping the *Orbitron* and reconfiguring the *Surfite* from an Art Center class project into a slick surf-buggy for Ed, I made sure that my next Roth-built vehicle concept drawings all had those "exo-mechanical" features.

When I reflect on the times spent at Roth Studios, I'm amazed that I never considered the possibility of any future importance being placed on those events. I think for all of us who worked there it was just "a fun job" (more to some than to others, I'm sure), but we were all too young to apply any kind of lasting significance to our efforts. It was merely a cool place to work. No big deal. When Roth Studios closed in 1970, we didn't figure "the dream was over" or anything like that, we just thought, "Oh well, it was great while it lasted." And for those of us mothers of invention on the creative end, it had really been a necessary evil, because we could think of no other type of business that would allow us the freedom to "be bad" and make honest money at the same time.

Ed's presence in the world of custom and specialty automotive interests will be felt for years to come. I personally consider Roth the "Walt Disney of Hot Rodding," because he was both a visionary and an organizer. He knew how to assemble talent and how to get the most out of it. And he was always in there, toe to toe, right or wrong, moving the ball down that formidable field of dreams.

Ed Newton's 1966 design rendering of Captain Pepi's Motorcycle and Zeppelin Repair Service, aka the Megahauler and Megacycle (or Newt's project title: The Bike Hauler). Shown here is the custom Harley XLCH that Roth originally intended as the Megacycle. But with rapidly approaching deadlines Roth acquired an award-winning Triumph show bike and modified the Megahauler's design so as to finish the vehicle on time. (courtesy of Ed Newton)

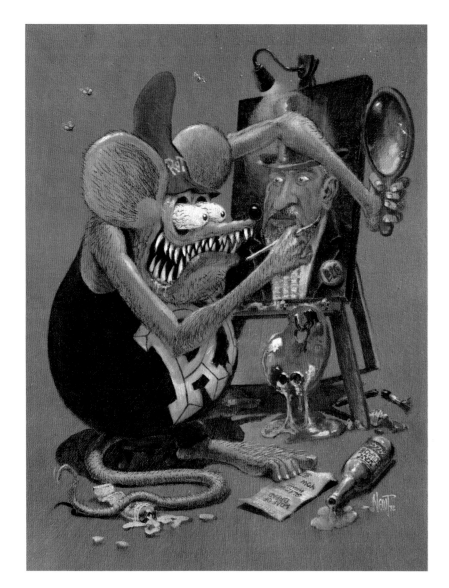

Of the hundreds of shirt designs penned for Big Daddy over the years, some are more fondly recalled than others. During the late '60s, personal favorites like ZL-1 by Corvette and Cobra Mustang were not the most successful sellers, but merely the most innovative in style. Of my earliest efforts, Sidewalk Surfer and Mighty Mustang were not really among my favorites, but they were a couple of Roth's all-time best sellers. Designs that I liked and that also happened to sell pretty well were Beaver Patrol, (collection of Aaron Kahan) Support your Local Fuzz...Bribe Them! and Do unto others...then Split! (collection of Jon "Fish" Fisher) Agreed, sometimes the title is more than half the battle for such a novelty to attain commercial success, but I like to believe that it's the entire package that creates lasting popularity. Other designs that I believe benefited from that combination were 57 Chevy: Ford Killer, Firebird and Camaro SS 350. When I look back at these individual designs, I'm amused at the negative flack we received from parents over designs like Wild Child, (collection of Aaron Kahan) which was probably my favorite of the earliest designs. In addition, I'd like to think that the style of art I developed for Plymouth Racing Team in 1966, and especially Hemicuda in late 1969, was the direct inspiration for the popular distorted-proportions '70s show car series called Zingers.

Opposite Page Left: Rat Fink's Self Portrait, an oil painting, inspired by something a tired Roth said to Newt while sharing an event booth in 1992. After a long weekend of signing autographs and selling "Finkobilia" at a car show a few years ago, Roth turned to me and said, "You know, Newt, sometimes I feel I actually _am_ Rat Fink." So I figured, well, if Ed thinks _he_ is Rat Fink, then Rat Fink must see himself as Roth. When I returned to my studio, I tried to capture that strange symbiosis with an oil painting I called Rat Fink's Self Portrait. (courtesy of Ed Newton)

Opposite Page Right: Old Rat Finks Never Die, They Just Blaze Away and the infamous PsychoFink were created for a Fink Reunion. The first Rat Fink Reunion was held in December 1977, at Jimmy Brucker's Cars of the Stars museum in Buena Park, California. This revival of our traditional Christmas party began as a legit reunion for those of us who actually worked at Roth Studios, but it has long since taken on a life of its own. While at the event, and just for fun, I airbrushed an original concept Rat Fink T-shirt to donate "to the cause." This little gesture became kind of a tradition at subsequent Rat Fink Reunions, and also became a focal point in Roth's desire for some "old style" designs I would do for Ed during the '80s and early '90s. This shirt art eventually gave way to color renderings, oil paintings and limited-edition prints. (courtesy of Copro/Nason Gallery)

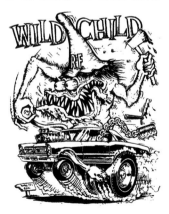

"Monkeymobile"

Newton
66

CALIFORNIA CHOPPERS

THREE WHEELER EDITION

BOOZE Wagon

67¢

"From 'Munster Koaches' to 'Monkeemobiles,' Roth and I submitted some wild specialty designs for TV theme cars. For a period during the mid-Sixties, Big Daddy became embroiled with selective efforts to build specialty cars for Hollywood, with limited success. He was involved with the 'B' picture crowd (where B stood for Beach), but never to any great extent. He'd managed to stripe, paint and supply a couple of cars that appeared on-screen, but the 'big TV-car contract' always seemed to elude him. Our concept for the mid-Sixties 'Munsters' TV show was 'not wild enough,' and then our idea for the proposed 'Monkees' TV vehicle was deemed 'too wild.' There was another attempt to propose a specialty car for the 'Addams Family' TV show. Again, 'close, but no cigar.'

One of the most unheralded successes to come out of the Ed Roth stable of specialty vehicles was the 'Mail Box' trike. Occasionally (or maybe rarely), Ed would let a project come together with a minimum of complications. Case in point: the 'Mail Box' trike. I used to design and illustrate any number of items for Roth's publication in mini-book form (the general size of a 'Reader's Digest'). Drawings of sissy-bars (the chrome back-rest on a chopper) and a trike 'styles' book come to mind. When Ed saw what I had submitted for a 'Three Wheeler Edition' of his 'California Choppers' magazine, he picked two or three designs for possible show vehicles. With the addition of a trailer, one became the 'Candy Wagon,' but the most successful effort (in my opinion) was the 'Booze Wagon.' In fact, Roth liked the design so much, he had me draw another view of the trike with the words 'Mail Box' lettered on the side, so he could use it as a department head for the mail correspondence column of his fledgling 'Choppers Magazine.' When this popular concept grew into a full sized custom trike, with Dan Woods and a hard-working Jim 'Jake' Jacobs doing most of the final construction, I was amazed how close it came to the original concept drawings."

– Ed Newton

Left: Ed Newton's cover for a California Choppers speciality issue of Roth's Choppers Magazine. Although this "mini-mag" is devoid of dates (Roth purposely left all references to dates off his "one off" books so he could continue to re-print, advertise and sell them as new), an event T-shirt advertisement found inside reveals that it must have been published in late 1967 or early 1968. (courtesy Ed Newton)

Above Left and Opposite Page: Monkeemobile concept sketches by Ed Newton (1966). (courtesy of Ed Newton)

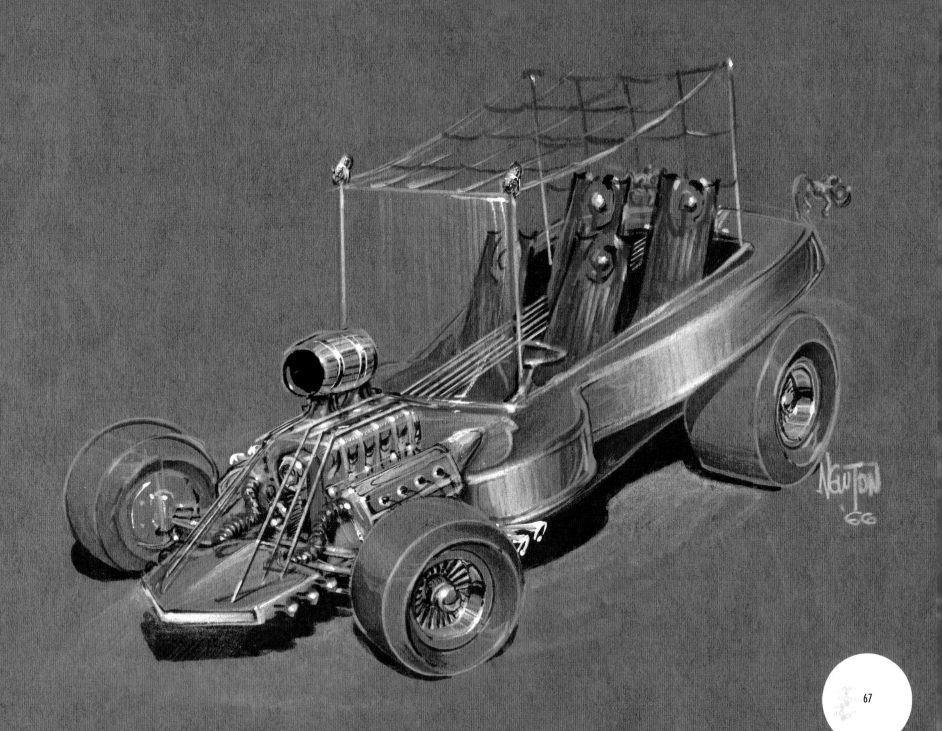

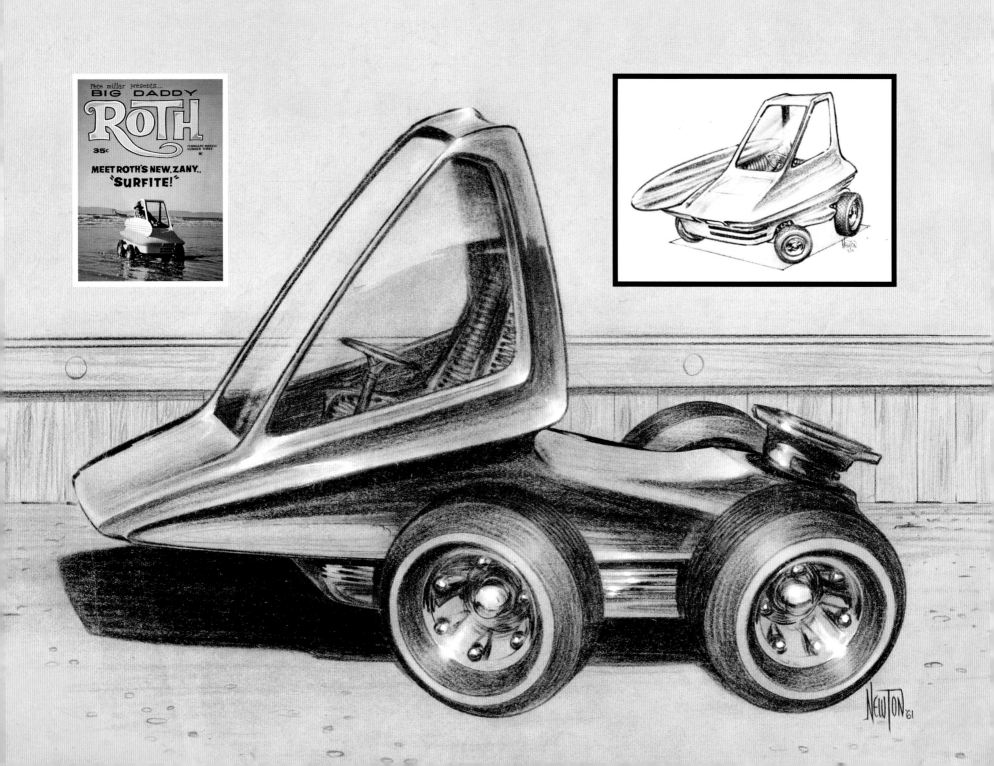

Newton '61

"What was the Creative Process like at Roth Studios in the Sixties?

Except for a three-wheeled motorcycle called the 'Mail Box,' the 'Surfite' (derived from a 1961 Art Center class project) came the closest to my original concept drawing. However, that was the exception rather than the rule. Roth and I always had a great creative relationship. He liked the idea that I didn't need much prompting to come up with a design we both liked. It was really easy with the shirt designs because he would merely tell me a caption, or the year and model of the car he wanted, and I would do tight thumbnails for his approval. It was a little tougher with the full-size vehicle designs. Ed would have an idea of the type of car or trike he wanted to build, and I would do rough concept sketches. Then I would follow up with even more variations until we agreed on something that I could work into a finished rendering for construction reference. Some running changes might follow during the sculpting of the plaster buck, but once the fiberglass was applied, it was a 'done deal.'

How long did Newt share an office with the ubiquitous Roth?

After working in-house for a couple years with Roth, I began picking up a fair amount of freelance work, so I renegotiated our agreement to allow me more freedom to schedule time for other projects. I still supplied nearly all of his shirt designs, worked on feature show cars and trikes, designed model kits with Ed under the Revell label, and eventually contributed layout services and cartoons for his new 'Choppers Magazine.' But I was able to work at home without any 'office pressure.' By 1966, Roth had hired Robert Williams as his full-time car magazine advertising designer-illustrator, and the resulting incredibly detailed art immediately reflected the added attention given this reinvigorated category. Bob ended up contributing much more than those clever ads during the late Sixties, along with freelance artists like Tom Daniel and Dave Deal, who were pleased to contribute their expertise to the Roth Studios effort."

— Ed Newton

Above: Ed Newton working after hours on some freelance dragster designs in the little office he shared with Roth. Note the Roth Studios T-shirt design he was working on before 5:00 p.m. shoved to the side of his desk. (photo courtesy of Ed Newton)

Background: These sketches were Newton's initial attempt at converting his concept semi Surfite (tractor) done at the Art Center School to a "kooky vehicle" that Roth could build (early 1964). (courtesy of Ed Newton)

Opposite Page: Ed Newton's 1961 concept sketch, done while attending Art Center, which was the basis for the Surfite. The inset sketch shows Newton's 1962 refinement of the Surfite design (as shown in Hot Rod magazine in 1964). (courtesy of Ed Newton)

Opposite Page Upper Left: Cover of Pete Millar Presents...Ed "Big Daddy" Roth (February/March 1965; Issue #3) introducing the Surfite. (collection of Shawn Attema)

Brother Rat Fink

BY DOUG HARVEY

AND THE ERUPTION OF THE GROTESQUE IN POP CULTURE

The very idea of assigning a "place" in art history to the work of Ed "Big Daddy" Roth still raises hackles on all sides. On the one hand, the art world establishment, so superficially open-minded, recoils from the lower-class pedigree and candid commerciality of the work (as well as more profound differences we'll look into shortly). On the other hand, many of Roth's supporters in the custom car, underground comic and lowbrow art subcultures perceive the mainstream art world as fundamentally corrupt, and they disdain any overtures toward inclusiveness. Nevertheless, Roth has contributed substantially to the visual culture of the last half-century in a number of ways: through his over-the-top, futuristic cartoon-like custom vehicles; through the invention and distribution of Rat Fink and his monstrous cartoon entourage; and through the openly and innovatively collaborative nature of his studio and marketing system, and its intersection with the larger social phenomenon of car shows.

In this essay I'm going to talk mainly about Rat Fink and his pivotal role in the reemergence of the Grotesque in American popular culture of the Fifties and Sixties.

Yet Roth's other areas of creative activity must be taken into account and provided with an art historical context first, both to buttress what I have to say about RF, and to emphasize the essential marginality of Roth's art. It is marginality — the existence on the very periphery of mainstream culture — that dictated the style and substance of all Roth's work and gave him unprecedented and virtually unregulated access to a massive and highly receptive youth audience.

Roth emerged from California's custom car subculture, itself a marginal arena for creative expression. The skills and aesthetics inherited by Roth and others were a codification of themes and variations on car design that arose from a collective, socially realized art process. Individual artists worked on factory-uniform vehicles to bring them into closer alignment with their own vision of how a car should look and function. Some modifications caught on with other customizers, while other experiments vanished, as the group mind gradually honed its ideal. Roth's early custom jobs were exemplary embodiments of the collective aesthetic aspirations, so that once he struck out in his own direction, he had a backlog of street credibility.

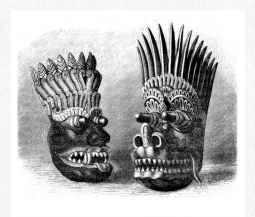

These native Cingalese (Singhalese) wooden masks from Ceylon, c. mid-1800s, look strangely familiar. Is it possible Rat Fink transcends culture and time? Did Big Daddy tap into a universal icon from the collective unconscious and cross-cultural symbolism? (courtesy of Jim Staub Photography)

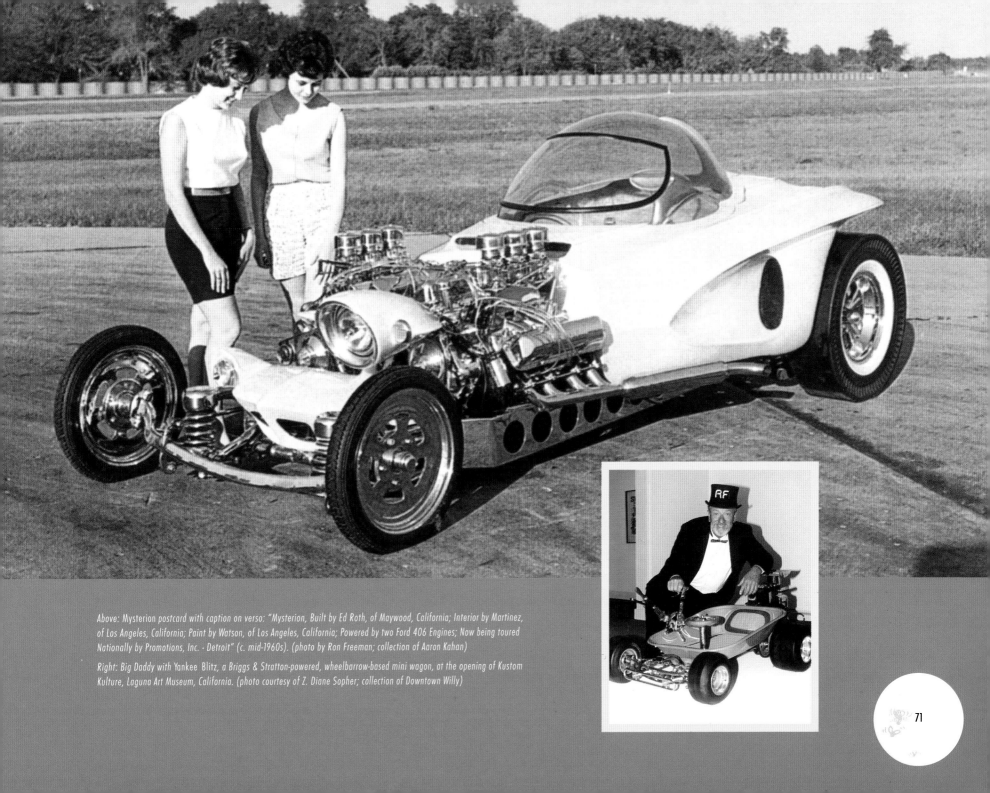

Above: Mysterion postcard with caption on verso: "Mysterion, Built by Ed Roth, of Maywood, California; Interior by Martinez, of Los Angeles, California; Paint by Watson, of Los Angeles, California; Powered by two Ford 406 Engines; Now being toured Nationally by Promotions, Inc. - Detroit" (c. mid-1960s). (photo by Ron Freeman; collection of Aaron Kahan)

Right: Big Daddy with Yankee Blitz, a Briggs & Stratton-powered, wheelbarrow-based mini wagon, at the opening of Kustom Kulture, Laguna Art Museum, California. (photo courtesy of Z. Diane Sopher; collection of Downtown Willy)

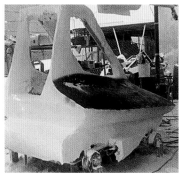

When he began to produce the outlandish moving sculptures for which he became renowned, handcrafting his unique version of the iconic industrially mass-produced object, it took a surprisingly short time for the mainstream culture to take note. Tom Wolfe's first book, *The Kandy-Kolored Tangerine-Flake Streamline Baby*, is centered around the title essay, a piece for *Esquire* that reported from the Teen Fair in Burbank on the burgeoning underground car culture, and specifically on Ed "Big Daddy" Roth. The "New Journalism" of the Sixties began with this very essay, composed straight from Wolfe's notes. (This odd correlation between West Coast automotive subcultures and New Journalism later resulted in Hunter S. Thompson's *Hell's Angels* and *Fear and Loathing in Las Vegas* and Wolfe's own cosmic bus-ride in *The Electric Kool-Aid Acid Test*.) Unfortunately, Wolfe's droll and detached tone undercut his otherwise convincing arguments for Roth's cars as objets d'art and Rabelaisian tours de force, and the East Coast art intelligentsia were, in any case, already unreceptive to the ideas of a writer who would later skewer them in *The Painted Word*.

The young artists of LA were more receptive to Big Daddy's aesthetics, and many of the legendary Ferus Gallery stable, including Robert Irwin, Billy Al Bengston, Craig Kaufmann and Ken Price, began introducing the techniques and visual vocabulary of custom car design into the artistic mainstream, eventually garnering Los Angeles its first attention as an international art center on par with New York or Paris. Additionally, many of the sculptural techniques pioneered by Roth in the fabrication of his fiberglass fantasy vehicles have been adopted by contemporary sculptors, to the point of replacing carving and metal casting as standard technologies.

Still, most of this influence has been un-, or at least under-acknowledged. The cost of admitting the techniques and visual nuances of custom car culture into the rarified artistic echelons was the shedding of its vulgar associations, i.e. everything Big Daddy personified. The very functionality of Roth's vehicles rendered them dismissible as mere design, however idiosyncratic. While the possibility of automotive corporate cross-financing of exhibitions has softened curatorial resistance to the idea of car design as an art form, other aspects of Roth's total package — his flamboyant mock-dandy persona; his participation in and reliance on the carnivalesque context of the teen car-show circuit; his communalistic, authorially indeterminate production strategies; and his access to mass markets (and concurrent independence from the endorsement of art world authorities) — remain difficult and under-explored frontiers to the world of high art. But while Roth remains a peripheral figure in the official canon of West Coast art, his real impact on American culture is more accurately measurable in his rhizomic infiltration of the embryonic Sixties youth subculture via the Revell model kits and his own cottage industry of T-shirts and related paraphernalia.

It is important not to underestimate the importance of the strictly vehicular model kits. Roth's baroque and innovative car designs, rendered intelligible in a three-dimensional tactile form to thousands of impressionable psyches, undoubtedly left a profound collective imprint. Yet I'd like to turn my attention at this point to Brother Rat Fink and his ilk, and their central role in the eruption (and celebration) of the repressed monsters of the American psyche. The proliferation of plastic model kit assembly as a hobby gave several generations of American children their primary experience of three-dimensional aesthetic

Composition with Rat Fink Green, Red, Blue and Yellow, No. 2 (Tribute to Piet Mondrian), 1995. Author Tom Wolfe, in his classic book The Kandy-Kolored Tangerine-Flake Streamline Baby, describes Ed Roth as a master of curvilinear and asymmetrical design. Yet Roth's style contradicts the rigid line work of De Stijl that was epitomized by Mondrian. The underlying composition was painted by artist Jean Bastarache, with the Rat Fink added by Roth. (collection of Dr. Arthur Katz)

Opposite Page Top: Street Racer. Original pencil sketch (c. mid-1960s). (collection of Jeffrey Decker)

Opposite Page Middle: The Surfite's fiberglass body under construction. (photo courtesy of Ed Newton)

Opposite Page Bottom: Surfite plaster construction with surfboard in place. (photo courtesy of Ed Newton)

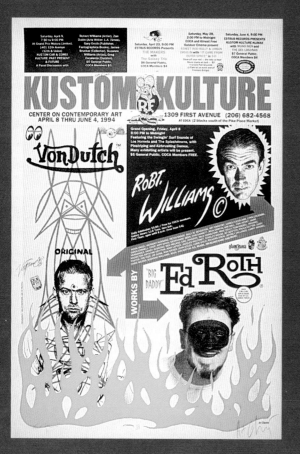

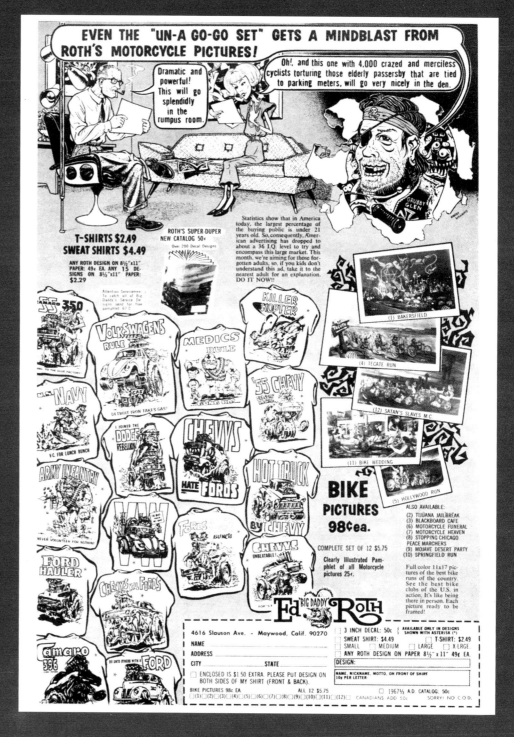

object-making, i.e. sculpture. For boys, monstrous figurative miniatures like Rat Fink (as well as the popular Aurora classic film creature series) were also one of the only gender-acceptable mediums for animistic play (green plastic toy soldiers being the anonymously scaled and psychologically meager alternative), nurturing aspects of the human imaginative faculty closely related to subjective numinous experience.

There's no denying that Roth's grotesque cartoon losers (as model kits, T-shirt designs, and infinitely copied schoolbook margin doodles) struck a chord at the most inchoate level of American society. But can it be reasonable to suggest that this zany, off-the-cuff marketing phenomenon had a deeper sociological, even spiritual significance? While some would argue for Roth's cartoons as distinctly, even quintessentially, 20th century artifacts, their art historical place embeds them in a tradition dating as far back as the discovery and excavation of the Golden Palace of Nero in 1480. It is from the decorative borders surrounding the frescoes lining these unearthed Roman "grottoes" that we have inherited our concept of the Grotesque. These borders depicted mythological figures intertwined with plant and animal forms, and monstrous hybrids of both. This was a stylistic revelation for artists like Raphael and Michelangelo, and a cornerstone for the paintings of Brueghel and Bosch, liberating them from the sterility of classicist geometrical purity to wallow in the strangeness of their humanity.

The term "grotesque" came to encompass a wide range of "unregulated" and "unnatural" artistic strains, including the depiction of fantastic creatures and scenes, extremes of violence, and bodily processes. As a whole,

these strategies quickly became the bête noir of polite, official art: a dividing line between races, classes and genders which favored WASPs and other groups who strived to disavow their senses; who saw art as a means to overcome the messy contingencies of bodily existence. In putting the sacred and magical technology of image-making in the service of the degraded human organism, these artists were locating the struggle for political and spiritual autonomy within the specifics of bodily function. The layers of mythological and psychological resonance surrounding this division boil down to a simple truth about human culture: Primate pack leaders get the most grooming, and grooming removes evidence of bodily functions. The richer you are, the more of your physicality you can afford to deny. To reinforce the idea that there is some essentialist difference between the rich and the poor, it behooves the rich to promote artworks that suggest they are incapable of breaking wind; like God.

Much of the history of art criticism finds notoriously uptight pundits like John Ruskin (allegedly horrified to discover, on his wedding night, that unlike the statues of classical antiquity, the female form is graced with pubic hair) arguing for the superiority of the serene, Apollonian, state-sanctioned visions of vaporous romantic landscape painters. The Grotesque came to be associated with anti-authoritarianism; and works by such artists as Goya, Munch, Beardsley, and the Expressionists and Surrealists made full use of this connection. The depiction of monstrous physicality became an act of defiance, not only against arbitrary aesthetic hierarchies, but the greater inequities of human politics.

Of course, the tremendous popular impact of this imagery derives from its symbolic power as a representation

Above: Prometheus Being Chained by Vulcan and Saved by Rat Fink (Tribute to Dirck van Baburen). *In a strange warp of time and artistic styles, Rat Fink appears to be applying a cross-shaped band-aid to Van Baburen's chiaroscuro Prometheus. Roth may have intended the gesture to be symbolic of the Christian-based Mormon values that saved him from the evils (which were often liver-antagonistic) of the hot-rod lifestyle. (collection of Mickey Bernheim)*

Opposite Page Top Left: Snuff Fink. *Screenprint by Robert Williams (original art from mid-'80s; fine art print from 1989). Williams was Big Daddy's art director during the mid-'60s, and this composition was obviously influenced by Roth's hot-rod-driving monsters. Like most of Williams' paintings, it has two alternative titles in addition to a common title. Its museum catalog title:* The Exuberance Of Youth Bordering On Self-Destruction Lends Romance To The Notion That Acne Is Never Really Cured, It's Just Thrilled Into Remission; *and a colloquial title:* Brodyin' On Feces. *(courtesy of Copro/Nason Gallery)*

Opposite Page Bottom Left: Kustom Kulture *screenprint by Art Chantry (1994). When Kustom Kulture traveled to The Center on Contemporary Art in Seattle, this silk-screened print was used as the invitation for the exhibition's opening. (courtesy of Copro/Nason Gallery)*

Opposite Page Right: Ed "Big Daddy" Roth *ad designed by Robert Williams from the mid-'60s. (collection of Verne Hammond)*

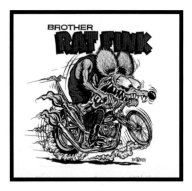

Above: Brother Rat Fink.. On A Bike! *This Revell model kit was custom built by Mark McGovern. (photo by Ken Roshak)*

Top: Brother Rat Fink, 1965. *This eight-color serigraph was published by L'Imagerie Gallery in 1992. (courtesy of Debi Jacobson)*

Opposite Page: Riding Through the Gates of Hell to Shake Hands with the Devil *(1990). Acrylic on paper illustration by Todd Schorr. (courtesy of Todd Schorr)*

of the dark, unknown side of human consciousness, the pieced-together and reanimated patchwork monster of all that has been cut off, denied and repressed in our beings. Referred to as the Shadow archetype in Jungian psychology, this monstrous "other" is considered the most difficult aspect of the psyche to approach, and its integration into our conception of the self a major psychological and spiritual accomplishment. The thought that such material can be eradicated from our experience of life is ridiculous, as evidenced by its inevitable reappearance after periods of repression, often in the least expected places.

Much of the first half of 20th century America can be read as a great experiment in repression, with authorities on all sides exploring the potentials of the newly emergent mass media and mind-control technologies of advertising and public relations. Prohibition served as a dry run to see just how far government supervision could intrude into the private lives of its citizens; but it was the superficially homogenized, deeply paranoiac "McCarthy Era" of the 1950s that took repression to its own baroque extreme. The attempt to construct a seamless blandscape of contented consumers has taken on its own surreal edge in retrospect, but at the time the imposition of normalcy was a matter of pious, deadly earnest.

A case in point is the persecution of the comic-book industry, particularly the quintessentially grotesque fare of the EC Company, whose *MAD* magazine was its only title to survive the imposition of the Comics Code Authority. Nevertheless, it was *MAD*, particularly the work of Basil Wolverton, that, alongside the renewed teen interest in horror films, set the stage for the emergence of Rat Fink.

It's probably unnecessary to point out the stylistic devices that identify RF as a classical Grotesquery — the

oozing, drooling, bulging, misshapen, contorted figures pass art historical scrutiny with ease — and the outrage of a million concerned parents and schoolteachers is the clincher. Rat Fink even evolved, like his Renaissance forbears, from baroque decorative peripheries, inspired in Roth's case by pinstriper Von Dutch's incorporation of phantasmagoric entities in his elaborate linework.

Objectively, it's hard to discern the qualities in the RF imagery that made it so successful. It's an accomplished bit of cartooning, but only the enormous vacuum of forbidden "unwholesome" symbolism at the heart of mainstream American culture can account for RF's wild success. It's virtually impossible to assess the full formative impact of Rat Fink on the generation of Americans that was to make up the counterculture. Far beyond the massive sales figures for the Revell models, the T-shirts, and his omnipresence in Petersen magazines (not to mention the many imitators and bootleg versions), Rat Fink and the other hot-rod weirdos entered the pop culture vernacular with a speed and depth of penetration unthinkable to the captains of the advertising industry. My own first exposure to the character was in the form of a sketch by another kid at school. It was Rat Fink all right, and widely recognized and appreciated, but it was a copy of a copy of a copy, its authorship and Kustom Kulture provenance lost to us. Only its iconic resonance held our attention and fired our imagination.

Roth's impact on underground comix (and, via osmosis, subsequent mainstream graphic design) was incalculable. A testament to Rat Fink's symbolic substance is his survival of the shifting tides of pop culture fashion, riding out the waves of countercultural animosity as a seminal figure of the ZAP aesthetic, only to be embraced by the fiercely anti-hippie punks.

While some of Rat Fink's continuing appeal may be ascribed to the same kind of retro boomer nostalgia that keeps *The Brady Bunch* in syndication, there is clearly more to it than this. Most deliberate use of the Grotesque in art has been, as described, in pointed opposition to the repressive monolithic mainstream culture. In contrast, RF celebrates his monstrous otherness without reservation or antagonistic grandstanding. Where earlier manifestations of the Grotesque subtly reinforced the power structure they critiqued, RF (in keeping with "Big Daddy" Roth's live-and-let-live philosophy) seems blithely unaware of his disruptive social potential, thereby staking claim to a symbolic primacy over the saccharine pieties that imagine themselves capable of containing him.

In spite of a few token art world incursions into the Grotesque over the years (Jim Nutt, Cindy Sherman), the dualism of clean, pure, rational transcendentalist high art — as opposed to vulgar, dirty, incoherent, materialist visual culture — raged on through the last decades of the Millennium. And it continues, beleaguered but undaunted in its self righteousness, to this day. In spite of the fact that popular visual culture — particularly movies, comix, advertising, and lowbrow art — has done a great deal to shake off the previous era's repressive codes of expression, old prejudices remain deeply embedded and vigorously sanctioned from on high. Rat Fink matters now for the same reason he mattered in the first place: his existence beyond the moral spectrum, as a rare and enduring eruption of the non-judgmental Grotesque into the placid surface of our over-groomed lives. He was, and is, something to aspire to: a role model.

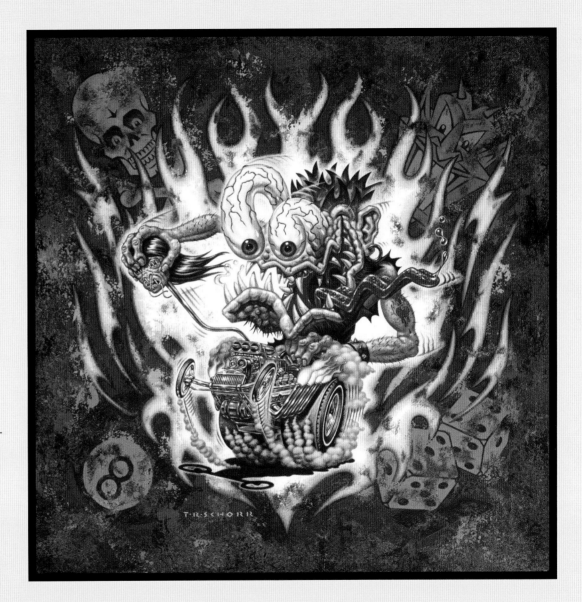

Monster Art 101 with Professor Roth

BY DAVE BURKE

Above: Embryonic Stage: Roth's original sketch for Rat Fink Comix #8 on 8½ x 11-inch paper. Pretty much all the information is here: The little fingers and toes are formed and the veins are starting to appear on the eyeballs. (collection of Dave Burke)

Opposite Page Left: Fetal Stage: Dave Burke's full size (12 x 18-inch) pencil sketch of Rat Fink Comix #8 on "onion skin." During the development the artist should typically increase intake of protein and sugary breakfast cereal. (collection of Dave Burke)

Opposite Page Right: Newborn: Comix Cover: It's a Fink! Dave Burke's finished acrylic painting for Rat Fink Comix #8. Both artist and child are resting comfortably and may receive visitors. (collection of Ed "Big Daddy" Roth)

WAKE-UP CALL, 6 AM: I didn't mind at all being woken out of a sound sleep by the phone. On the line was a voice of someone I'd met only a month or so earlier, but whose work had been an inspiration since I was old enough to put a nickel in a vending machine. A machine from whose hinged chrome mouth I retrieved a plastic ring sporting a jagged toothed, but somehow friendly looking, green monstrosity with the letters R.F. on its belly. "Hey Dave, it's Ed Roth. Do you still wanna draw Rat Fink?" "I'm a Fink fan forever. Of course!" I replied. And so began my collaboration with Big Daddy to create four cover paintings for Rat Fink Comix, and get a little schoolin'...monster style.

THE PROCESS: Ed would send me a pencil rough laying out characters and situation. I'd redraw it on onion skin with full detail and shading. By the time it came back in the mail, Ed would have made small notes and lettering suggestions right on it, like a corrected math test. For the finished art I used acrylics on bristol, about 1½ times the size of the actual comic, then off to Manti, Utah it went. A few days later I'd get a phone call. Early.

THE CONVERSATIONS: From the beginning I sensed that my Monster Art education was being furthered not only through hands-on application, but in the philosophical arena. My conversations with and observations of other artists over the years have had a huge impact on the direction of my work, and the talks I had with Ed were of great importance to me. We discussed the merits of using a nickname and the advantage of creating a trademark character. We talked about other artists he had worked with and their respective strengths. Imagination and originality topped the list of admired traits.

"These guys all get good drawing Rat Fink, I'm tellin' ya. But you've got to get your own style goin.' When it can be said that your work looks like somebody else's, collectors will shy away," Ed imparted. He was quick to relate to me his feeling about sensationalism. "Stay away from gore and cheap, sensational ways of getting attention. They'll hurt you in the long run."

Ed's interest in keeping the comics "Always G-Rated" had dual significance. On the one hand he was concerned with giving the kids a break from pervasive sex, violence and strong language. But from the artist's perspective it was about cultivating a talent for creating high impact, engaging work which didn't rely on a cheap "hook." Ed felt that this ultimately took more talent to accomplish.

I recently heard a story about an art history degree holder who claimed that there was no such thing as "Monster Art." Isn't that a bit like being a cultural historian and claiming there's no such thing as current events? Ed "Big Daddy" Roth was a pioneer in many ways, and while his departure indeed marked the end of an era, he fathered a movement which still lives and breathes and drools through sharp, crooked teeth.

"The situations depicted on the comix were socially or personally relevant to Ed. He had observed kids making spare cash by collecting shopping carts on roller blades at Wal Mart and decided to assimilate the scene into Rat Fink's world."

– Dave Burke

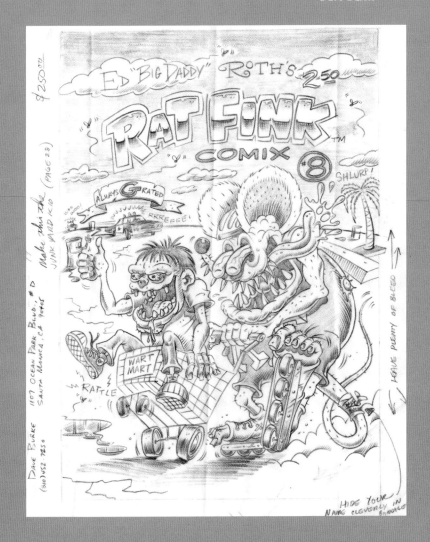

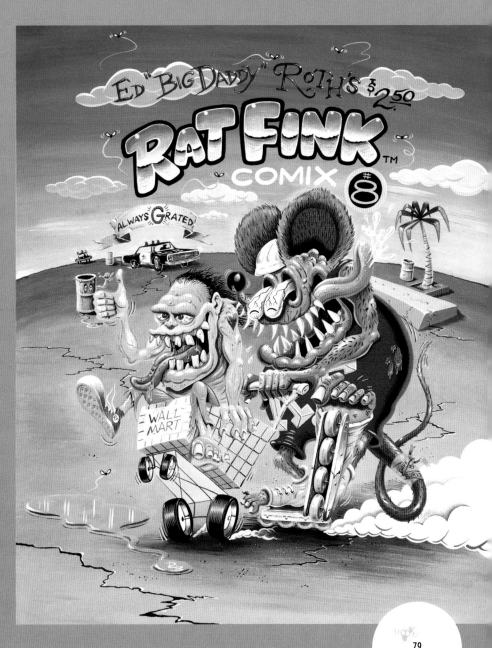

Above: Final Dave Burke illustration for Rat Fink Comix #13 (as yet unpublished!). (collection of Ed "Big Daddy" Roth)

Left: Final Dave Burke illustration for Rat Fink Comix #9. The bubble top production process depicted on the cover of #9 was essentially accurate though presented comically. This was the last issue published by the time of Ed's passing. (collection of Ed "Big Daddy" Roth)

Opposite Left: Roth's original sketch for Rat Fink Comix #9. (collection of Dave Burke)

Opposite Right: Dave Burke's developed sketch for Rat Fink Comix #9. (collection of Dave Burke)Centerspread: Detail of Roth's original sketch for Rat Fink Comix #9. (collection of Dave Burke)

The Subjective Side of Roth's Vehicles

BY GEORGE GOODRICH

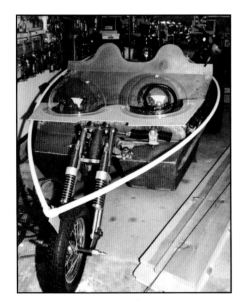

Above: Surf Angel (2002) is an in progress three-wheeler now in the hands of George Goodrich. Roth and Goodrich designed this trike in a clay model. Roth managed to build his signature tube frame complete with "Bordo" styled forks before moving on to another project. Goodrich subsequently installed a steering mechanism and built an interior similar to BDR's Globe Hopper. Roth gave approval and signed the bubble windscreens just prior to his passing. (photo by D. Nason; collection of George Goodrich)

Right: Rotar (1962), also known as the Roth Air Car. This car was designed to float on a propeller-created cushion of air and directed by two Triumph 650 motorcycle engines mounted sideways. (photo collection of George Goodrich)

Over the years, more than 12 of Ed Roth's creations have passed through my hands. During my inevitable restoration and repair of every inch of these creations, I grew to respect the man for his ability to create so many wonders of the automotive world. I marvel that I was there, observing and sometimes lending a hand. During these encounters, which I consider cherished moments, I saw the gears grinding away in his brain. The impulses would magically be directed to his extremities; and with tools flailing in a most articulate manner, he would grind out his creations with consistency, year after year. His only distractions were design U-turns and life changes.

I would listen to him fuss sometimes over modifications new owners would make to his creations. It was as if the Mona Lisa were given a sex change. Once, a late addition cheapo turn signal light had fallen off the Globe Hopper due to the bondo breaking loose. I very carefully installed some nice little chrome lights that did not even disturb the body. Every time he saw them he would ask, "Why did you do that?"

Ed was a thinker, a seeker, a teacher and a doer. His works, particularly with the automobile, along with his cast of characters had a profound influence on the world around him. Ed's unconventional manners often overshadowed his artistic purpose, but in the end, the impact was unavoidable. His workmanship may not have compared with the high-tech world of car design, and some felt the need to nitpick the workmanship, practicality, and drivability to death. The average person simply did not realize that they were witnessing art in the making. Ed's mind and tools were his paint brush. His garage was the Sistine Chapel.

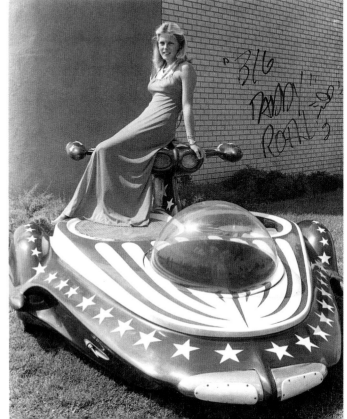

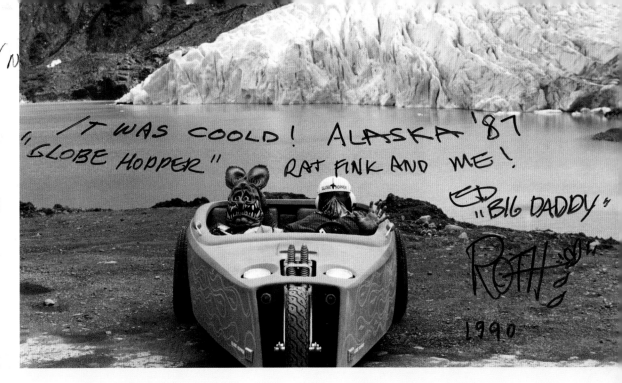

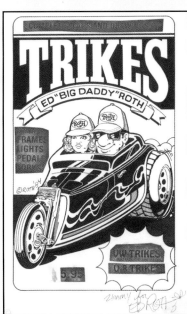

Above: Ed "Big Daddy" Roth sitting in the cab of the Globe Hopper in Alaska, 1987. He drove this custom trike all the way from his Southern California home in La Mirada. Roth's driving companion was a Rat Fink mask pulled over his sleeping bag and a change of clothes. Powered by an 1800cc 914 engine with an automatic transmission, the Globe Hopper had a fiberglass body with an open roof. After successfully driving it to Alaska and back, Roth drove the vehicle cross-country where it eventually broke down in a rural area of Oklahoma. Goodrich subsequently purchased the abandoned vehicle from Roth under the condition that he came along to help retrieve it. (photo collection of George Goodrich)

Far Left: Roth's concept sketches for his Trikes instructional booklet. (collection of George Goodrich)

Left: Finished cover art to the Trikes book, which was released in 1984 by Ed Roth. On the cover is Roth's Globe Hopper, which he built concurrent with the release of this book. The finished trike did not include the windows depicted on the cover illustration. (collection of George Goodrich)

The Magic of Big Daddy

BY NASH YOSHII

The great artist Ed "Big Daddy" Roth has left us with a legacy of amazing works in countless fields of art, from pinstriping to airbrushed T-shirts featuring Rat Fink and his gang. His genius can be seen in all of these great works of art. Out of all of the many genres he worked in, my personal favorites are his elaborate and groundbreaking hot rods.

When someone speaks about a custom car or hot rod, they are usually referring to the traditional approach of starting with a base car, like a '32 Ford or '49 Mercury, and adding to its existing structure. This process is not as easy as it sounds because the body of the car is three-dimensional. In comparison to a two-dimensional world, a person needs a certain amount of technique in them to bring out the curves of a car in perfect symmetry. This is why a custom car built by artisans with those techniques should be hailed as a work of art rather than just a mechanical design. I consider the custom car to be fine art.

But the hot rods Big Daddy built were totally different. If you look at any of Roth's designs, his car creations are all so original and mind-blowing that you are unable to tell, looking right to left, what the base of the car was to begin with. His hot rods are pieces of art that could only have been created by Big Daddy.

Now picture a bunch of kids with a love for cars. These kids always draw their dream hot rods in their sketch books, wishing they could one day drive one of their fantasy cars. This is where reality must collide with the dream to make it come true. This is also where Big Daddy came in. He waved his magic wand and created these dream hot rods, some from scratch. To have built these amazing cars, one after another, he had to have been part artist and part magician. *Beatnik Bandit, Mega Hauler, Mysterion, Surfite,* all of these were created by Big Daddy's magical originality. His one-of-a-kind hot rod pieces of art have cast a spell on me and left me entranced.

Ed "Big Daddy" Roth (detail) from the back cover of Pete Millar Presents...Big Daddy Roth, Issue No.1, October/November 1964. (collection of Aaron Kahan)

Big Daddy Roth doing one of his favorite things in life – EATING! (photo by Nash Yoshii with Burnout magazine)

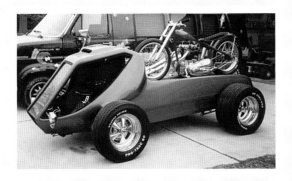 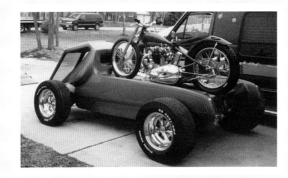

Mega Hauler with Mega Cycle was built by Roth in 1966 and based on a concept sketch of a futuristic bike hauler by Ed Newton. Originally named Captain Pepi's Motorcycle and Zeppelin Repair Service by artist Robert Williams, this vehicle was powered by a Buick V-6 and included a Corvair front end and rack-and-pinion steering. Roth's initial intent was to have the vehicle haul a custom Harley Davidson Sportster. But through a series of trades, he acquired an award-winning custom Triumph built by Bob Acquistepace from Hollister, California. The Mega Hauler and Mega Cycle have since been repainted and are now owned by Junior Sammet with Sammet Towing & Garage, Inc. (photo courtesy of Junior Sammet)

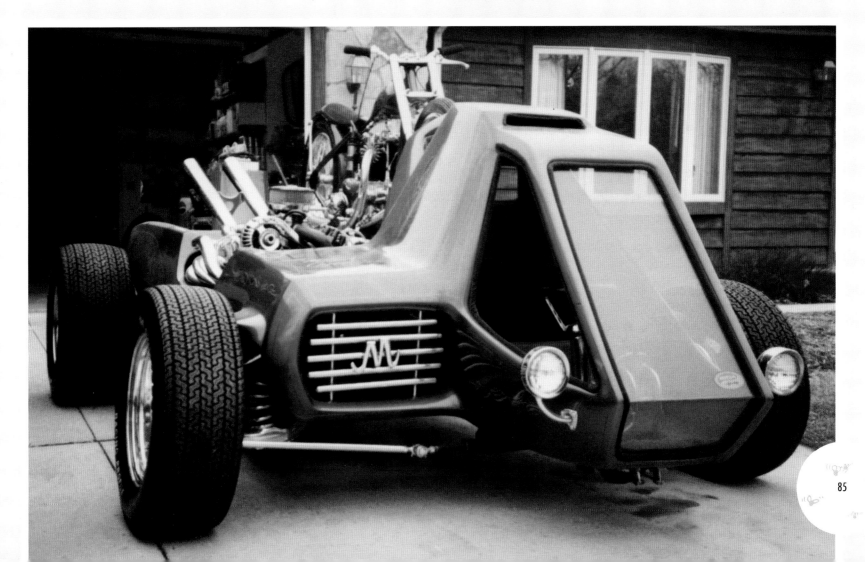

Collecting Rothabilia

BY VERNE HAMMOND

Above: Framed vacuum form molded plastic promotional display of Ed "Big Daddy" Roth's bust issued by Revell during the early 1960s. (photo by D. Nason; collection of Verne Hammond)

Above Right: Mothers Slave water decal by Ed "Big Daddy" Roth. This is a prime example of how influential customized Sting-Ray bicycles and Big Daddy-type monsters were on mid-1960s to mid-1970s youth. (collection of Jon "Fish" Fisher)

When I was a kid, there was a bike store right up the street from our house. That's where my older cousin Virgil got his chopper front end and high sissy bar for his Schwinn Sting-Ray. He just might have been the coolest 10-year-old in Burbank. When I first layed my eyes on his chopped Sting-Ray I realized that by kustomizing his bike Virgil had made a statement. He was no longer just part of the crowd, but an individual that stood out from the other kids.

There were also a couple of hobby stores in the neighborhood where we'd go and check out the built models on display. The monsters and hot rods always caught our eye. We would buy the kits, build them on the kitchen table, then take them outside and blow them into pieces with firecrackers — a story I'm sure Ed Roth must have heard a million times.

Southern California was at that time the center of the surfing, hot rod, and kustom car universe. If you weren't living here, I'm sure you wished you did. Los Angeles was also where Roth Studios was located, and where Ed Roth became the figurehead of this unconventional youth scene. Roth turned many kids onto hot rodding. Kids like me. We had a slot-car track right across the boulevard, a couple of mini-bikes and a go-kart in the back yard. We were too young to actually have hot rods, but I used to dream that one day I would.

I had a Rat Fink shirt when I was a kid, but when Roth Studios closed, Rat Fink seemed to fade away, all but forgotten. For a time, I forgot too. Then in the early Eighties I saw a picture of Nick Cave wearing an old Roth shirt. On it was a biker next to a tombstone with the inscription, "A Good Cop is a Dead Cop." Using what I had learned in art class, I silk-screened my own Rat Fink T-shirt. I was totally into punk rock, and I saw Rat Fink and punk rock as one and the same. To me, both meant rebellion, had shock value, and were non-conformist. As for the Rat Fink shirts, wear one and see how many guys tell ya, "I was sent home from school when I was a kid for wearing one of those."

It wasn't until a swap meet in the mid-Eighties that I ran across a Drag Nut model again, still in the box! I was amazed these could still be around. Then I found an Angel Fink. Wow, what a trip. These things were cool. That got me looking for other Roth model kits, and I discovered there were a lot more than I had remembered. There was a lot of mystery about them then, and there were no books about Roth, as there are now. Some models, like the Surfite and Boss Fink, were nearly impossible to find. I kept running into a few of the same guys at different swap meets, calling themselves "the Chislers." They were the first guys I met that also collected Rat Fink stuff, and they all became best friends of mine. Eventually we did find all the model kits, and more.

Some of my favorite "Rothabilia" is what we call "built-ups." They are "modified Finks." Every one of them has character, and these things can be hilarious. Some kids got really creative, with cotton glued on for hair, glitter in the paint, and flocking to make them fuzzy. Finding one of these Finks some 30 years later is a trip; my guess is the kids who built these must not have had any firecrackers.

Above: Chislers club group shot taken at the Rat Fink Reunion party at Mooneyes in December, 1999. From left to right: Verne Hammond, Jon "Fish" Fisher, Deron Wright, Aaron Kahan, Sandy Wachs and not pictured, Keith Weesner. (photo by Nicole Kahan)

Above Left: Original Rat Fink or Mouse hat from the '60s (photo by Aaron Kahan; collection of Jon "Fish" Fisher)

Left: Rat Fink Portrait, painted with 1-Shot on a 1-Shot can lid by Ed "Big Daddy" Roth in 1997. (photo by Aaron Kahan; collection of Dave Burke)

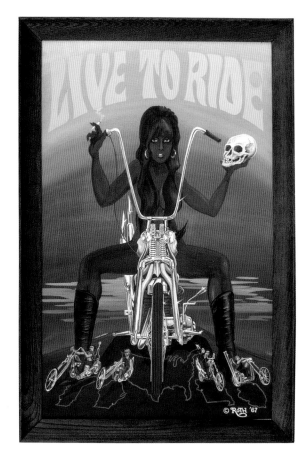

Above: Surfer's helmets issued by Ed "Big Daddy" Roth in the mid-1960s. (photo by Aaron Kahan; collection of Verne Hammond)

Above Right: Live to Ride original Dave Mann painting, copyrighted by Roth in 1967. (photo by Mike Salisbury; collection of Jim and Danny Brucker)

Opposite Page: Beer Girls a Go Go original Dave Mann painting, copyrighted by Roth in 1966. (photo by Mike Salisbury; collection of Jim and Danny Brucker)

Right: How to Extend Your Spring Forks instruction booklet (c. late-1960s). (photo by/collection of Aaron Kahan)

More favorites are what might be considered not-so-politically-correct, as if any of Roth's stuff was ever politically correct. By looking at his Vietnam-era decals and T-shirts, you can tell Roth was no peace-and-love hippie. There were also plastic metal-flake-painted Nazi helmets that Roth sold as "Surfer Helmets," and Iron Cross decals and necklaces, sold by the thousands. Can you imagine kids in the 1960s running around wearing this stuff? Roth used the stuff not as a political tool, but in defiance of public opinion, in much the same way as the surfers, bikers, and punk rockers did after him.

I like the Sixties biker stuff for the same reason — the Dave Mann biker run prints, the posters of Hells Angels like Sonny Barger and Terry the Tramp that Roth printed and sold, the how-to books, decals, and t-shirts. It got to where the increasingly respectable hot rod magazines would not run Roth Studios ads. As the Sixties went on, Roth fell deeper into the growing chopped motorcycle scene. To me, Roth always seemed to be open-minded to new stuff going on, regardless of public opinion.

Since the late Eighties, I've been collecting Rothabilia and going to Rat Fink parties with members of my car club, the Choppers (formerly the Chislers) from Burbank, California. Roth had a huge influence on our club, and we owe a debt to him. I met these friends because of our shared interest in hot rods and Roth's art. It was our introduction to the art world, in which we all eventually became participants, one way or another. We built our friendships and our collections attending those parties.

The final official Rat Fink party was in December 2000, and it was a lot different than those parties in the Eighties. Back then there were only a hundred or so people there. At the final party in 2000 there were hundreds of hot rods and thousands of people. Ed was back on the scene. His art, once popular then hard to find, had made a monstrous

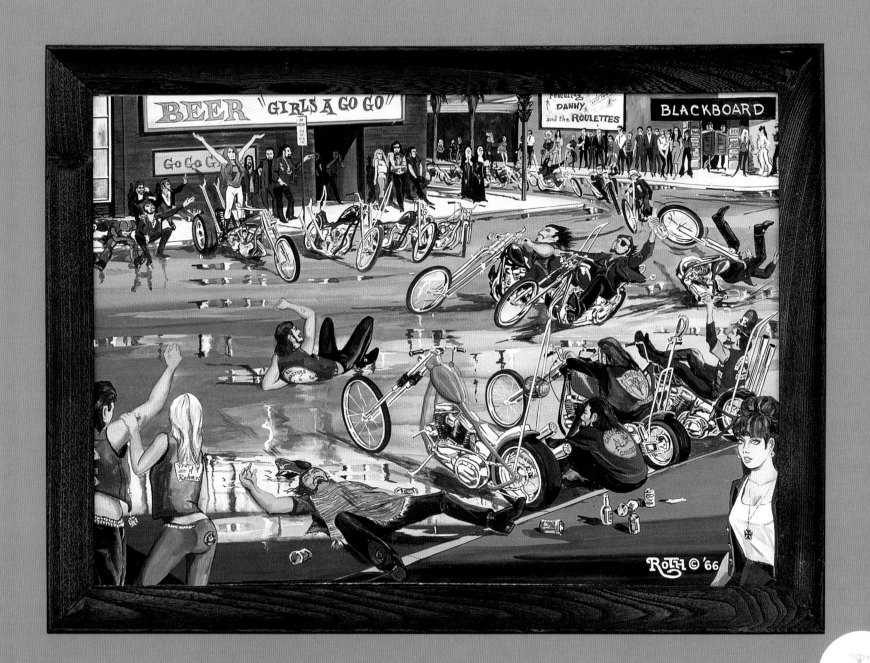

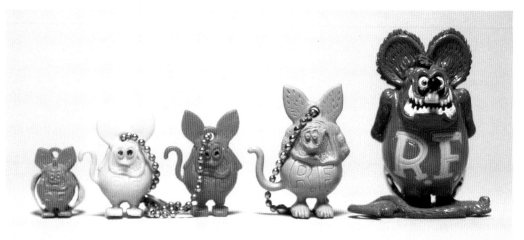

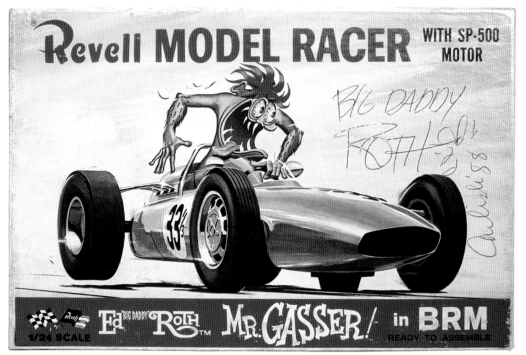

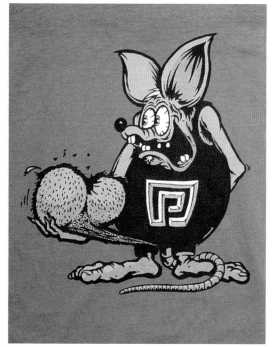

comeback with collectors like me finding true value in what he had done. That final Rat Fink party at Mooneyes was the way I feel it should have been. A film crew was there shooting a documentary on Roth. Hot rods and kustoms were parked on the sidewalks and in the middle of the street. All the parking lots around were full, for blocks. Police helicopters were overhead, and police cars blocked both ends of the four-lane boulevard. The cops shut down the show because they said there were "too many people." I don't know how Ed "Big Daddy" Roth felt about all this, but I do know he was there, and got to see that his popularity and influence was still being felt, five decades after he first picked up a paint brush. I was glad I was there.

I think Ed's influence on art today is impossible to assess, as it is way too broad. It can be found everywhere, from art galleries down to tattoo shops. *Juxtapoz* magazine called him the "greatest artist of the 20th century." A lot of people, myself included, would say he was that, and that's all that matters.

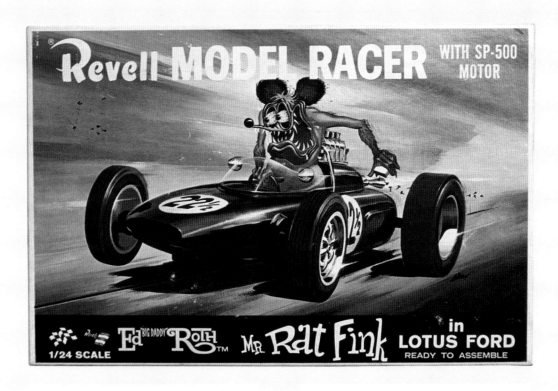

Opposite Page Clockwise: Progression of miniature Rat Finks. (Left to right) The first is a c. mid-1960s novelty ring; the second two are early edition key chains with the telltale squared-off feet; the fourth is the 1984 version by "Bigdaddysville"; and the largest one is a recent release by Mooneyes. (photo by D. Nason; collection of George Goodrich) A collection of Ed "Big Daddy" Roth's Hard Rock Hotel and Casino poker chips issued by House Industries in 1998. (photo by Carlos Alejandro; courtesy of House Industries) Rat Fink influenced T-shirt design for Powell Peralta Skateboard Company (c. early-1990s). (photo by/collection of Aaron Kahan) Ed "Big Daddy" Roth - Mr. Gasser! in BRM box cover for a ready-to-assemble slot car kit issued by Revell in 1964. (photo by D. Nason; collection of Verne Hammond)

Above Right: Ed "Big Daddy" Roth - Mr. Rat Fink in Lotus Ford box cover for a ready-to-assemble slot car kit issued by Revell in 1964. (photo by D. Nason; collection of Verne Hammond)

Right: Eyeball gearshift knob made from a cue ball painted by Ed "Big Daddy" Roth (1995). (photo by Aaron Kahan; collection of Verne Hammond)

Right: Plaster casted Rat Fink from the early 1990s. (photo by D. Nasan; collection of Shawn Warcot)

Far Right: Nitro-Burning Rat Fink Comix was a sketch done in 1988 for a Rat Fink Comix cover that was never used. (collection of George Goodrich)

Below Right: Yellow molded plastic Here is Your Very Own Rat Fink from the mid-'60s. This one is unique in that Rat Fink is spelled out across the chest. (photo by Ren Messer; collection of Shawn Attema)

Opposite Page Left: Rat Fink Halloween costume from the early 1960s. (photo by Ren Messer; collection of Long Gone John)

Opposite Page Right: Green molded plastic Here is Your Very Own Rat Fink in original package from the mid-'60s. (photo by Aaron Kahan; collection of Jon "Fish" Fisher)

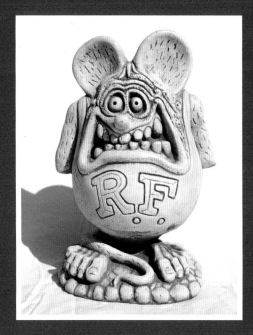

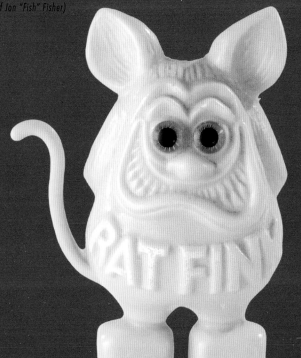

92

Collegeville

BRIGHT
FOR NIGHT

LARGE
EYE-HOLES

FLAME
RETARDED

COLORFUL
MASKS

DeLuxe
Quality

Costumes

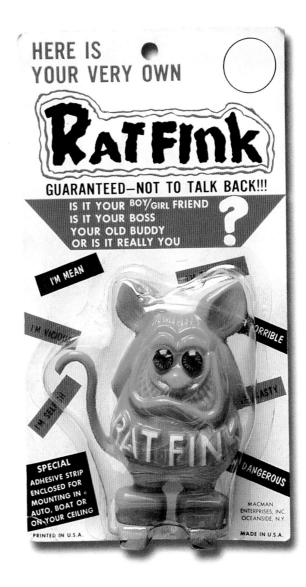

HERE IS
YOUR VERY OWN

RAT FINK

GUARANTEED—NOT TO TALK BACK!!!

IS IT YOUR BOY/GIRL FRIEND
IS IT YOUR BOSS
YOUR OLD BUDDY
OR IS IT REALLY YOU ?

I'M MEAN

I'M VICIOUS

HORRIBLE

NASTY

I'M SELFISH

RAT FINK

DANGEROUS

SPECIAL
ADHESIVE STRIP
ENCLOSED FOR
MOUNTING IN
AUTO, BOAT OR
ON YOUR CEILING

MACMAN
ENTERPRISES, INC.
OCEANSIDE, N.Y.

PRINTED IN U.S.A.

MADE IN U.S.A.

Upper Right: Rat Fink Ring in original package from the early '60s. (photo by/collection of Aaron Kahan)

Far Right: Martian Finks ring vending machine card and rings issued in 1965 by Henal Novelty and Premium Co., Brooklyn, NY. Noting the popularity of the Rat Fink rings it produced and distributed through nickel vending machines, Henal appropriated the motif, added an outer space twist and – viola! – Martian Fink was born. With his hands behind his back, little square feet and even an "M.F." carved into his belly, Martian Fink was, at best, a questionable infringement on R.F. Henal must have realized it was too close for comfort, as the company soon renamed the character Moon Goon. Vending machine header cards were printed, but Moon Goon never made it to the consumer. Martian Fink vanished until the late 1990s, when artist Dave Burke trademarked the character and resurrected M.F. in the form of T-shirts, stickers and miniature action figures. Interestingly, when Ed Roth was asked about Martian Finks in the late 1990s, he said he had no recollection of them. (photo by/collection of Aaron Kahan)

Lower Right: Original vending machine card for the Rat Fink key chains. Roth had this first run of Rat Finks made in Japan in 1962. (photo by/collection of Aaron Kahan)

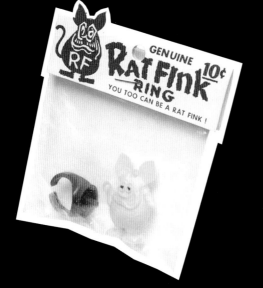

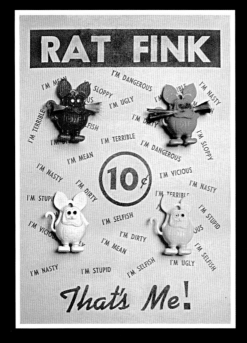

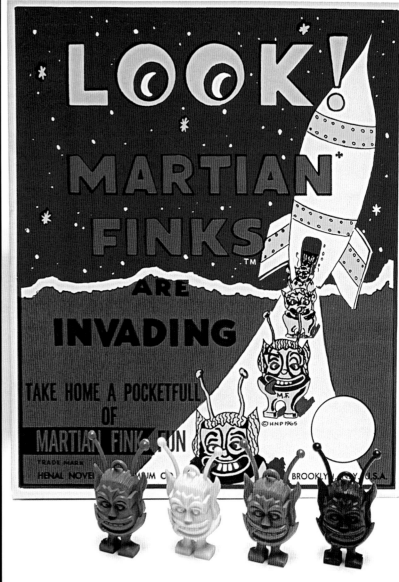

4

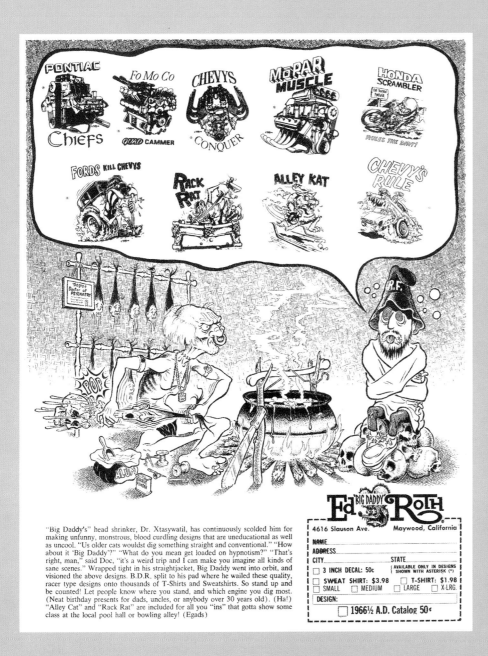

"Big Daddy's" head shrinker, Dr. Xtasywatil, has continuously scolded him for making unfunny, monstrous, blood curdling designs that are uneducational as well as uncool. "Us older cats wouldst dig something straight and conventional." "How about it 'Big Daddy'?" "What do you mean get loaded on hypnotism?" "That's right, man," said Doc, "it's a weird trip and I can make you imagine all kinds of sane scenes." Wrapped tight in his straightjacket, Big Daddy went into orbit, and visioned the above designs. B.D.R. split to his pad where he wailed these quality, racer type designs onto thousands of T-Shirts and Sweatshirts. So stand up and be counted! Let people know where you stand, and which engine you dig most. (Neat birthday presents for dads, uncles, or anybody over 30 years old). (Ha!) "Alley Cat" and "Rack Rat" are included for all you "ins" that gotta show some class at the local pool hall or bowling alley! (Egads)

Far Left: Never used Ed "Big Daddy" Roth advertisement by Robert Williams from 1966. (collection of Verne Hammond)

Above Left: Balinese styled Rat Fink head carved by Mitchell Miller (1999) (photo by D. Nason; collection of Gary Pressman)

Above Right: Primitive looking Rat Fink carved in the Philippines by artisan Mang Lee with paint by Jimmy C. (photo by Ren Messer; collection of David Chodosh)

Left: Tiki Fink, a Roth-inspired carved Tiki by Twisted Tiki. It was displayed at Moldy Marvin's 3rd Annual Rat Fink Party in July of 2002. (photo by D. Nason; courtesy of Moldy Marvin)

Pinstriping & Sign Painting

BY JIMMY C

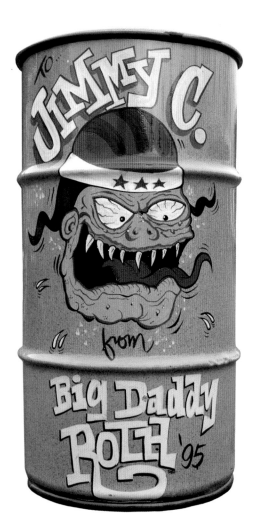

We have a lot more information today, rules too! In Big Daddy's day the "Rules" were made up as you went along. Big Daddy was an innovative hot rodder with a wild imagination and tons of energy, and he had the intelligence to find the help he needed to see his creations come alive. "You can't paint unless you have paint on your brush... load it up!" Old school sign painters understand that line. Big Daddy was also a sign painter. He was known as a "Krazy Painter," which meant that he was a pinstriper too. Big Daddy, Von Dutch and Dean Jefferies pinstriped with thick and thin lines together in the same design. Those Kats had styles of their own, but the "Thick & Thin" line technique is something they shared that you don't see in the custom scene today.

Left: Trash can that Big Daddy painted for Jimmy C (1995). (photo by D. Nason; collection of Jimmy C)

Right: Big Daddy life-size sculpture by Jimmy C (2002). (photo by D. Nason; courtesy of Mooneyes)

Opposite Page: All About Pin Striping panel (1996). (collection of Lou Perdomo)

Opposite Page Inset: Big Daddy painting the All About Pin Striping panel at a 1996 hot rod show in Sarasota, Florida. (collection of Lou Perdomo)

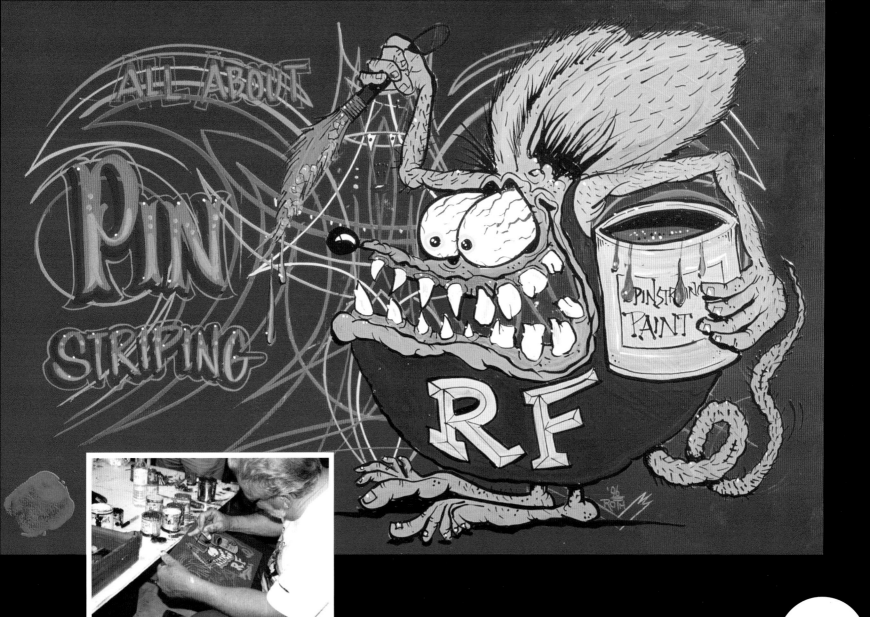

ALL ABOUT
PIN STRIPING

RF

PINSTRIPING PAINT

97

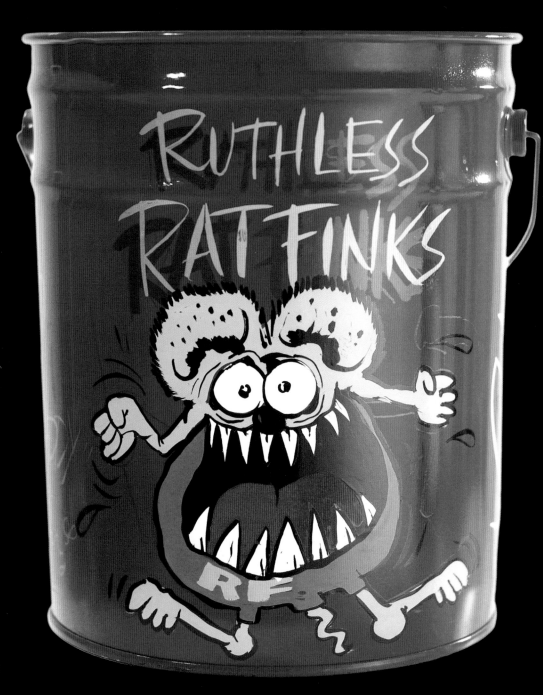

T-SHIRTS
$15.00

*toilet
Seats
Deluxe $85.00 $55.

*Above: Two practical signs by Big Daddy Roth.
(collection of Bert "The Shirt" Grimm)*

*Left: Ruthless Rat Finks garbage can painted by Big Daddy and
purchased by auction at a mid-1980s Rat Fink Reunion party.
(photo by Ren Messer; collection of D. Nason)*

*Opposite Page: Make a Good Looking Corpse!!! (1996).
Striped panel by Ed "Big Daddy" Roth (private collection)*

98

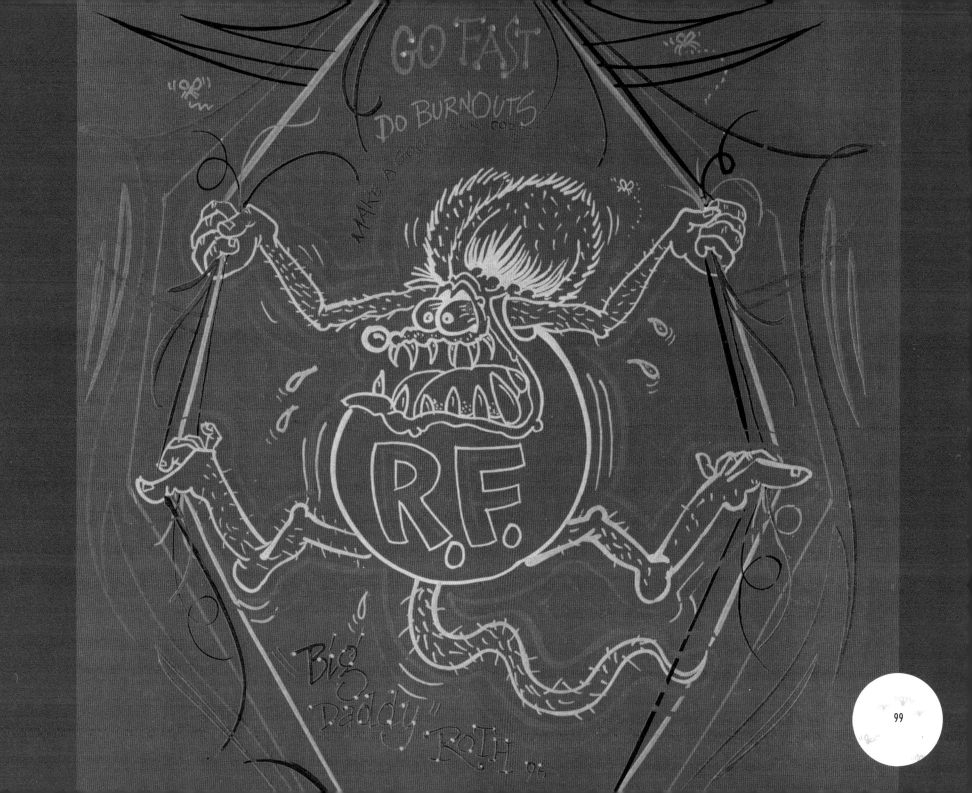

Above: Pinstriped panel by Ed "Big Daddy" Roth (mid-'90s). (collection of Dr. Arthur Katz)

Right: Pinstriped panel by Ed "Big Daddy" Roth (mid-'90s). (collection of Craig and Jolene Myers)

Opposite Page: Three pinstriped panels by Ed "Big Daddy" Roth (mid-'90s). (courtesy of Copro/Nason Gallery)

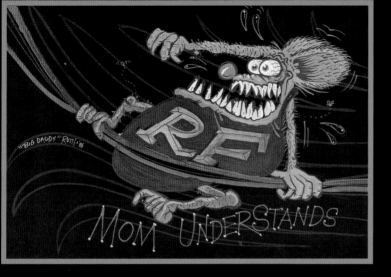

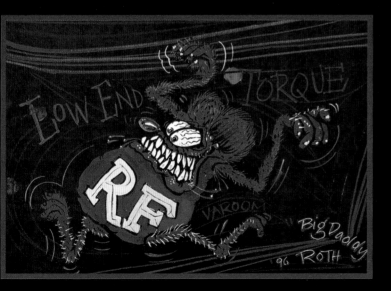

Above: Pinstriped panel by Ed "Big Daddy" Roth (mid-'90s).
(courtesy of Copro/Nason Gallery)

Right: Pinstriped panel by Ed "Big Daddy" Roth (mid-'90s).
(collection of Adrian Olabuenaga with ACME Studio, Inc.)

Opposite Page: Pinstriped panel by Ed "Big Daddy" Roth (1996).
(collection of Junior Sammet)

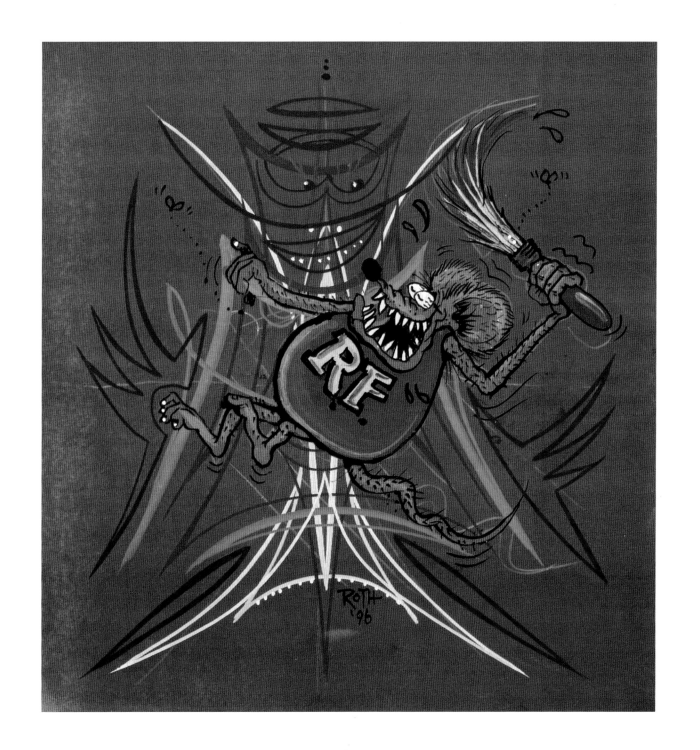

Above: 50's Live (detail) pinstriped design by Ed "Big Daddy"
Roth on a Schwinn Black Phantom chain guard (c. 1986).
(photo by/collection of D. Nason)

Right: Pinstriped panel by Ed "Big Daddy" Roth (mid- '90s).
(courtesy of Copro/Nason Gallery)

Opposite Page: Pinstriped panel by Ed "Big Daddy" Roth (1996).
(collection of Fausto Vitello)

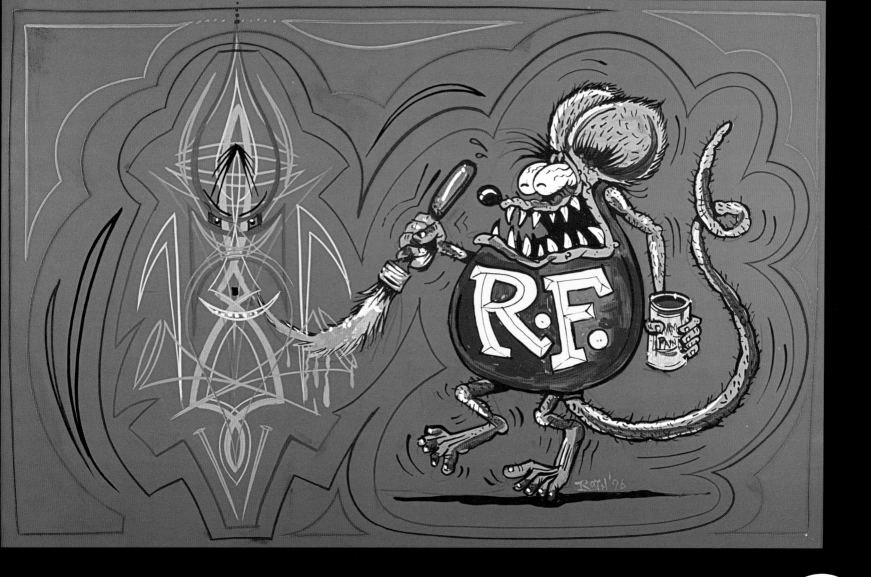

Airbrushing

BY VON FRANCO

It was in 1963 at the San Jose Autorama when I first met Ed. I was just a kid then. I stood there staring at this 6 foot 5 inch beatnik holding in his giant hands what I soon learned was an airbrush. I remember watching him airbrush and pinstripe that first time. I was amazed that such a big man could paint so well. The brush seemed to disappear in his large hands. But man, he could pull a straight line as good as anybody I had ever seen. It was right then and there that I knew wanted to be just like him.

Years later, there I was with Ed at a car show painting shirts. He had paint all over his hands, and I noticed that he had gotten it on one of the shirts. I thought he was going to have to dump it and start all over again, so I told him that the shirt had his thumbprints all over it. He told me that the thumbprints only added character to the shirt and that he could sell it for more. Of course, he did. When it came to painting, Ed was a messy man. But when it came to making money, he was very smart.

To this day I think he is one of the most creative people I have ever met. I hope this book will help inspire other people the way I was inspired by him in my life. Endsville.

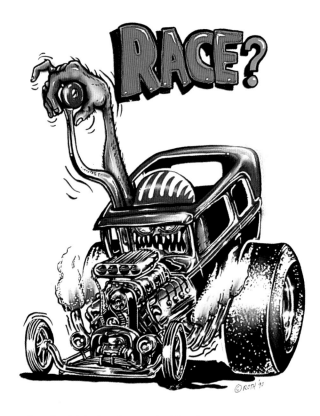

Above: Race? Airbrush on illustration board (1990). (courtesy of Copro/Nason Gallery)

Top Left: Hogs 'B' Bad. Airbrush on illustration board (mid-'90s). (courtesy of Copro/Nason Gallery)

Bottom Left: Brotherhood of the Carpenters. Airbrush on illustration board (mid-1990s). (collection of Fred O'Connor)

Opposite Page: Beatnik Fink airbrushed T-shirt by artist Von Franco (1989). Von Franco is a versatile artist who excels at "old school" style pinstriping and freehand airbrushing. He is an artist who has much respect for, and drew much inspiration from, Ed "Big Daddy" Roth. (collection of George Goodrich)

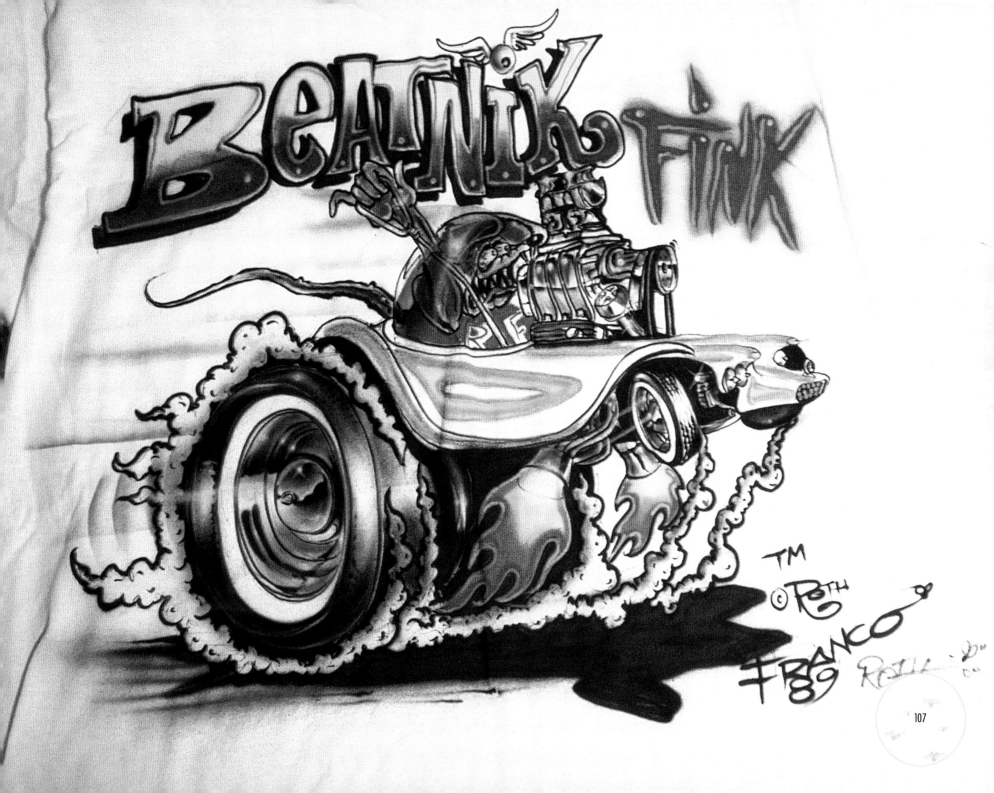

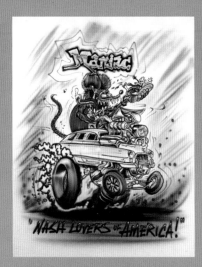

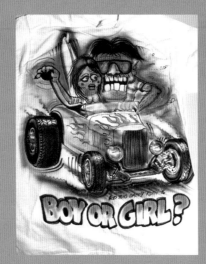

This Page Clockwise: Maniac. Airbrush on illustration board (mid-'90s). (collection of Dan Stiel) Boy or Girl? Airbrushed T-shirt by Ed "Big Daddy" Roth (1986). (collection of George Goodrich) Sick Minds Demand Sick Toys. Airbrush on illustration board (mid-90s). (collection of Dr. Arthur Katz) Full House Mouse. Airbrush on illustration board (mid-'90s). (courtesy of Copro/Nason)

Opposite Page: 12 original airbrush illustrations by Ed "Big Daddy" Roth (1992). These illustrations were commissioned by L'Imagerie art gallery. (courtesy of Debi Jacobson)

QUALITY SPEAKS FOR ITSELF

KEEP YOUR HEAD IN THE RIGHT PLACE!

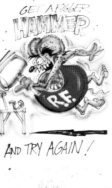

BIG MESS... BIG SUCCESS!!!

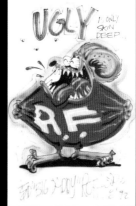
GET A BIGGER HAMMER AND TRY AGAIN!

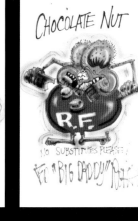
UGLY IT'S ONLY SKIN DEEP

CHOCOLATE NUT NO SUBSTITUTES PLEASE!

SUPPORT YOUR LOCAL... JUNK YARD!

HAPPY CAMPER

LOTSA MONEY AND NO TIME... IS AS BAD AS... NO MONEY AND LOTSA TIME.

BE DIFFERENT DON'T COPY ANYONE! DO YOUR OWN IDEAS!

DREAM IT DO IT!

EXERCISE AND PIZZA FOR GOOD HEALTH

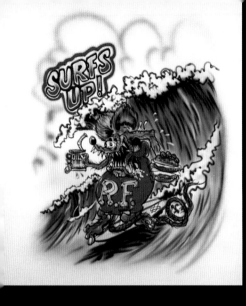

Above: Throttle Jockey. Airbrush on illustration board (mid-'90s). (private collection)

Right: Rat Fink's Wild Ride. Airbrush on illustration board (mid-'90s). (collection of Merry Karnowsky)

Opposite Page Clockwise: Surfs Up! Airbrush on illustration board (mid-'90s). (collection of Greg and Kristin Escalante) Crankin. Airbrush on illustration board (mid-'90s). (courtesy of Copro/Nason)
You Had Better Believe It! Airbrush on illustration board (mid-'90s). (collection of Greg and Kristin Escalante) Going My Way? Airbrush on illustration board (mid-'90s). (private collection)
Mega Rat. Airbrush on illustration board (mid-'90s). (collection of Richard Martinez) Rat Finks Forever! Original airbrush illustration by Ed "Big Daddy" Roth (1992). (collection of D. Nason)

GRIM REAPER!

BOSS CHEVY

FINK!

BEWARE of CHEVY

RACE?

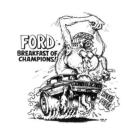
FORD BREAKFAST OF CHAMPIONS!

Killer Coupe

JOKER is WILD

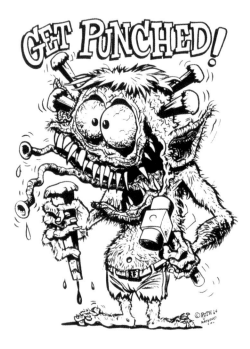
GET PUNCHED!

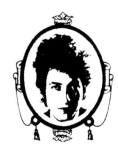
POWER KING

HARLEY HOUND

LOVER BOY

MAKE MINE FORD
I'D RATHER DIE THAN RIDE IN A CHEVY!

FORDS KILL CHEVYS

OINK

TRIUMPH UNHOLY TERROR

Pure Hell

Mr Gasser!

Thou Shalt Drag
HELP PROMOTE STREET RACING

the FUGITIVE VETTE

Thou Shalt Drag
HELP PROMOTE STREET RACING

PACK RAT

RF

Fugitive

Decals

BY CHRIS "COOP" COOPER

As a long-time fan, collector, and plagiarist of the prodigious output of Ed "Big Daddy" Roth (and his busy little finks in the Roth Studio), my favorite bit of Roth ephemera has always been the water slide decals.

Fragile, delicate and precious, these cheap little things (once printed in the millions) have had poor luck surviving the relentless onslaught of time. Get 'em a little wet and you have a soggy handful of greasy paper and no doubt toxic ink. Too dry and they disintegrate like a vampire at a pancake breakfast. Given such narrow requirements for survival, the few remaining decals in mint condition have become as rare as the proverbial hen's tooth.

Of course, that rarity only makes the darn things that much more desirable to a craven collector such as myself! After hunting down the little critters for years, I've managed to accrue a pretty decent collection. I could spend hours poring over those little bits of paper and ink, savoring their musty reek, and grooving on the eyeball kicks provided by funky little pictures. I've even (Horror of Horrors!) actually applied a few of these priceless gems to the windows of whatever jalopy I happen to be driving around at the moment!

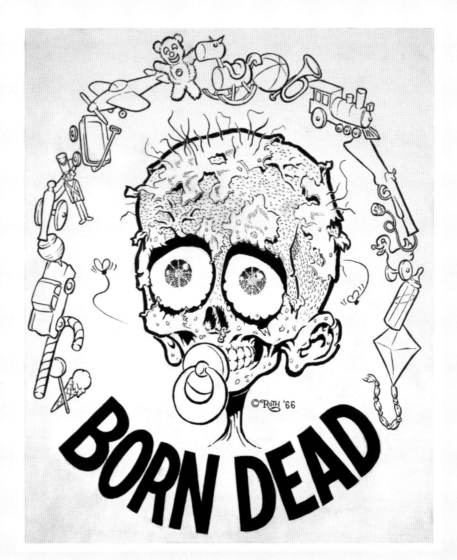

Above: Born Dead color decal from 1966. (collection of Aaron Kahan)

Left: Born Dead original decal inking done in 1966. (photo by C.R. Stecyk III; collection of Suzanne Williams)

Opposite Page: A collection of 24 decals from Ed "Big Daddy" Roth issued during the 1960s. (collection of Aaron Kahan with the exception of Get Punched, which is from the collection of Verne Hammond)

DR-104

LOVER BOY

Manufactured under license from Revell, Inc.

® Ed "BIG DADDY" ROTH

DR- 012

HEY, BABY!

R.F.

® Ed "BIG DADDY" ROTH

SUPPORT YOUR LOCAL FUZZ
...BRIBE THEM!

DR-002

DR-100

® Ed "BIG DADDY" ROTH

BROTHER
RAT FINK

DR-009B

® Ed "BIG DADDY" ROTH

13

STREET RACER

® Ed "BIG DADDY" ROTH

Five classic day-glo water decals from the mid-'60s. These decals were manufactured by Impko, a New Jersey based company. (Lover Boy, Support Your Local Fuzz and Street Racer from the collection of Verne Hammond; Brother Rat Fink and Hey Baby from the collection of Jon "Fish" Fisher)

DR-0016

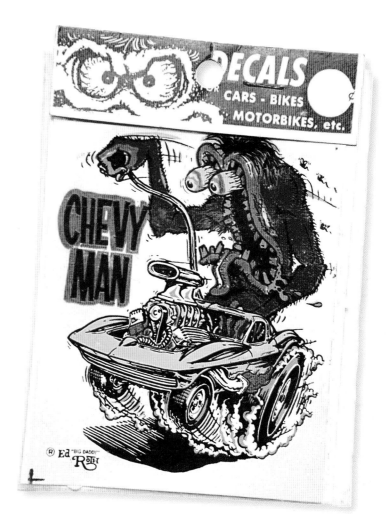

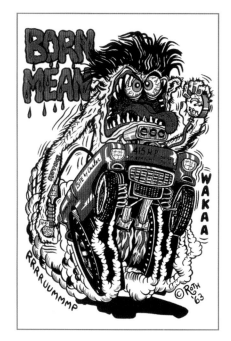 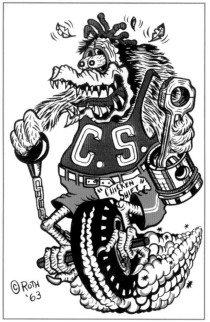 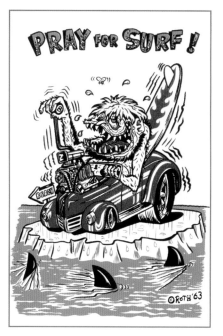 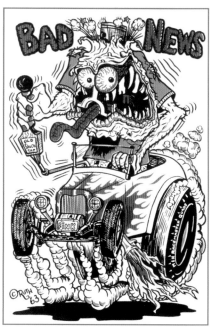

Above: Four vintage color water decals from 1963 issued by Fink City (a.k.a. Ed "Big Daddy" Roth). While most of Roth's 1960s decal and T-shirt designs were illustrated by Ed Newton and Robert Williams, these four early designs were penned by artist Wes Bennet, who worked for Roth before he hired Newt. (collection of Verne Hammond)

Opposite Page: A collection of 14 water decals by Ed "Big Daddy" Roth from the mid-'60s. (Ford Hauler, Harley, Sprite, Jeep and Wild Willy from the collection of Aaron Kahan; Mother's Worry, Knuckle Heads Forever, To Hell With Death, '40 Ford, Chevys Dominate, Hooray For The Bad Guys and G.T.O. decals from the collection of Verne Hammond; Genuine Chevy Parts and Genuine Junk Parts from the collection of Jon "Fish" Fisher)

FORD HAULER

LET'S GO GET LOADED!

MOTHER'S WORRY

KNUCKLE HEADS FOREVER

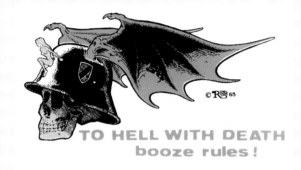

TO HELL WITH DEATH
booze rules!

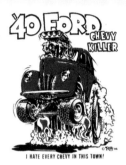

'40 FORD CHEVY KILLER

I HATE EVERY CHEVY IN THIS TOWN!

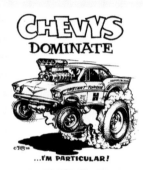

CHEVYS DOMINATE

...I'M PARTICULAR!

HOORAY FOR THE BAD GUYS!!

GENUINE CHEVY PARTS

I'D RATHER FIGHT THAN SWITCH!

G.T.O. RACE ANYTIME ANYWHERE

HARLEY

the bike that made MILWAUKEE famous

GENUINE JUNK PARTS

SPRITE

Jeep

KING OFF THE ROAD!

WILD WILLY

 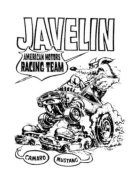 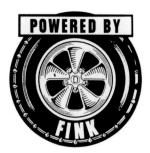

A collection of 15 water decals by Ed "Big Daddy" Roth from the mid-'60s. (Roadrunner, Evil Spelled Backwards Is Live, Ford Is The Best Idea!, Wayside Honor Farm, Plymouth GTX, Fast Is Spelled AMX, Shift Pattern, Cougar, Here Comes De Judge, Dodge R/T, Do Unto Others With A Ford and Javelin from the collection of Aaron Kahan; I Hate Every Cop In This Town and G.T.O. Means B.A.D. from the collection of Verne Hammond; Powered By Fink from the collection of Jon "Fish" Fisher)

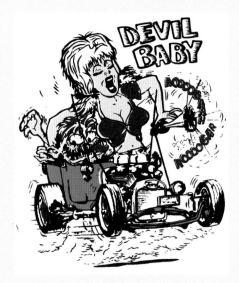

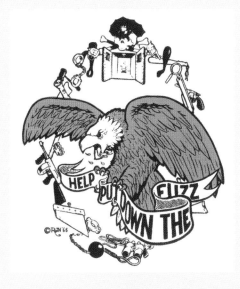

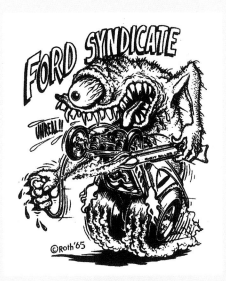

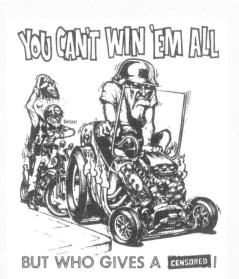

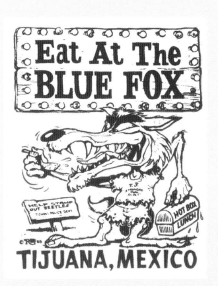

A collection of six water decals from the mid-'60s. All decals by Roth Studios with the exception of Devil Baby, which is a Scandinavian bootleg of a Roth-inspired image. (Tijuana Reject, Ford Syndicate, Help Put Down The Fuzz from the collection of Aaron Kahan; Devil Baby from the collection of Verne Hammond; You Can't Win 'Em All and Eat At The Blue Fox from the collection of Jon "Fish" Fisher)

Model Kits

BY TODD SCHORR

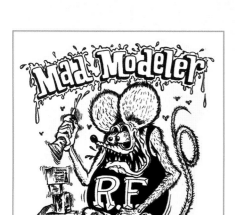

Above: *Mad Modeler water decal from 1964. (collection of Aaron Kahan)*

Above Right: *"Big Daddy" Roth fooling with some miniature car kits at the Petersen offices in Hollywood (c. early '60s). (photo collection of Verne Hammond)*

Background: *Promo art for Revell's No Name (Big Daddy Roth) Monster which eventually was named Scuz Fink (1965). (collection of Verne Hammond)*

Opposite Page: *Mr. Gasser! model kit box cover from original 1963 issue. (photo by Ren Messer; collection of Long Gone John)*

A veil of delirium was upon me. It was the early 1960's and I was consumed in a world of monsters. *Famous Monsters of Filmland* magazine, *The Munsters* and *Addams Family* television shows, Ray Harryhausen movies, Monster Laffs and Mars Attacks gum cards, and, best of all, plastic monster model kits.

Starting with the Aurora movie monster models that had made their debut in 1961, I had been building and painting any and all monster models I could lay my trembling little hands on. Little did I realize, this was all a mere prelude to that crisp autumn afternoon in 1963 when I stepped through the door of our local five-and-dime and laid my nine-year-old eyeballs on Mr. Gasser.

What was a Mr. Gasser and who was this burly looking beatnik called Ed "Big Daddy" Roth? It was truly a moment of revelation. I became gripped in a feverish state of nervous excitement, overcome by this strange hybrid of monsters, Tex Avery cartoon lunacy and fire-belching hot rods. Here was the best of all worlds, as far as my young mind was concerned. From this point on, dozens of tubes of Testor's glue would be drained of their life-giving fluids for the glory that was finkdom. I collected all of Roth's fink monster models, but my absolute favorite was Scuz Fink. That four-armed, three-eyed creature has worked its influence into more than one of my paintings. Years later, when I finally got to meet Ed, I asked him who had won the Scuz Fink naming contest. I had to laugh when he told me it was a 12-year-old girl from Saddlebrook, New Jersey.

With the onset of my teenage years, my monster delirium slipped into remission, replaced by a new obsession with the female form. Sadly, my beloved fink menagerie was banished to the family attic, where it gradually disappeared into the netherworld of lost childhood possessions. Anyway, it wasn't until the late 1980s that I managed to again collect all the Roth model kits I had as a kid. They now reside proudly with all my other objects of desire that were, and still are, such an important part of my life as an artist.

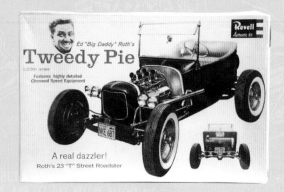

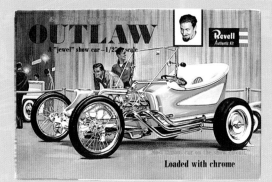

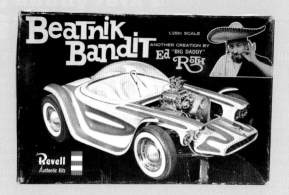

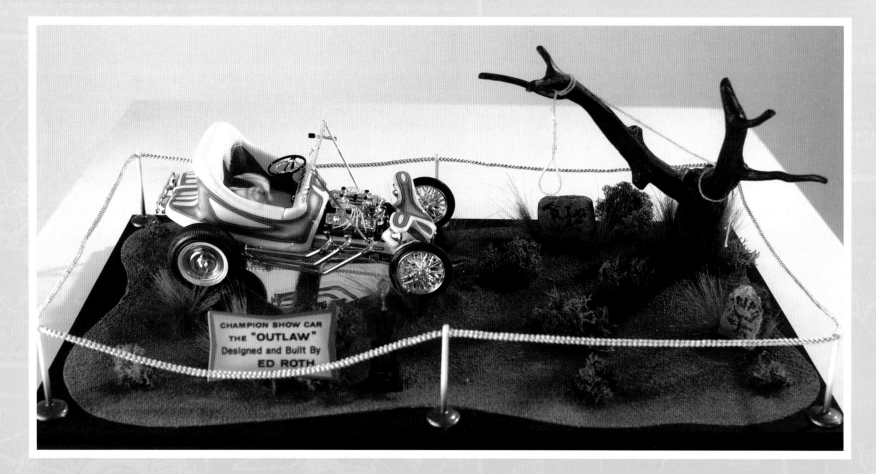

CHAMPION SHOW CAR
THE "OUTLAW"
Designed and Built By
ED ROTH

Opposite Page Clockwise: Tweedy Pie model kit box cover from original 1963 issue. (photo by Ren Messer; collection of Long Gone John) Outlaw model kit box cover from original 1962 issue. (photo by/collection of Aaron Kahan) Beatnik Bandit model kit box cover from original 1963 issue. (photo by Ren Messer; collection of Long Gone John) Outlaw built-up complete with diorama setting by model builder Paul Madsen. (photo by Ren Messer; collection of Long Gone John)

This Page Clockwise: Rat Fink model kit box cover from original 1963 issue. (photo by Ren Messer; collection of Long Gone John) Rat Fink built-up kit by model builder Paul Madsen. (photo by Ren Messer; collection of Long Gone John) Rat Fink built-up by Paul Madsen, featuring a paint job that appears to have been inspired by artist Alan Forbes. (photo by Ren Messer; collection of Long Gone John)

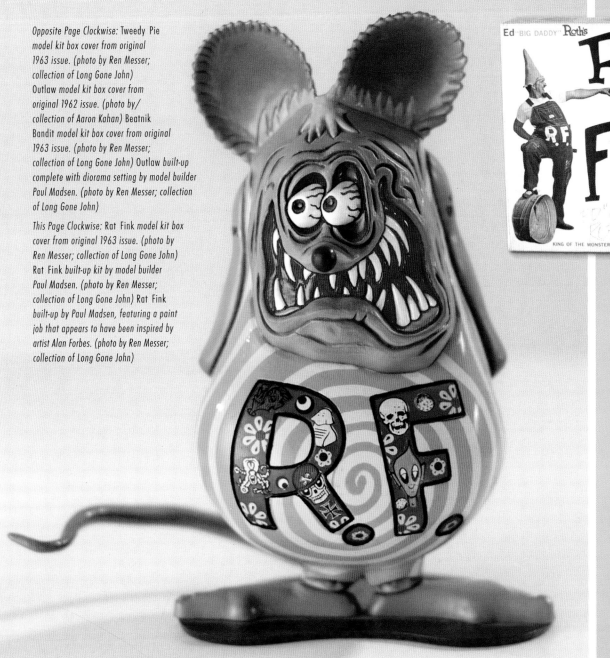

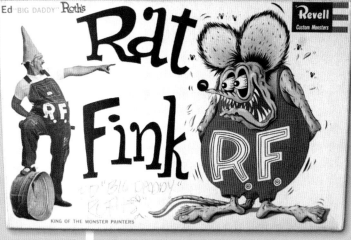

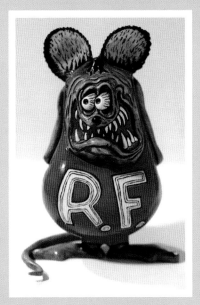

Right: Edward Roth publicity photograph taken prior to his adopting the "Big Daddy" handle (c. early-'60s). (photo collection of Verne Hammond)

Far Right: Rat Fink promotional poster. (collection of Sean Attema)

Below: Build! Ed "Big Daddy" Roth's Beatnik Bandit publicity poster, dated 1963, depicting a masked gun slinger, obviously inspired by the popularity of the mid-'60s "spaghetti western" movie craze. (collection of Jon "Fish" Fisher)

Opposite Page: Diorama of an early '60s car show built by Minnesota-based model builder Bill Michaelson for Mooneyes in 1999. Many of the featured vehicles were meticulously scratch-built with incredible detail. (photo by D. Nason; collection of Mooneyes)

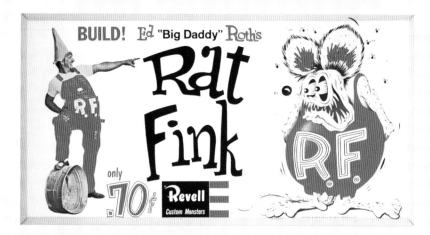

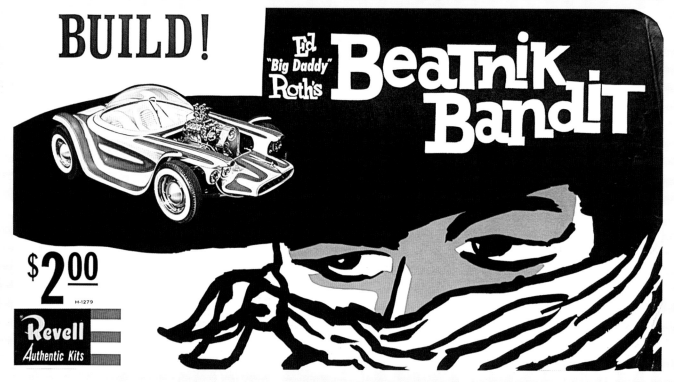

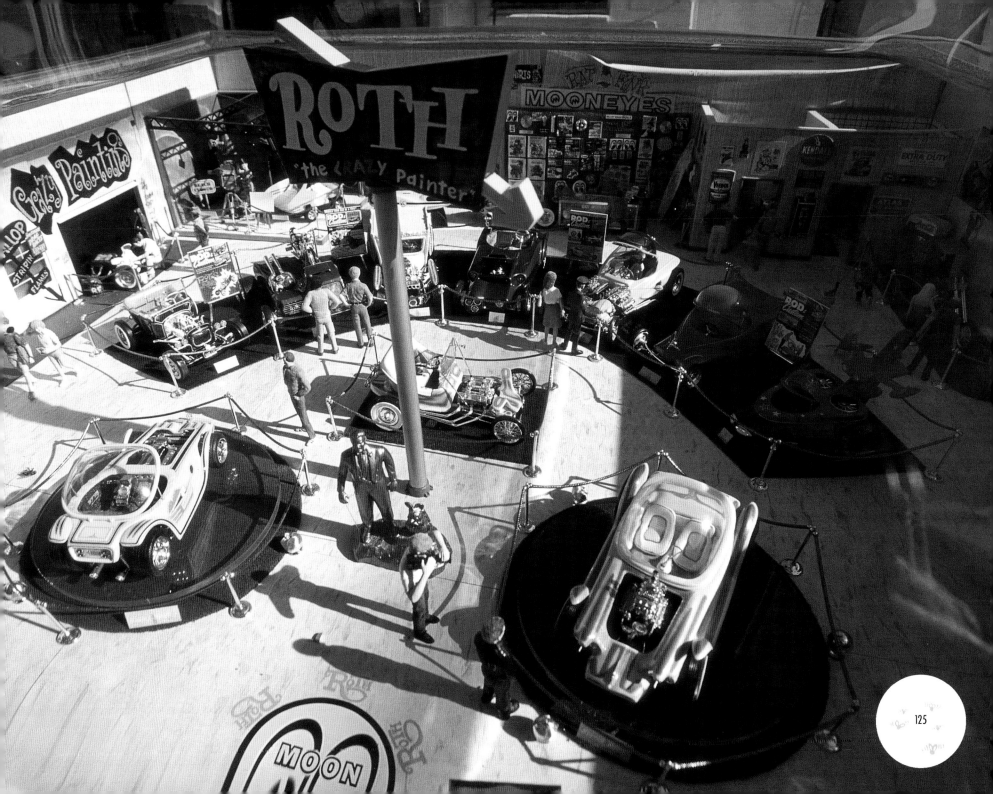

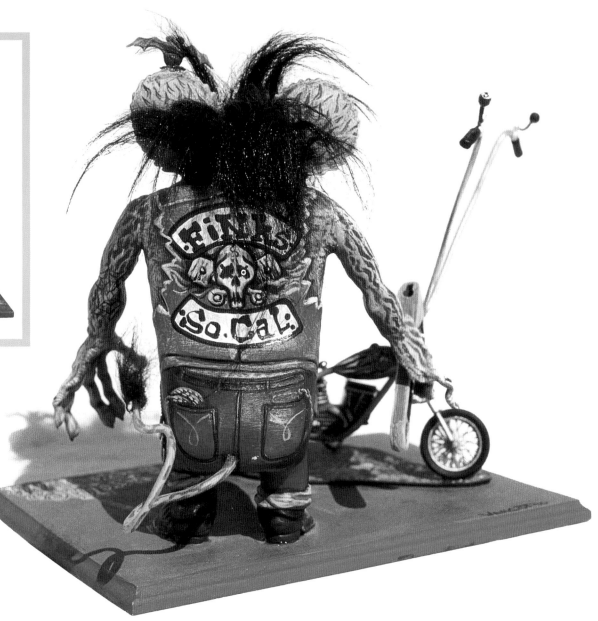

This Page: Shawn Warcot built-up of Brother Rat Fink... On a Bike model kit. (photo by D. Nason; courtesy of Shawn Warcot)

Opposite Page: Brother Rat Fink... On a Bike model kit box cover from original 1963 issue depicting an animated looking "Big Daddy" Roth on a Taco mini-bike. (photo by Ren Messer; collection of Long Gone John)

Ed "BIG DADDY" Roth's

Brother Rat Fink

.. on a BIKE!

Revell
Custom Monsters

A New Roth RAT FINK CUSTOM MONSTER

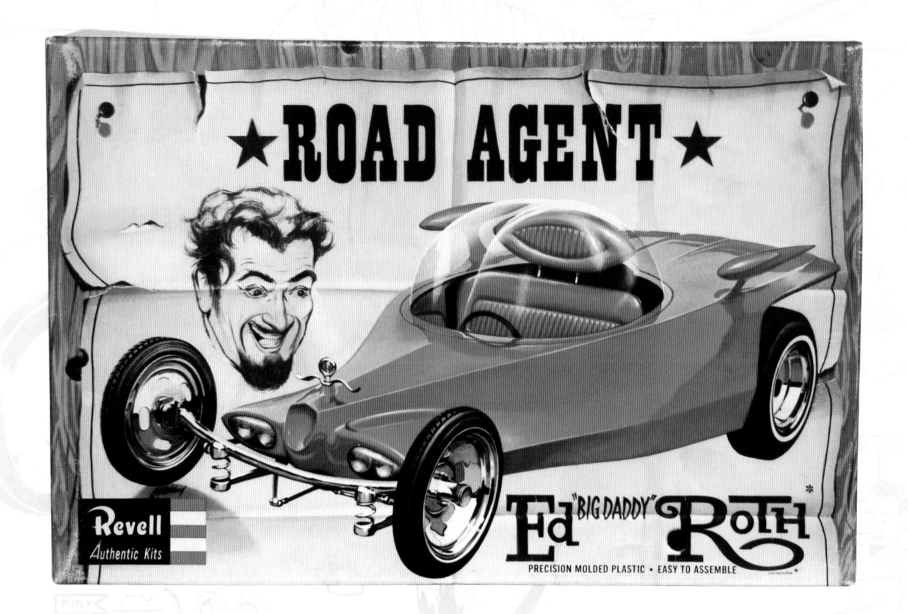

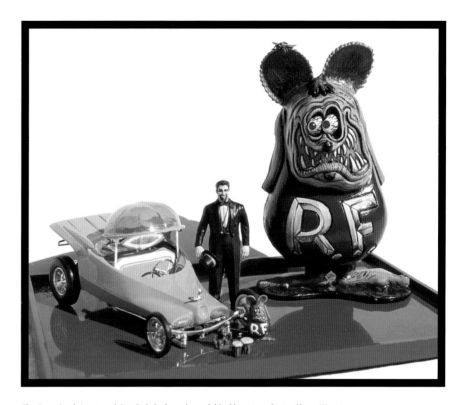

This Page: Road Agent and Rat Fink *built-ups by model builder extraordinaire Shawn Warcot. (photo by D. Nason; courtesy of Shawn Warcot)*

Opposite Page: Road Agent model kit box cover from original 1964 issue. (photo by Ren Messer; collection of Long Gone John)

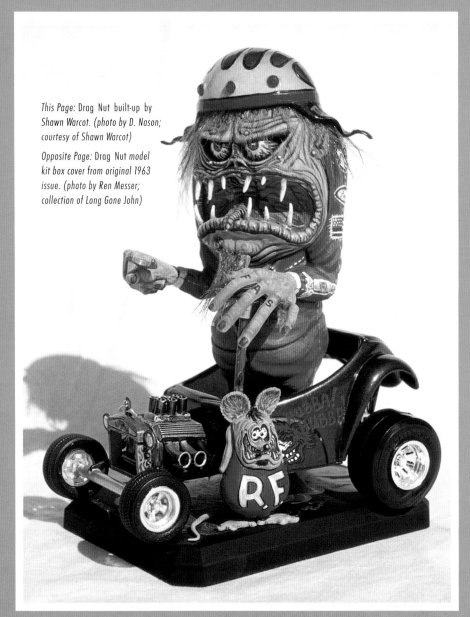

This Page: Drag Nut built-up by Shawn Warcot. (photo by D. Nason; courtesy of Shawn Warcot)

Opposite Page: Drag Nut model kit box cover from original 1963 issue. (photo by Ren Messer; collection of Long Gone John)

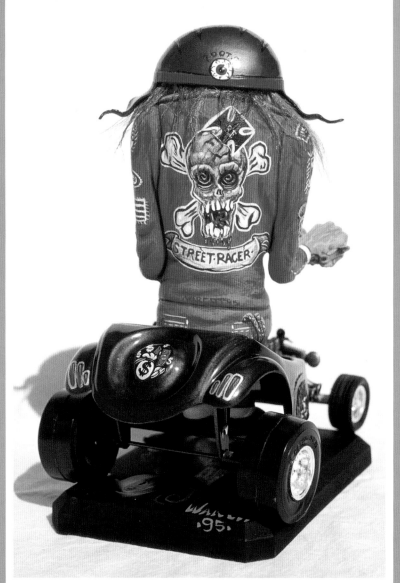

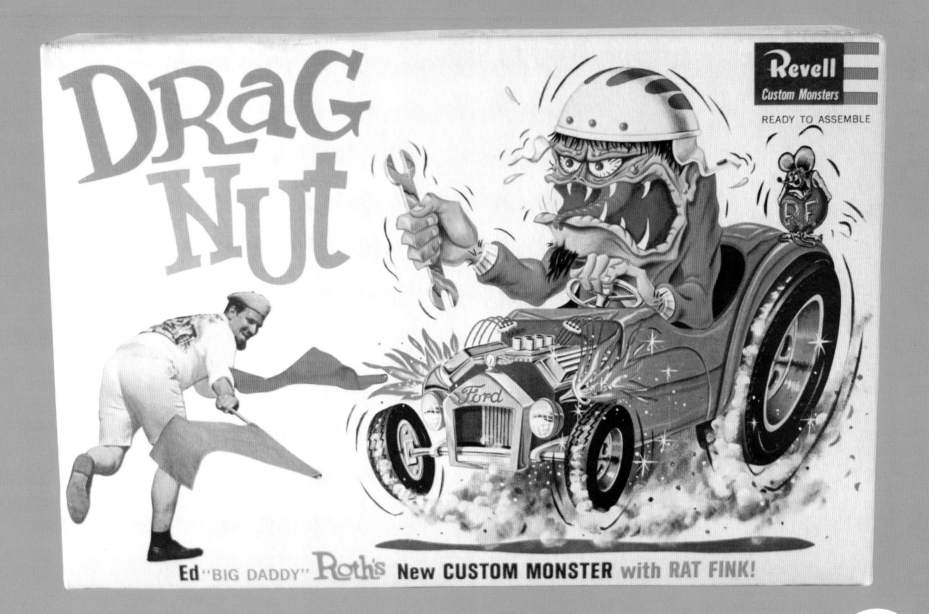

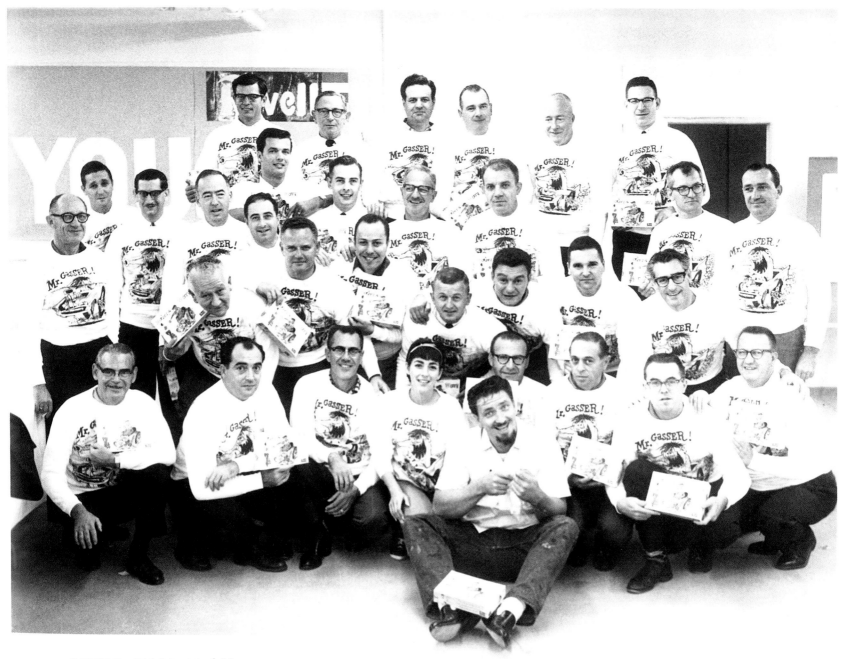

REVELL CLASS OF '63

Right: Mother's Worry model kit box cover from original 1963 issue. *(photo by Ren Messer; collection of Long Gone John)*

Bottom Right: Mr. Gasser! promotional poster from 1963. *(collection of Shawn Attema)*

Below: Ed "Big Daddy" Roth's Custom Colors Spray Enamel by Testor's was the model builder's choice during the '60s, and was offered in either cans or bottles. *(photo by/collection of Aaron Kahan)*

Opposite Page: Revell Class of '63 photograph. Ironically, BDR is the only one not wearing a T-shirt. *(photo collection of Verne Hammond)*

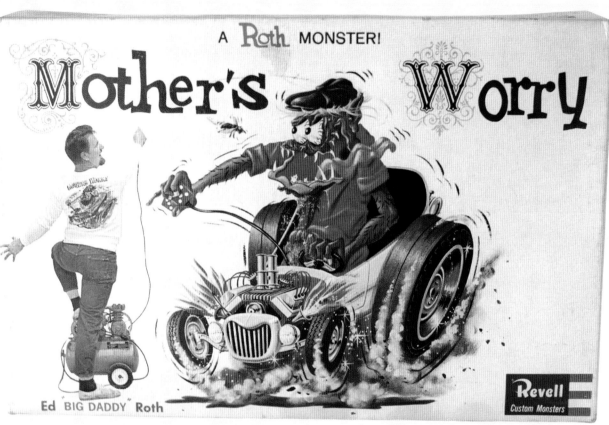

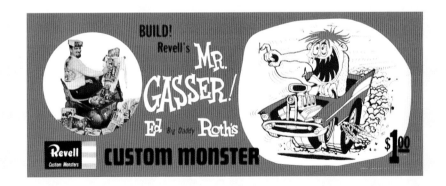

Right: Super Fink model kit box cover from original 1964 issue. (photo by Ren Messer; collection of Long Gone John)

Bottom Right: Surfite built-up kit by model builder Paul Madsen. (photo by Ren Messer; collection of Long Gone John)

Bottom Left: Ed "Big Daddy" Roth promotional stickers. (collection of Jon "Fish" Fisher)

Opposite Page Top: Surfite model kit box cover from original 1965 issue. (photo by D. Nason; collection of Verne Hammond)

Opposite Page Right: Build Surfink! promotional poster. (collection of Shawn Attema)

Opposite Page Bottom: Surfink! model kit box cover from original 1965 issue. (photo by D. Nason; collection of Verne Hammond)

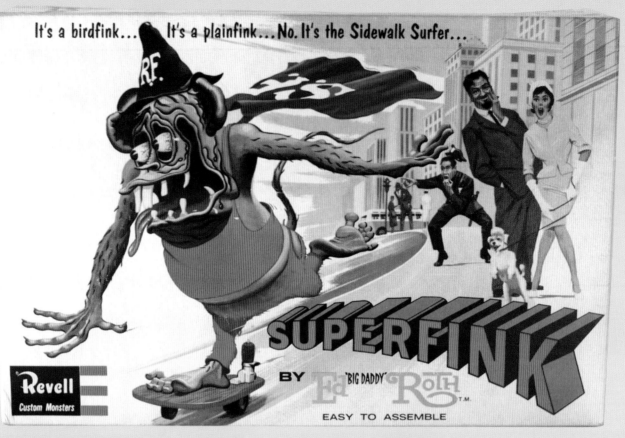

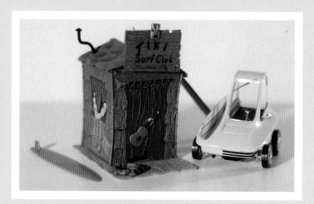

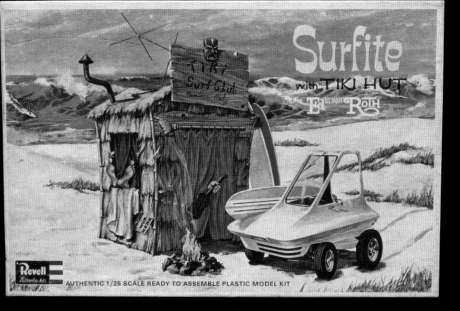

Surfite with TIKI HUT
Ed "Big Daddy" Roth

Revell Authentic Kits

AUTHENTIC 1/25 SCALE READY TO ASSEMBLE PLASTIC MODEL KIT

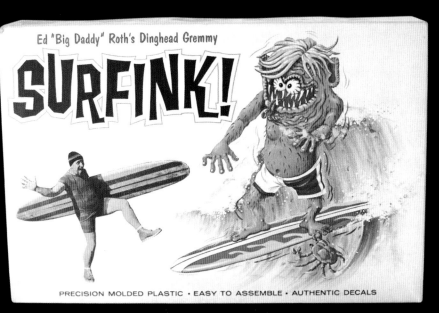

Ed "Big Daddy" Roth's Dinghead Gremmy

SURFINK!

PRECISION MOLDED PLASTIC · EASY TO ASSEMBLE · AUTHENTIC DECALS

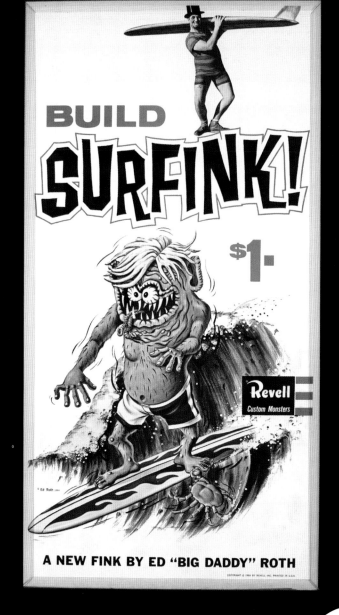

BUILD SURFINK!

$1.

Revell Custom Monsters

A NEW FINK BY ED "BIG DADDY" ROTH

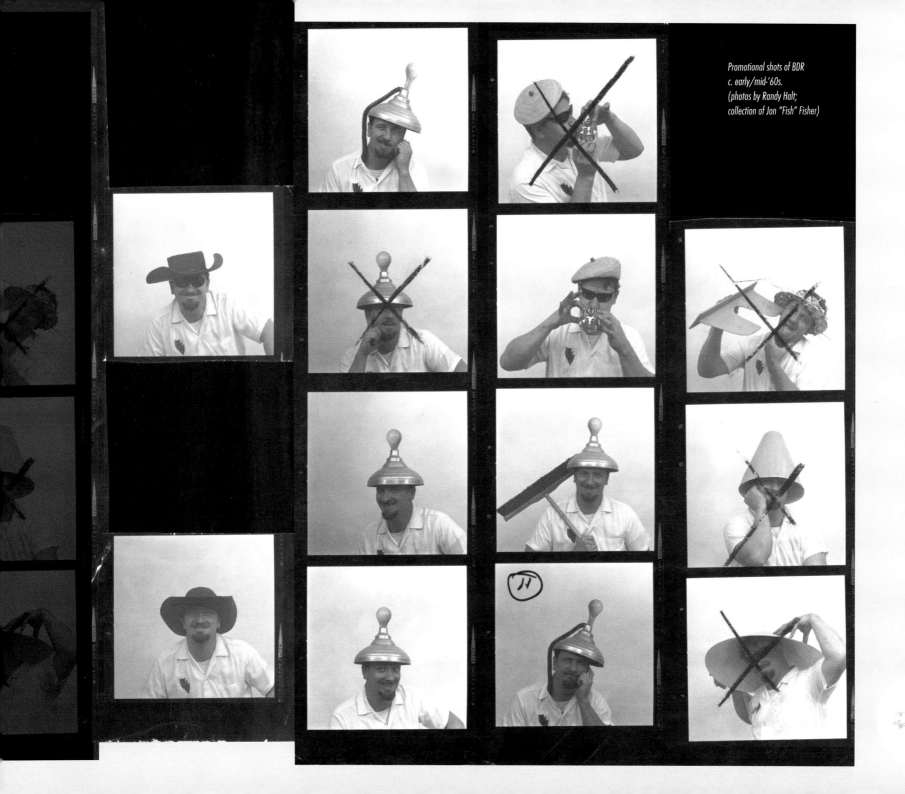

Promotional shots of BDR
c. early/mid-'60s.
(photos by Randy Halt;
collection of Jon "Fish" Fisher)

137

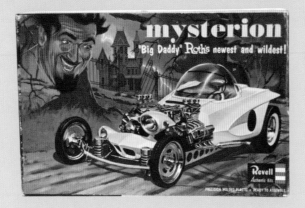

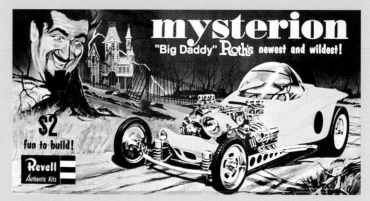

Top Left: Mysterion model kit box cover from original 1964 issue. (photo by/collection of Aaron Kahan)

Top Right: Mysterion publicity poster from 1964 (collection of Shawn Attema)

Right: Fink-Eliminator model kit box cover from original 1965 issue. (photo by Ren Messer; collection of Shawn Attema)

Opposite Page Top: Revell Custom Monsters Ransom a Rat Fink and His Gang publicity poster. (collection of Shawn Attema)

Opposite Page Bottom Left: Angel Fink model kit box cover from original 1965 issue. (photo by Ren Messer; collection of Long Gone John)

Opposite Page Bottom Right: Angel Fink built-up kit by model builder Shawn Warcot. (photo by D. Nason; collection of Shawn Warcot)

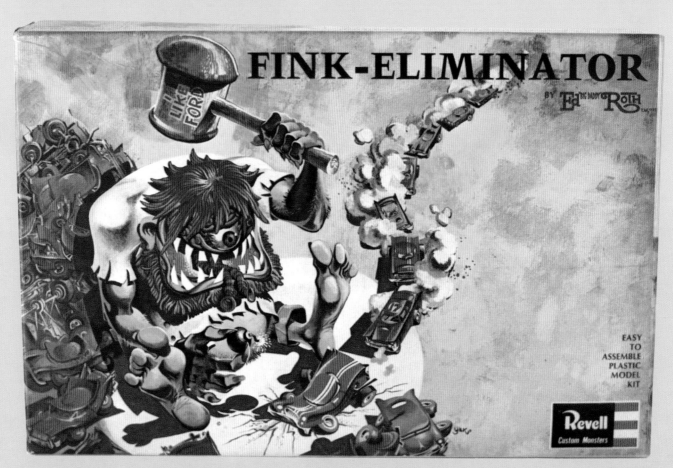

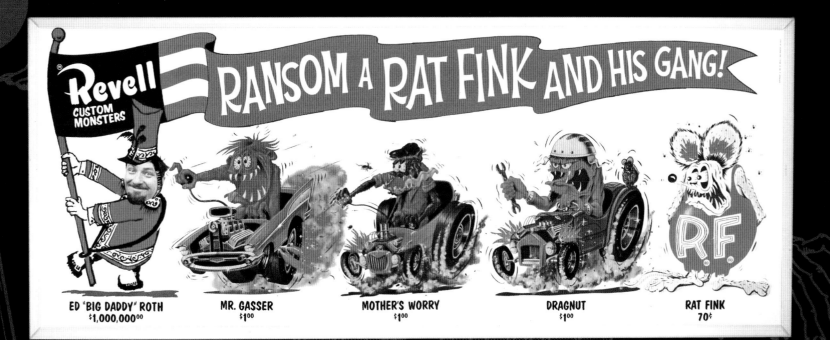

RANSOM A RAT FINK AND HIS GANG!

Revell CUSTOM MONSTERS

ED "BIG DADDY" ROTH
$1,000,000.00

MR. GASSER
$1.00

MOTHER'S WORRY
$1.00

DRAGNUT
$1.00

RAT FINK
70¢

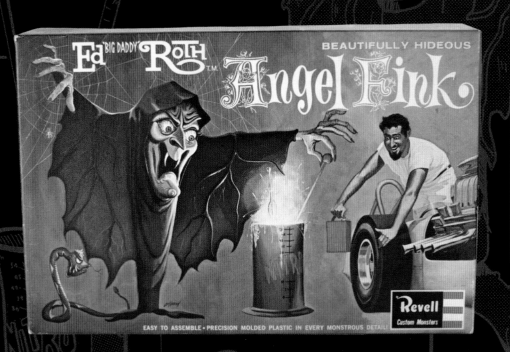

Ed "BIG DADDY" ROTH T.M. *Angel Fink*

BEAUTIFULLY HIDEOUS

Revell Custom Monsters

EASY TO ASSEMBLE · PRECISION MOLDED PLASTIC IN EVERY MONSTROUS DETAIL!

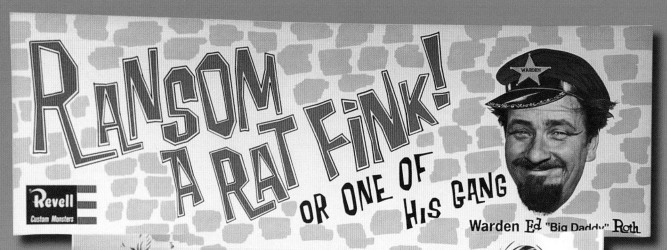

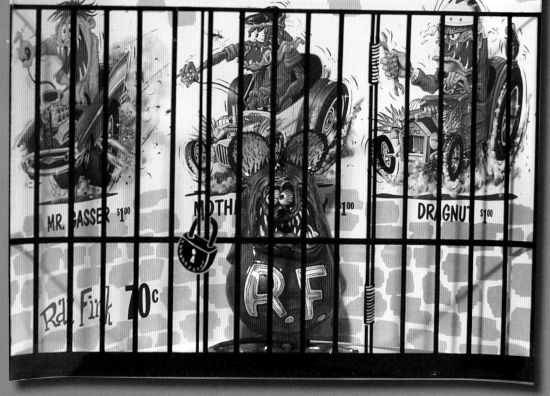

This Page: Ransom a Rat Fink! promotional display with Rat Fink model kit built-up by model builder Paul Madsen. (photo by Ren Messer; display collection of Shawn Attema; Rat Fink model collection of Long Gone John)

Opposite Page Top: Outlaw with Robin Hood Fink model kit box art concept illustration by Ed Newton from 1965. (collection of Long Gone John)

Opposite Page Right: Outlaw with Robin Hood Fink built-up kit by model builder Paul Madsen. (photo by Ren Messer; collection of Long Gone John)

Opposite Page Bottom: Outlaw with Robin Hood Fink model kit box cover from original 1965 issue. (photo by Ren Messer; collection of Long Gone John)

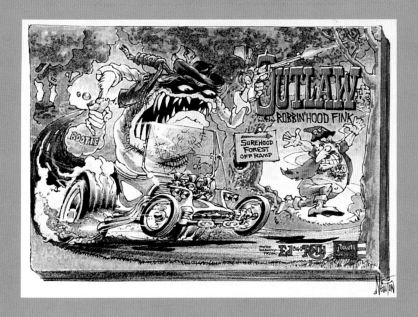

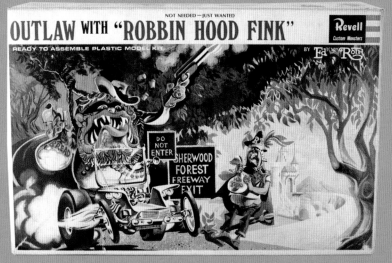

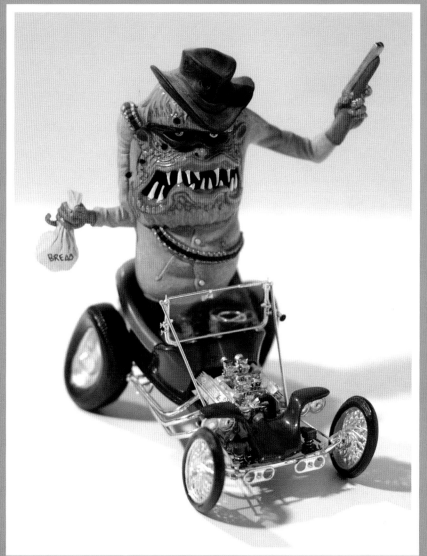

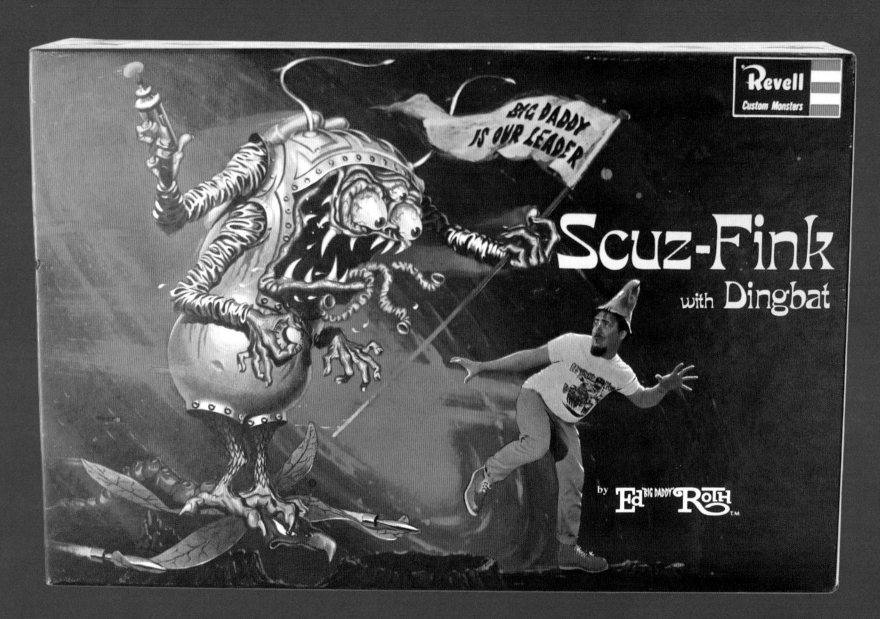

Scuz Fink with Dingbat model kit box cover from original 1965 issue. (photo by Ren Messer; collection of Long Gone John)

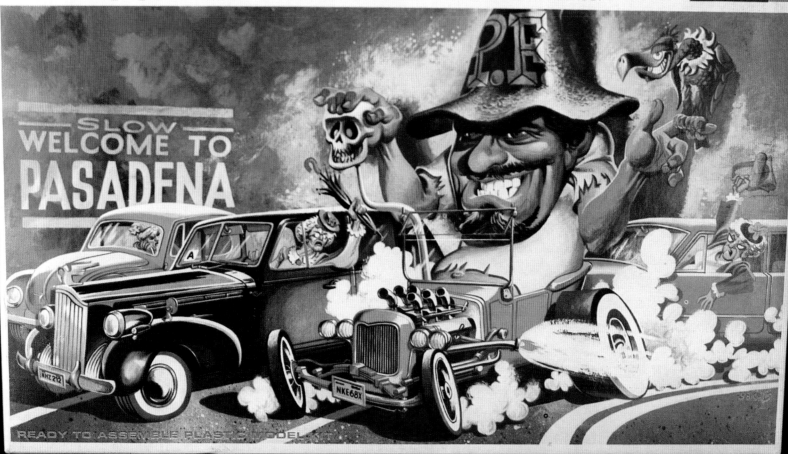

Tweedy Pie with Boss Fink model kit box cover from original 1965 issue. (photo by Ren Messer; collection of Long Gone John)

Above (from left to right): Korporal Amerika & Road Freak, Shift Kicker and Heavy Head model kit box covers from Revell's Freaky Riders Collection c. 1971. (photos by D. Nason; collection of Verne Hammond)

Right: Mail Box Chopper model kit box cover from original 1970s issue. (photo by D. Nason; collection of Verne Hammond)

Above: One of four Gold Fink necklaces built by the Chislers for an early '90s Rat Fink Reunion Party. The necklaces were inspired by the re-issue of the Rat Fink model kit and were a spoof on the then-current Rap music trend of over-the-top gold jewelry. Hence the huge chain and L.E.D. eyes that blink on and off. (photo by/collection of Aaron Kahan)

Upper Left: Agata model kit box cover from late 1980s Revell Mexico (Lodela) release. (photo by D. Nason; collection of Verne Hammond)

Left: Beatnik Bandit II model kit box cover from 1996 release of Big Daddy's updated version of the Beatnik Bandit. (photo by/collection of Aaron Kahan)

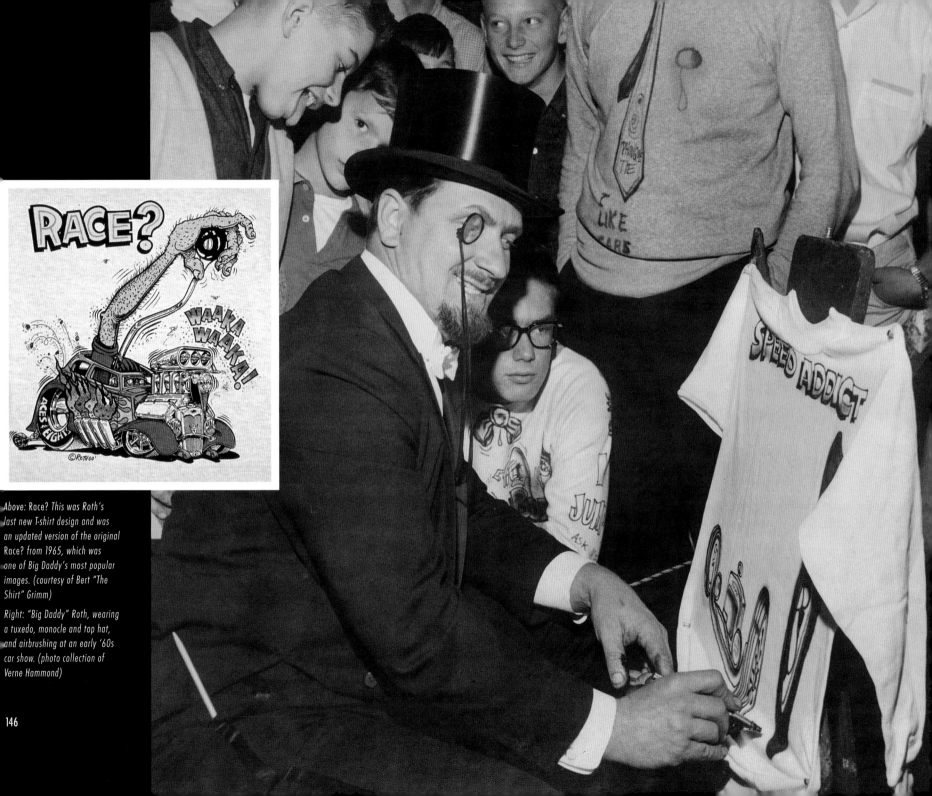

Above: Race? This was Roth's last new T-shirt design and was an updated version of the original Race? from 1965, which was one of Big Daddy's most popular images. (courtesy of Bert "The Shirt" Grimm)

Right: "Big Daddy" Roth, wearing a tuxedo, monocle and top hat, and airbrushing at an early '60s car show. (photo collection of Verne Hammond)

T-Shirt Designs

BY BERT "THE SHIRT" GRIMM

Start with a slogan combed from the vibe at a car event, like, "Forget the House, How Big is the Garage?!" or "The More I Learn About Women, The More I Like My Car!" or "I Eat, Sleep and Drink Hot Rods!" Add a vehicle, like a chopped Merc or a Willys coupe. Then drop in Finkie or one of his many cohorts, like Wild Child or Drag Nut. Polish it off with a blown Hemi and smokin' tires, and there you have it: Instant T-shirt, an Ed Roth trademark.

All of the parts worked together in a magical, harmonious balance to produce an image that is a miracle of design aesthetic. In so being, it remains as timeless and as fresh today as when it was originally done. The secret of Ed's T-shirt art mastery was simple: He would draw, sketch, or paint, any time, on any substrate put in front of him, be it a napkin or an Anglia trunk. He had little patience for the past and used his art as a way to push forward into new territories. If it had been done before, it had no relevance to him. Ever the practical artist, Ed's T-shirts were a means to an end — a way to fund his numerous vehicle projects from the *Outlaw* to the *Stealth 2000*, or to quench his never-ending hunger by bartering for an In-N-Out Double-Double burger or a vibrant green lime snow cone. His appetite was as colorful as he was.

The real purpose of his T-shirts was realized when the requisite battery-acid burns and oil stains were teamed with a frayed collar and worn with pride by one of Ed's many admirers. The look on Ed's face said it all when one of these "things of beauty" approached the booth. With a grease-stained T-shirt, Ed had succeeded in creating the truest accessible art form. For the price of a burger and fries, an Ed Roth original had found its home. A perfect match of art and wearer; a wonder to behold.

Above: Original art for magazine or catalog about T-shirt art by artist Pete Millar. (collection of Long Gone John)

Right: Ed "Big Daddy" Roth catalog cover from the mid-'60s. (collection of Shawn Attema)

Ed "BIG DADDY" Roth shirts

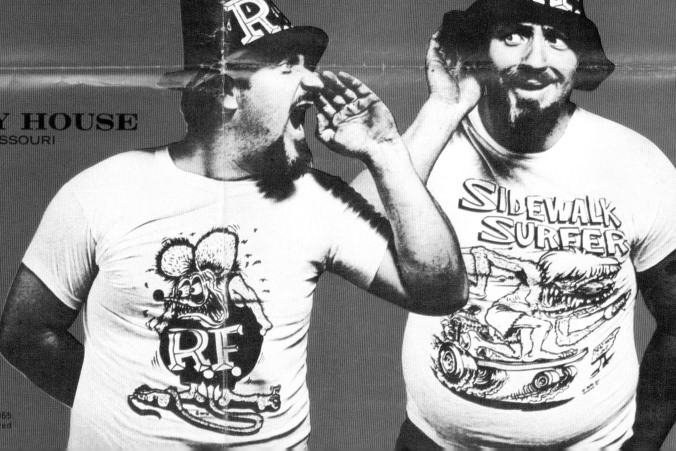

SHIRTS BY
VARSITY HOUSE
KANSAS CITY, MISSOURI

ROTH CAR
MODELS &
ROTH FINKS
BY

Revell
Authentic Kits

VENICE, CALIFORNIA

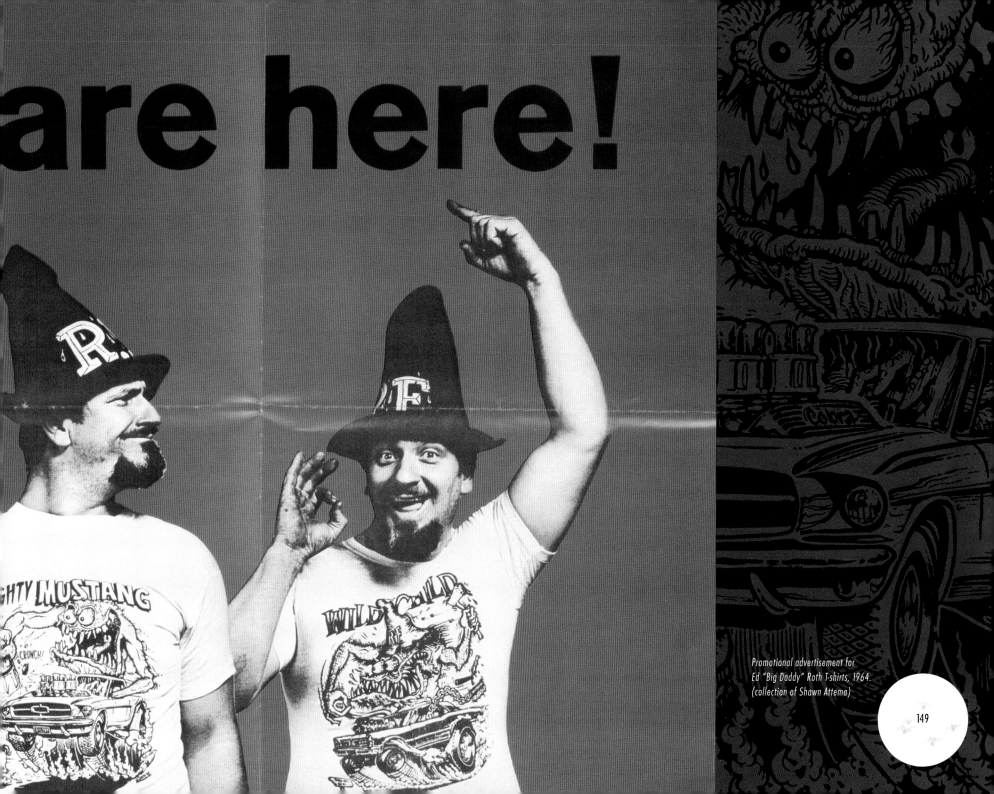

are here!

Promotional advertisement for
Ed "Big Daddy" Roth T-shirts, 1964.
(collection of Shawn Attema)

149

TRIUMPH "UNHOLY TERROR"

OINK!

H-D

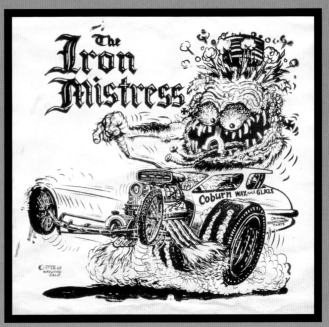

Above: Original art for The Iron Mistress T-shirt design (1964). Evidently the then-Mayor of the city of Maywood acquired this art from Roth during the mid-'60s. (collection of Dena Lux)

This Page And Opposite Page: Ed "Big Daddy" Roth T-shirt designs from the '60s. (courtesy of Bert "The Shirt" Grimm)

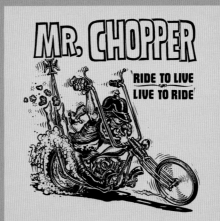

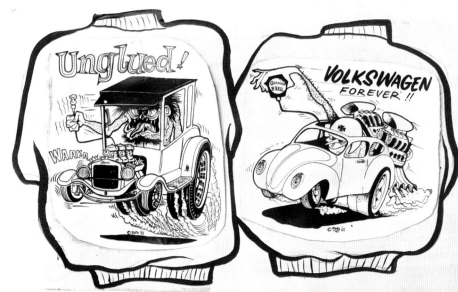

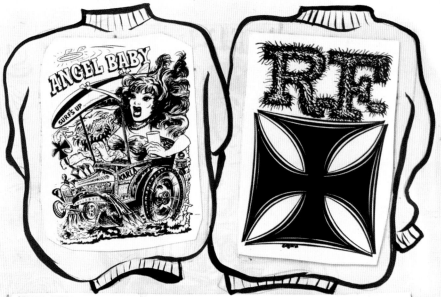

"I DREAMED I TOOK TOP ELIMINATOR IN MY WEIRDO T-SHIRT BY ROTH" is what you'll say after receiving one of our full-color goodies — only Big Daddy guarantees you to have Fluorescent-Tinted nightmares! Be the first Sleep-Bragger on your block!

HURRY, BEFORE WE RUN OUT! Yeah, man, like hurry up and finish reading this catalog and get your order in before I run out of funny little paragraphs like this one. . . .

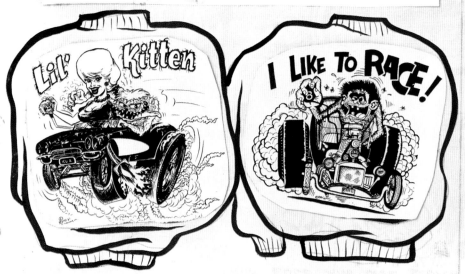

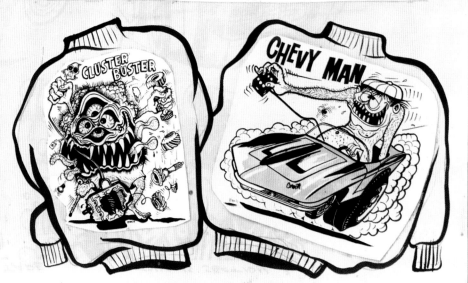

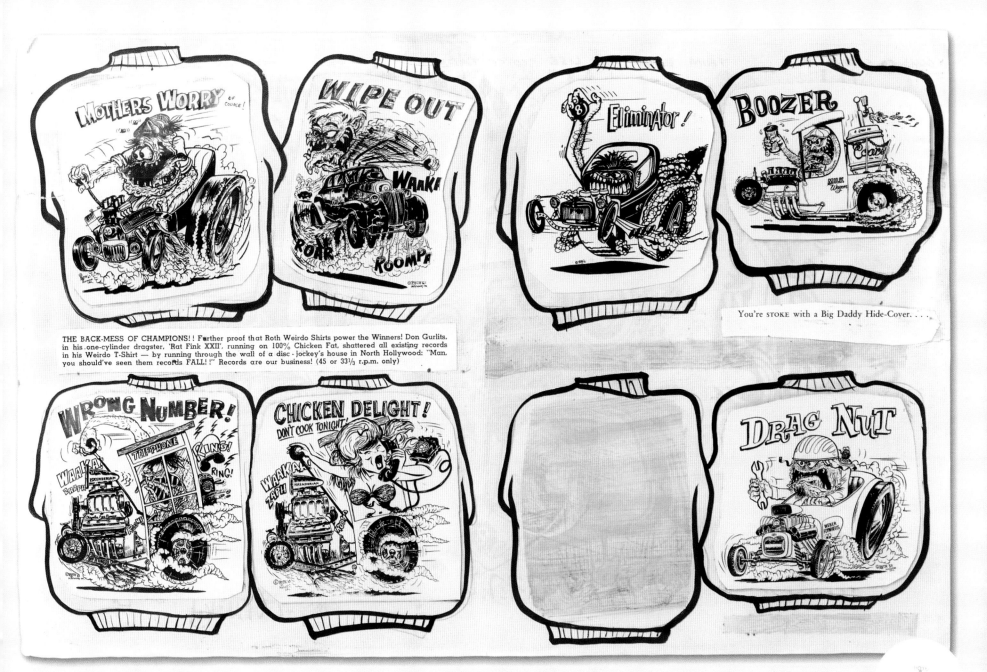

THE BACK-MESS OF CHAMPIONS!! Farther proof that Roth Weirdo Shirts power the Winners! Don Gurlits, in his one-cylinder dragster, 'Rat Fink XXII', running on 100% Chicken Fat, shattered all existing records in his Weirdo T-Shirt — by running through the wall of a disc-jockey's house in North Hollywood: "Man, you should've seen them records FALL!!" Records are our business! (45 or 33⅓ r.p.m. only)

You're STOKE with a Big Daddy Hide-Cover....

Original camera-ready artwork for a spread in an early '60s Ed "Big Daddy" Roth catalog. (photo by Ron Slenzak; collection of Lynn Coleman)

Top: Big Daddy silk-screening some T-shirts at his home in Manti, Utah, in 1993. At this time Roth said he had well over 600 designs, as evidenced by row after row of screens lined up on the shelf. When he passed away in 2001, Roth's legacy included well over 1,000 T-shirt designs. (photos by D. Nason)

Bottom: Ed "Big Daddy" Roth T-shirt designs. (courtesy of Bert "The Shirt" Grimm)

Bert ... the green in RAT FINK is perfect
Don't ever change it !

thanx

ED "BIG DADDY" ROTH

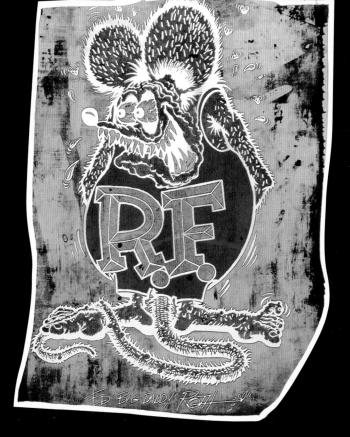

The first color silk-screen of Rat Fink. For some reason, Big Daddy never much liked the color green and he hardly ever used it. But in the late '80s, while experimenting with different colors on screen printed T-shirts, he found he liked Pantone Matching System (PMS world standard) color No. 375, and this became the monster green now recognizable as Rat Fink green. (photo by Aaron Kahan; courtesy of Bert "The Shirt" Grimm)

ORDER FOR STANFORD July 22
COLORED MOTHERS WORRY s m l xl
RF ½ ½ 1 1
 1666

Vietnam & Other Military Images

BY THE PIZZ

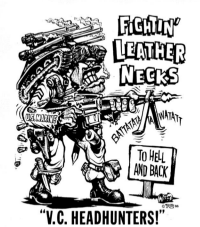

"V.C. HEADHUNTERS!"

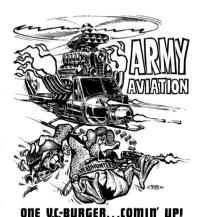

ONE V.C-BURGER...COMIN' UP!

One of the problems with historical revisionism is that by bending past events and motives to fit a more up-to-date picture, we can easily misconstrue just what, exactly, is what.

Roth's Vietnam-era T-shirt designs are among some of his most controversial works. Never known for his subtlety, Roth created images that can seem extremely shocking in this oversensitive, politically-correct era of creeping Moralism. But one has to place things in context; and having known him, I do not believe Roth was a war-monger. I never heard him make any racially derogatory remarks ever. But Roth was an ex-GI himself, having done a hitch in Korea. It was no piece of cake.

As a true populist, Roth always took the side of the underdog. This was his way of giving the grunts something to be proud of. The designs were all divisional, and could be considered in league with the average football or hockey team jersey. Given his solid, working-class, blue-collar background, it was typical of the times for Ed to be pro-American. He felt he was doing his part for the boys by making the T-shirts. It seems odd now, but most bikers were, in fact, in favor of the Vietnam war, as a lot of them were veterans. Remember, too, that the military recruited lots of young hot rodders, recognizing their mechanical skills. Roth saw himself in the young GIs

going off to war. Ed knew a lot of the boys going over, and he wanted them to have something to represent.

The closest cousin to any of this stuff would have to be WWII-era propaganda art, but this gung-ho Vietnam army imagery mixed with hot-rod mayhem is totally unique to the Roth Studios. Nowadays you can walk into any PX store on any base and find a wide assortment of "Kill Them All and Let God Sort Them Out" T-shirts, but it took the turbo-adolescent mentality of the Roth Studios to equip a Huey chopper with a blown Hemi. These will always be my favorite pieces to come out of this talent pool. They'll never get co-opted into the mainstream, staying too raw to get past the sensitivity radar of polite society. But they were all Ed.

Left: Two Vietnam war T-shirt designs from the mid-'60s. (courtesy of Bert "The Shirt" Grimm)

Opposite Page: U.S.N. ...If You Gotta Go...Go Navy! (detail). Water decal from 1966. (collection of Verne Hammond)

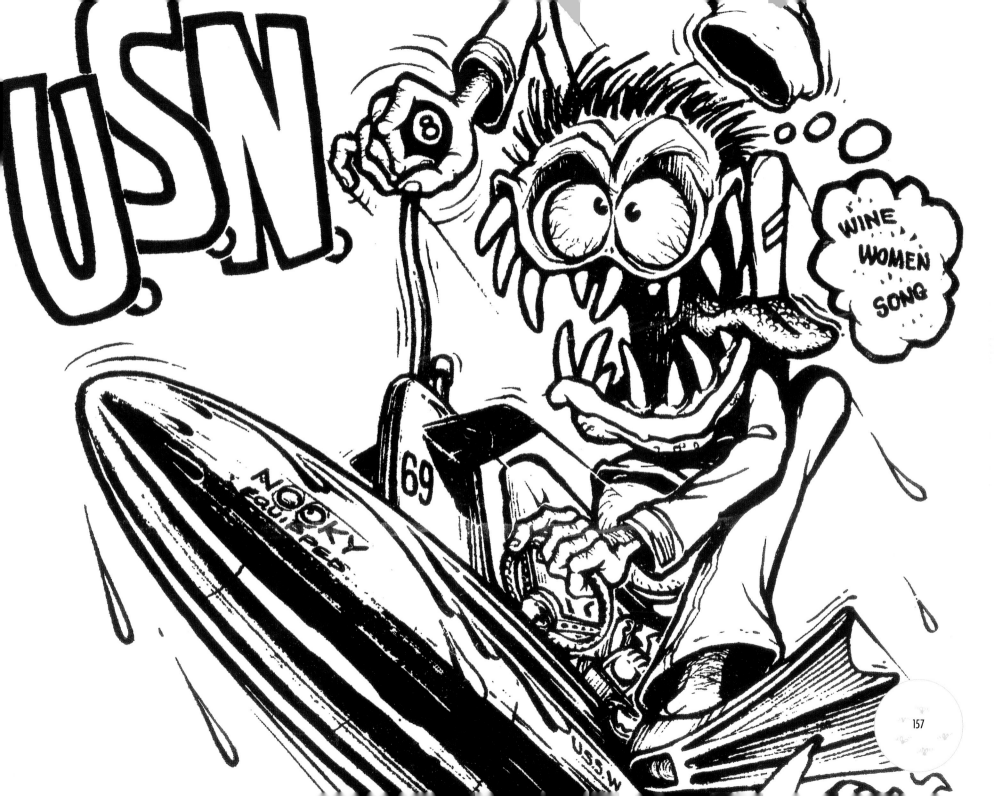

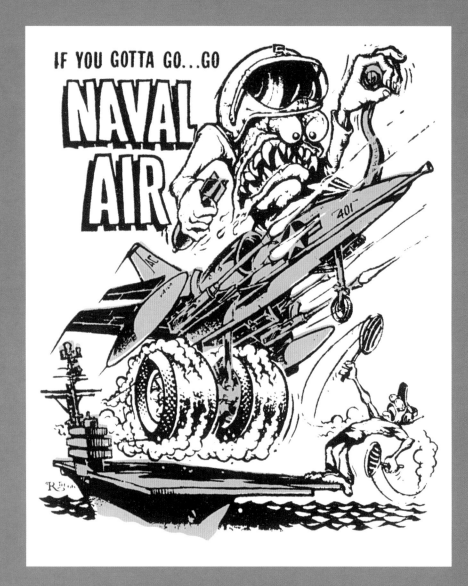

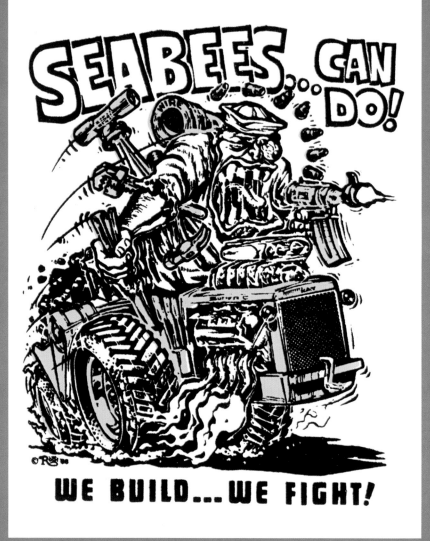

Collection of four decals from 1966 in support of several factions of the U.S. military. (collection of Jon "Fish" Fisher)

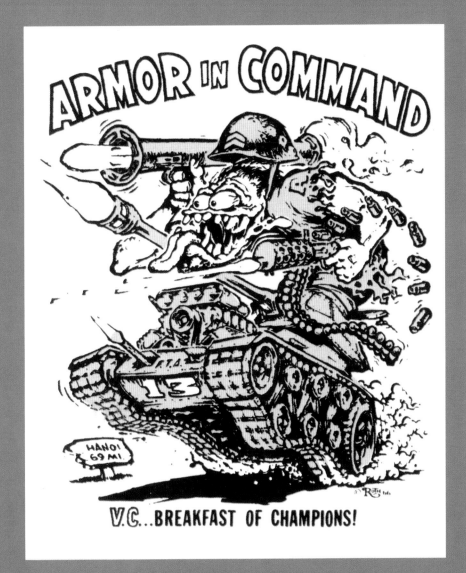

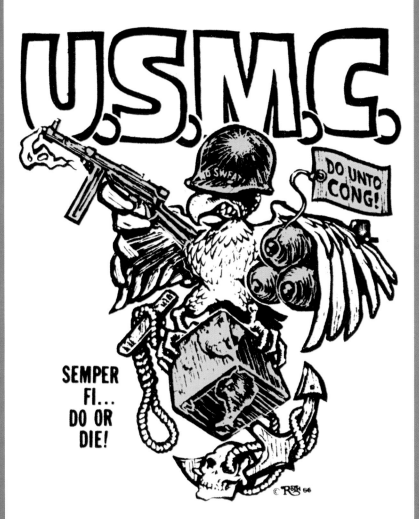

BE A LOVER, NOT A FIGHTER!

Let Big Daddy's Souvenir Department turn you on to the latest new junk for the local tank drags. Turn on the spectators by first laying a nice green loogie (lunger) on the starting line and increasing the traction on the tank treads. Be sure that you *non-chalantly* let your Maltese Cross hang loosely around your neck as it will immediately place you into the "in" group. Not only with the racing crowd but with your parole officer as well. Big Daddy has confessed to an over-supply of these precious crosses and has consented to sell them for only four bits (50c) postage included (Big Deal)! Go to the tank races or street races or just plain cruisin' the drive-ins with confidence. The proud cat to the left also is sporting Big Daddy's plastic Kruisin' Kap© for runnin' away from the fuzz, $1.98 includes postage.

For you upper class kats, Roth's Souvenir Dept. has a plastic Kaiser Kap©, with chin strap and full race Golden Eagle Decal on front with inscription, "Down Mit Der Local Fuzz", carefully inscribed on it, $2.98 (postage paid!)

50c.

$1.98

$2.98)

VIET NAM VETERAN

NEVER VOLUNTEER FOR NOTHIN!

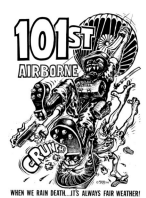

WHEN WE RAIN DEATH...IT'S ALWAYS FAIR WEATHER!

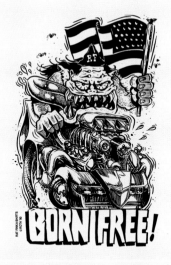

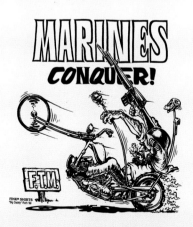

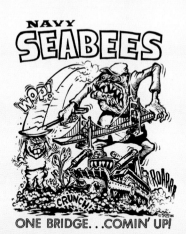

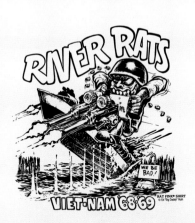

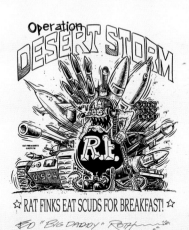

This Page: The six T-shirt designs to the left are from the late '60s Vietnam era, while the two designs on the far right are from the early '90s. (courtesy of Bert "The Shirt" Grimm)

Opposite Page Left: Three T-shirt designs of military images from the late '60s. (courtesy of Bert "The Shirt" Grimm)

Opposite Page Far Left: Be a Lover, Not a Fighter! advertisement by artist Robert Williams for Roth studios that was never used. (collection of Verne Hammond)

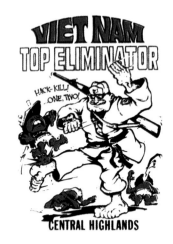

VIET NAM TOP ELIMINATOR

HACK-KILL! ONE, TWO!

CENTRAL HIGHLANDS

THE MARINES HAVE LANDED

BANZAI

MADE IN JAPAN

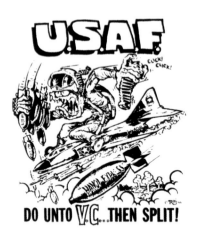

U.S.A.F.

CLICK! CLICK!

DO UNTO V.C...THEN SPLIT!

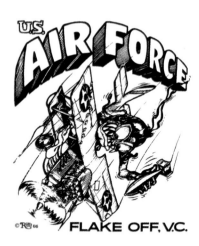

U.S. AIR FORCE

FLAKE OFF, V.C.

K-9 SUPER DOGS

DON'T MIT FUZZ R.F. DER YOCAL

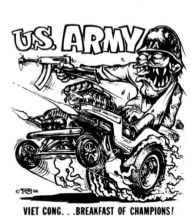

U.S. ARMY

VIET CONG. . .BREAKFAST OF CHAMPIONS!

This Page: A collection of military oriented water decals from the mid-'60s. (top left Viet Nam Top Eliminator collection of Verne Hammond; all others collection of Jon "Fish" Fisher)

Opposite Page: PT69 original sketches by an unidentified artist (1966). Roth's style was often imitated, and he frequently received unsolicited artwork from his many fans. We believe these two sketches may be the work of a Roth admirer who was serving a tour of duty for the U.S. military in Vietnam. (collection of Lynn Coleman)

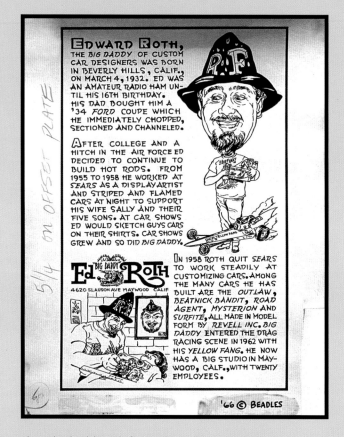

Above: Edward Roth biography from a mid- '60s advertisement (1966). (collection of Jeffrey Decker)

Above Left: Big Daddy from a computer-generated image by Ed "Big Daddy" Roth. This art was originally used for a 1997 art exhibition featuring Ed "Big Daddy" Roth, Stanley Mouse, Von Franco and Jimmy C at the J. Moore Gallery in Seal Beach, California. It was then subsequently used by House Industries for a T-shirt and drinking glass set design. (courtesy of Jeff Fieldson with the J. Moore Gallery)

Left: Ed "Big Daddy" Roth logo by Ed Newton. This logo was originally inked by Newton in February of 1964 when he first began working for Roth. It immediately became Big Daddy's primary logo and is still used by Ed "Big Daddy" Roth, Inc. to this day. (courtesy of Ed "Big Daddy" Roth, Inc.)

Logos & Commercial Work (Working with Big Daddy)

BY HOUSE INDUSTRIES

We first met Ed at a car show in Long Island, NY. It was your standard Big Daddy circus: shade-tree hot rodders hovered over a huge table of monster shirts, sucking up all the R.F. merchandise, while the outlaw-biker set hung out on the fringe, still a little miffed over the 1-percent sticker thing. There was a new twist, though; an ad agency hack was trolling around with a blank check and his creative director's helmet, hoping to get a custom Roth stripe job. And there was us, a bunch of doe-eyed suburbanites looking for the Big Daddy seal of approval on a set of eight fonts based on original Roth Studios lettering.

The Rat Fink Fonts project was the beginning of a great relationship and the first of many BDR/House collaborations to follow. A few years later, in 1997, while Big Daddy was touring the East Coast, he stopped off at House Industries for a short breather between shows. He intended to work in our studio for a week or so before unveiling some of his new paintings at our "Ed Roth Drops in on House Industries" gallery show. We weren't in the best of neighborhoods back then, which Ed clearly realized when he pulled up with a gun drawn lest any of the local crunks decided to make off with the Beatnik Bandit II. He promptly retired to the McIntosh Inn (the luxurious Hampton Inn we had reserved was "too nice"), where the cheap room had a clear view of his trailer in the parking lot and he could pack heat without being bothered by the other patrons.

Sure, Big Daddy left us with some great stories. But, more importantly, his willingness to explore uncharted creative territory left its mark on everything we do.

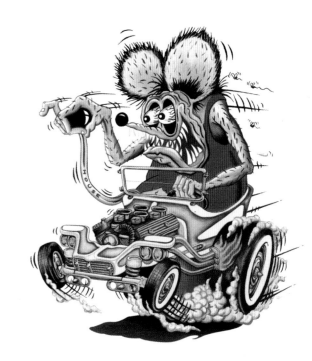

Above: Rat Fink driving the Outlaw illustration by House Industries artist Adam Cruz (1996). (courtesy of House Industries)

Left: Ed "Big Daddy" Roth Show Cars... of the 60s! This T-shirt and box design was released in 1996 by House Industries. This clever packaging design retained the look of a vintage '60s Revell Ed "Big Daddy" Roth model kit. (photo by Carlos Alejandro; courtesy of House Industries)

Background: Rat Fink Fonts concept illustrations. (courtesy of House Industries)

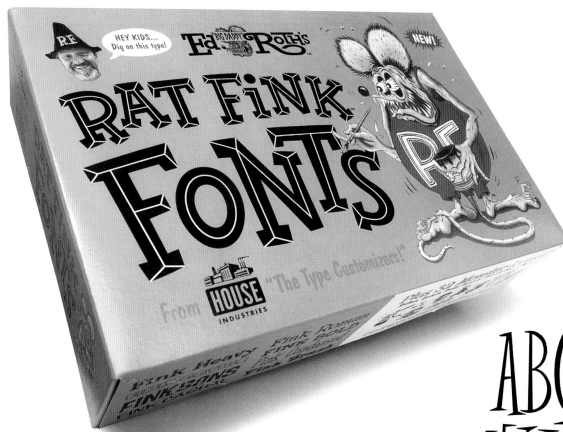

This Page: Rat Fink Fonts box art and sample fonts from House Industries. These fonts were originally released in 1996 and have now become an industry standard. (photo by Carlos Alejandro; courtesy of House Industries)

Opposite Page: Rat Fink Fonts concept illustrations. (courtesy of House Industries)

FINK SANS **Fink Brush**

FINK BOLD **FINK CASUAL**

FINK GOTHIC **Fink Condensed**

Fink Heavy **Fink Roman**

ABCDEFG
HIJKLMNO
PQRSTUV

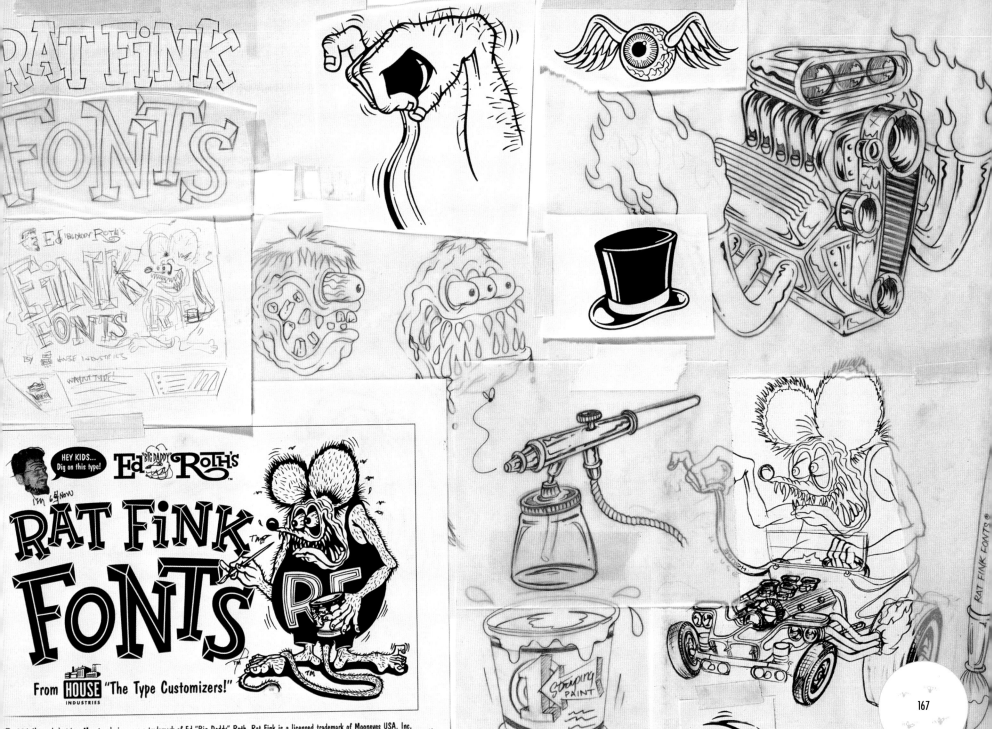

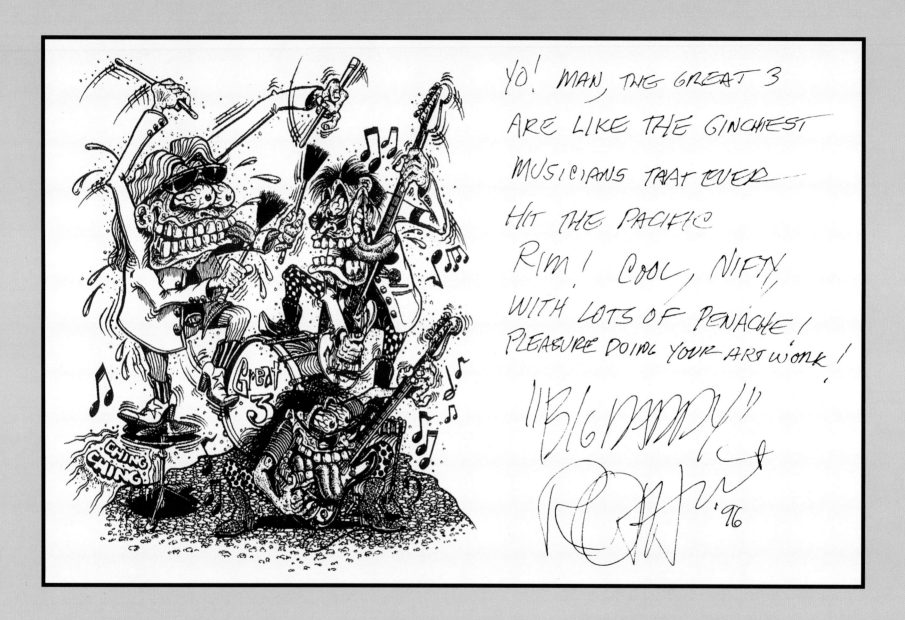

YO! MAN, THE GREAT 3
ARE LIKE THE GINCHIEST
MUSICIANS THAT EVER
HIT THE PACIFIC
RIM! COOL, NIFTY,
WITH LOTS OF PENACHE!
PLEASURE DOING YOUR ART WORK!

"BIG DADDY"

'96

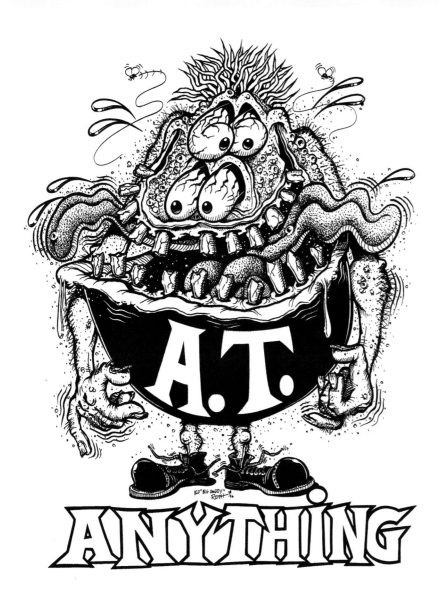

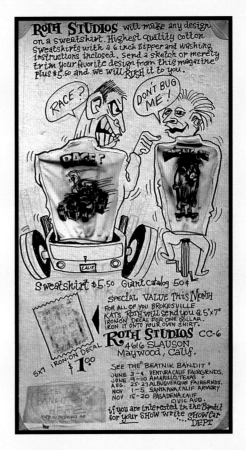

Above: Roth Studios sketch intended for an advertisement (c. early '60s). (collection of Jeffrey Decker)

Left: Anything logo by Ed "Big Daddy" Roth (1996). Anything is a Tokyo-based clothing company that commissioned Roth for this impressive design. (courtesy of Copro/Nason)

Opposite Page: Great 3 logo by Ed "Big Daddy" Roth (1996). Great 3 is a popular rock band from Japan whose members are Big Daddy fans. The concept sketches were by Big Daddy Roth with the final inking (shown) by artist Garry Mizar. (courtesy of Copro/Nason)

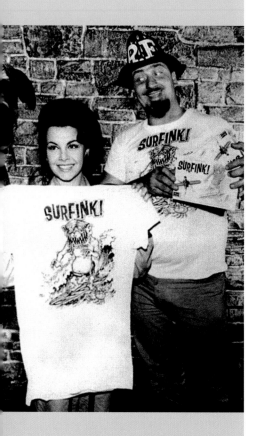

Surfing & Skateboarding

BY DR. ARTHUR KATZ

"Big Daddy" Roth was always a friend to the surfers. This might not sound like any big deal, but before BDR's early 1960's popularity, the Hodads — hot rodders who did not surf — and the surfers were two distinct schools that didn't really care for each other. Roth, who for obvious reasons was more affiliated with the Hodad camp, didn't really buy into this separatist thing. Roth wholeheartedly advocated surfing, as evidenced by some of his earliest T-shirt and decal designs, which depicted surfers with hopped-up vehicles (like Hunter and Sidewalk Surfer), and by his mass-produced surfer helmets and crosses.

The Germanic nature of these helmets and crosses sparked a controversy that led *Surfer* magazine to write "Sign of the Kook," an article that denounced what it saw as Nazi imagery. Though the magazine tried hard to portray Roth as a Nazi sympathizer, he answered back that they were just solid designs. He embraced his "Kook" status. And when he surfed Malibu or the Huntington Pier, he wore his helmet proudly.

Surfing influenced his designs just as he influenced surfing. It was from an unknown shaper that he first came across moldable fiberglass, which he would use to revolutionize his car designs. Certain surf historians recount that Ed was there hashing out board designs with Tom Morey of Morey Bodyboards when Morey first started tossing around the idea of making boards shorter, lighter and more streamlined for speed. Some

could say this led to the eventual evolution of the modern-day shortboard.

During the 1965 production of Frankie Avalon's *Beach Blanket Bingo*, Roth went down to the Malibu film set with his Surfite vehicle and a whole lot of merchandise for the film. There he met Annette Funicello, America's teen heartthrob, and befriended guest star Buster Keaton. In this film, a supporting character, Bonehead, wore one of Roth's "weirdo" scarecrow hats displaying a big "R.F." and a Surfink! T-shirt. Roth's Surfite was in the movie, albeit for only a few frames, with Annette in the foreground.

Another Avalon film, 1964's *Bikini Beach*, featured the Mantaray, a Roth-inspired vehicle by Dean Jeffries, and a Roth-inspired character named "Big Drag," played by Don Rickles. The plot centered around not only surfing, but the drag strip as well. This film, obviously influenced by Roth, continued the groundwork he had begun by showing surfers at the drag strip.

Some lines from this film exemplified the changing attitude of surfers towards hot rodders. When Annette said, "Would you trade that beautiful ocean for a dirty old rail [dragster]?" her supporting star replied, "Well there's room for both!" But perhaps the most profound line was Avalon's, who, as he was climbing into a dragster, said to Annette, "The ocean, it's wild and it's free, it's something you can't change. This [referencing the dragster], this is an engine, a machine, which can be controlled!"

Above: Mouseketeer/teen heartthrob/ beach movie star Annette Funicello with Ed "Big Daddy" Roth, posing with their Surfink! T-shirts circa 1965. Big Daddy claimed to have had a crush on Annette, along with the rest of America. (photo courtesy of Pat Ganahl)

Above right: Scandinavian bootleg water decal of a Big Daddy-type image from the '60s. (collection of Verne Hammond)

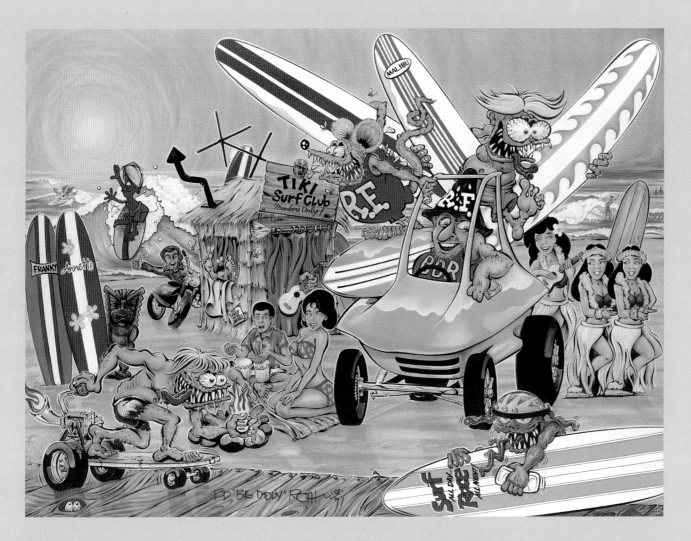

Above: Tiki Surf Club painting by artist Jimmy C. As is the preference of most sign painters, this masterpiece was painted with 1-Shot enamel. This painting was featured alongside Roth's Surfite vehicle in the Surf Culture exhibition at Laguna Art Museum during the Summer of 2002. (courtesy of Jimmy C)

Right: Wood laminated skateboard deck with pinstripe design by Ed "Big Daddy" Roth (1997). (photo by D. Nason; collection of Ray Flores with Board Gallery, Venice, California)

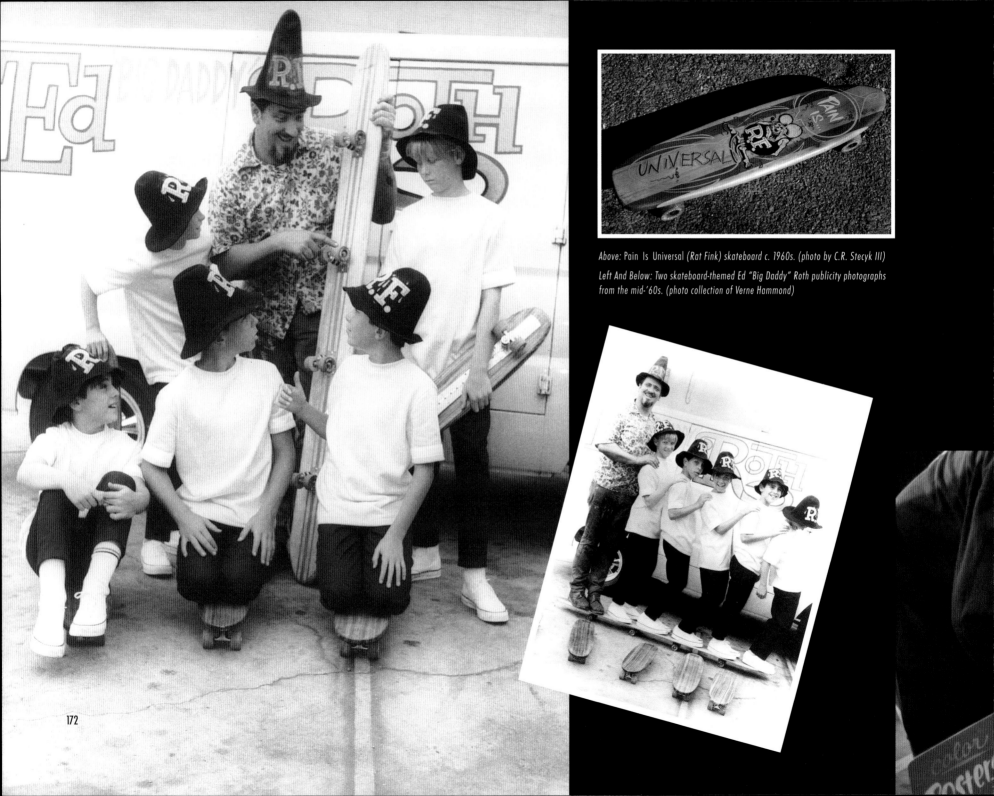

Above: Pain Is Universal (Rat Fink) skateboard c. 1960s. (photo by C.R. Stecyk III)

Left And Below: Two skateboard-themed Ed "Big Daddy" Roth publicity photographs from the mid-'60s. (photo collection of Verne Hammond)

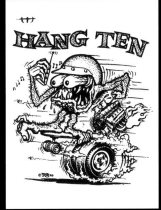

Above: Two skateboard-oriented water decals from 1965. (collection of Aaron Kahan)

Right: Skateboard deck with pinstriped design by Ed "Big Daddy" Roth from 1996. (photo by D. Nason; collection of Lou Perdomo)

Above Right: Ed "Big Daddy" Roth pinstriping a skateboard deck at a 1996 hot rod show in Sarasota, Florida. (photo by/collection of Lou Perdomo).

Bottom Right: Two Rat Fink skateboards by Nash Skateboards from the early- to mid-'60s. (photo by Aaron Kahan; collection of Verne Hammond)

Below: Ed "Big Daddy" Roth pinstriping a skateboard deck at a late '90s Rat Fink Reunion party. (photo by Greg Escalante)

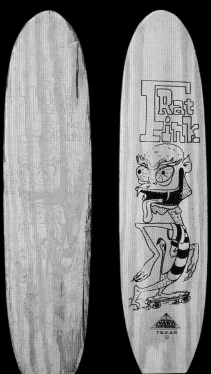

Above: Rat Fink Rides Madrid logo for Madrid
Skateboards from 1986. (photo by Aaron Kahan;
courtesy of Jerry Madrid)

Right: Defy Gravity with Lighting Force skateboard
deck issued by Madrid Skateboards in 1986.
(photo by Aaron Kahan; collection of Jon "Fish" Fisher)

Middle Right: Rat Fink Rides skateboard deck
issued by Madrid Skateboards in 1986.
(photo by Greg Escalante; courtesy of Jerry Madrid)

Far Right: Joel Tudor Think Sidewalk Surfboard
deck with custom pinstriped design by Ed "Big
Daddy" Roth in 1997. (photo by D. Nason;
collection of Gregory and Marcela Phillips)

Opposite Page: Into the Tube of No Return
original illustration by Todd Schorr from
1990. (courtesy of Todd Schorr)

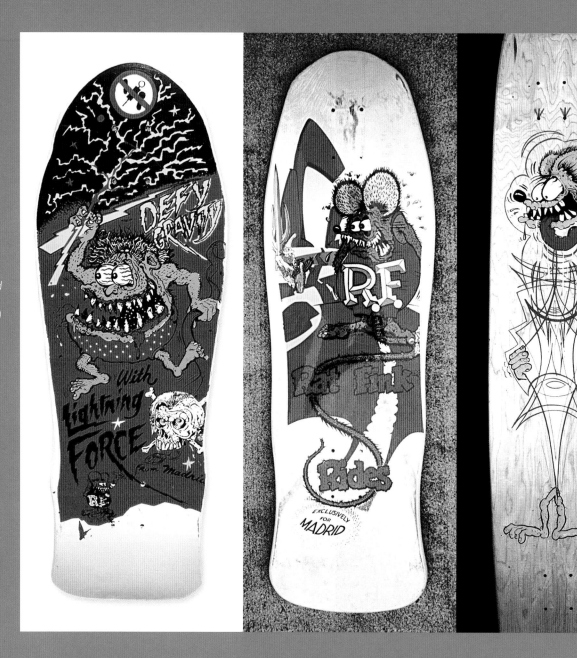

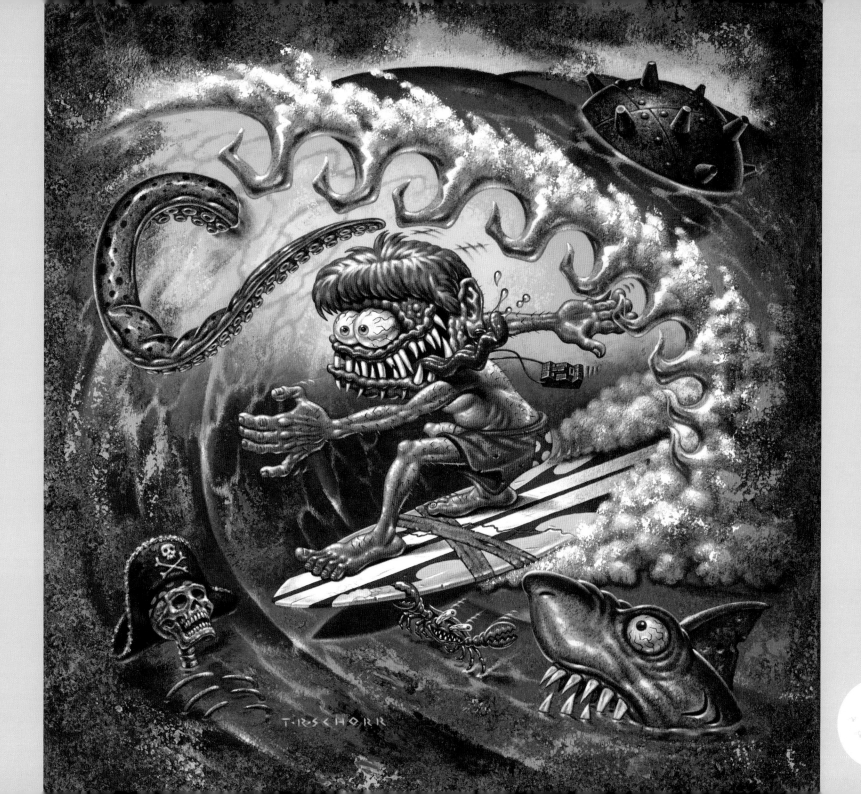

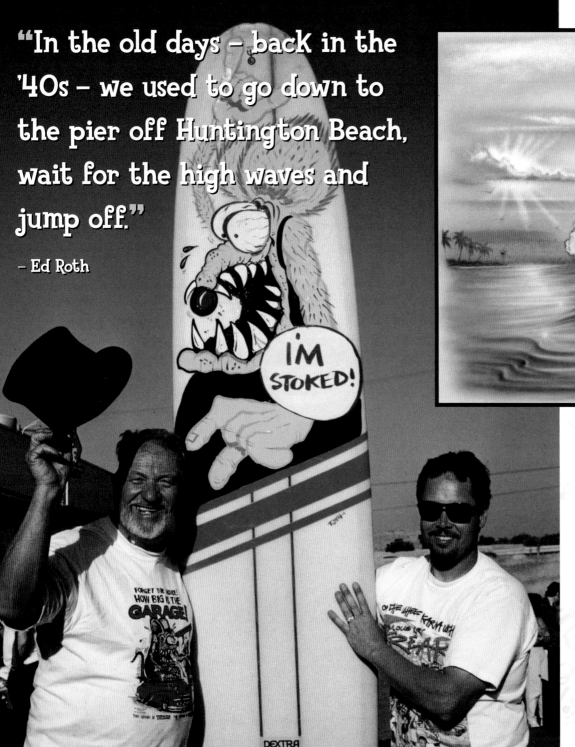

"In the old days – back in the '40s – we used to go down to the pier off Huntington Beach, wait for the high waves and jump off."

– Ed Roth

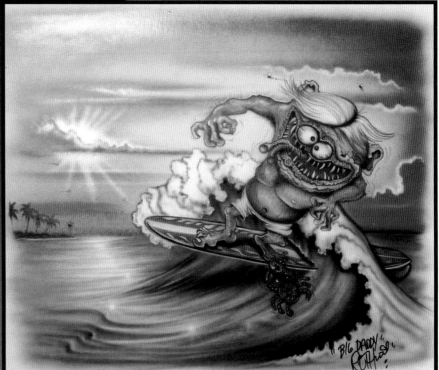

Above: Surfink! airbrushed original illustration used for the box cover for Ed "Big Daddy" Roth's Surfink! model kit, which was reissued by Revell in 1990. (photo by D. Nason; collection of Verne Hammond)

Left: Ed "Big Daddy" Roth and Roy Fjastad proudly standing by a freshly painted I'm Stoked! surfboard by Roth at a mid-'90s Rat Fink Reunion. (photo by Greg Escalante; collection of Roy Fjastad with West Coast Street Rods)

Background: Ed "Big Daddy" Roth skateboard T-shirt design from 1986. (courtesy of Bert "The Shirt" Grimm)

Opposite Page: A collection of Ed "Big Daddy" Roth's surf-and skateboard-oriented T-shirt designs from the mid-to late-1980s. (How To Cruise design collection of George Goodrich; all other designs courtesy of Bert "The Shirt" Grimm)

"Nobody could get a real surfboard. In those days it was swim fins and snorkel tubes. And the first boards, the wooden ones, were 7 feet long. You just got out there and rode in. There were no lip curls, no airmails, no back dashes, nothing. The old-time surfers didn't worry about a tube because you couldn't get in anyways. You just went with the wave. Now they're really sophisticated. They've got these quad thrusters and all. Well, you've got to be an athlete to run one of those."

– Ed Roth

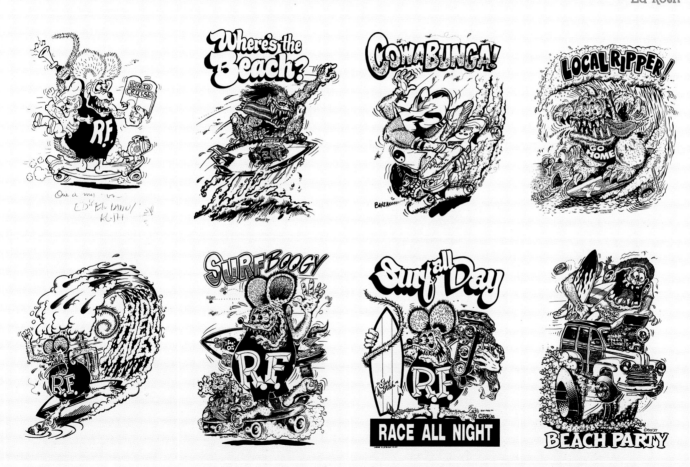

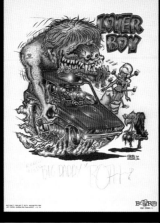

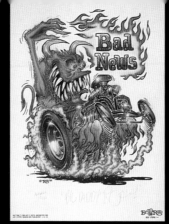

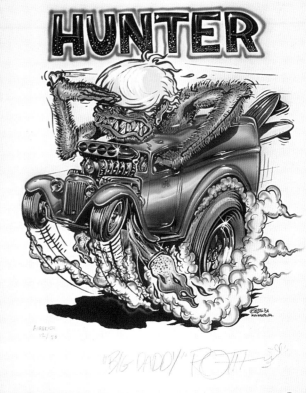

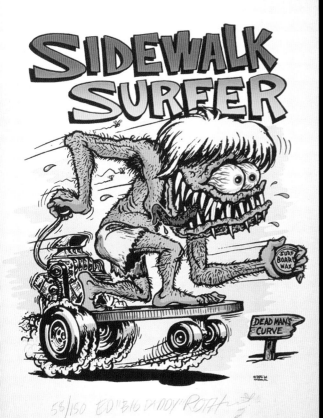

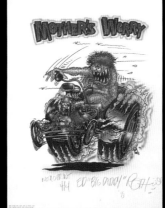

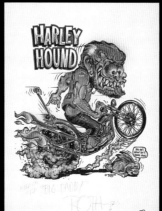

A sampling of seven vintage Ed "Big Daddy" Roth images printed by master silk-screener Jeff Wasserman and published by Copro/Nason Fine Art. Sidewalk Surfer is a 14-color hand-pulled serigraph signed and numbered by Ed "Big Daddy" Roth. Published in 1991 and limited to an edition size of 150, the Sidewalk Surfer was from an unaltered Roth Studios image originally from 1964. Mother's Worry is a single-color hand-pulled serigraph signed and numbered by Ed "Big Daddy" Roth. Published in 1993 and limited to an edition size of 30, Mother's Worry was from an unaltered Roth Studios image originally from 1964. Shown here is a custom airbrushed monoprint. Sinker Toy, Lover Boy, Bad News, Harley Hound and Hunter are part of The Rat Fink Portfolio, which is comprised of eight single-color, hand-pulled serigraphs signed and numbered by Ed "Big Daddy" Roth. Published in 1995 and limited to an edition size of 125, The Rat Fink Portfolio images are unaltered and originally from the early- and mid-1960s. Shown here are custom airbrushed monoprints. (courtesy of Copro /Nason)

Prints & Posters

BY DOUGLAS NASON

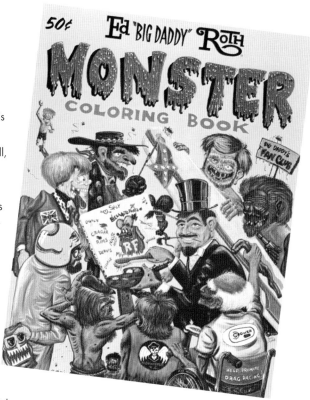

Ed "Big Daddy" Roth's Monster Coloring Book
from 1965. (collection of Coby Gewertz)

At sunrise, I pulled into a deserted parking lot in an industrial enclave of Orange County. Looking around, I thought to myself, Where was Big Daddy? This Rat Fink party was to be the debut of our first collaboration, and so I had arranged with him to meet before the party so he could sign the prints. Roth had stipulated we meet at 6 a.m. in a lot which hours later would be the site of a Rat Fink party. Did he really mean 6 p.m.? Then, off in a remote section of the parking lot, I spied his nondescript Japanese pickup. Sure enough, Roth was fast asleep in the driver's seat, with the tell-tale remnants of an egg sandwich in his beard and a grease-stained Jack-in-the-Box bag in his lap. I stood there a moment before I mustered the courage to wake him.

"You should have woken me up earlier!" he exclaimed, getting out of his truck. I asked if there was some place safe to sign the freshly made, silk-screened Sidewalk Surfer prints I'd brought. "I do the best work on the hood of my car," he said. When I pulled out the finished prints, he looked pleased. "They're a winner!" he said with a smile. It was a delight to see him execute his signatures, as it marked the end of our first successful publishing project.

This venture began at a meeting we had at a San Francisco Rat Fink party in mid-1991. I distinctly remember discussing the project with Roth as he ate a hot dog smothered in mustard that flowed down his chin and dribbled onto his paint-soiled Rat Fink T-shirt. By this time Roth had been silk-screening T-shirts since the early Sixties and knew the entire process quite well, from converting an image to line art, to color separations, to making the screen, and finally the printing. However, the objective of our project was to produce a higher-quality, limited-edition, fine-art print that would rival the blue-chip prints of such leading contemporary artists as Andy Warhol, Ed Ruscha, Roy Lichtenstein and Frank Stella.

To create the prints we wanted, we first enlarged the essential *Sidewalk Surfer* image that originally appeared in Roth's 1965 *Monster Coloring Book*. With the help of master screen-printer Jeff Wasserman — who has, in fact, produced prints by the likes of the aforementioned contemporary artists — we printed the outline of the image in black line-art. Next, Roth colored in this prototype with crayons and selected PMS colors (a world standard of printable colors) to be used for each of the colors he had specified for the print. In his creative enthusiasm, Roth went overboard and selected way too many colors for our limited budget, but I convinced Wasserman that this was what he wanted and that we should not compromise Roth's choices. We then carefully deciphered and individually screen-printed each of Roth's chosen hues, ending up with a 14-color masterpiece.

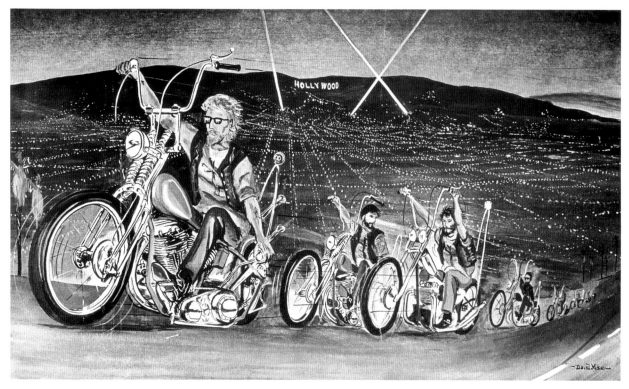

HOLLYWOOD RUN

Hollywood Run, *Ed "Big Daddy" Roth poster, circa 1966, by Roth Studios artist Dave Mann. (collection of Jason Kennedy)*

The initial collaboration among Roth, Wasserman and Copro/Nason spurred the production of several other prints and posters, each of them signed by Roth outdoors on the hood of his car or in the bed of his truck. He liked to sharpen his signing pencil with a knife and inevitably got pencil shavings on some of the works. Once he even purposely ground the shavings into a print. Upon seeing my worried expression he said, "It's O.K., it will be worth more this way!" During our early morning signing

sessions, as he would drink hot chocolate and eat donuts, I would watch nervously, fearing that he would spill on the pile of prints. One time he drooled on a print, but again found a silver lining. He wrote across the print, "Drool and the whole world will drool with you!"

Quirkiness aside, all the silk-screens came out great and bore his over-sized scrawl of a signature, complete with swarming flies. Indeed, regardless of whether the finished product was a $1.50 mini-poster merchandised for a car show or a $500-plus fine-art mono-print targeted for a high-fallutin' gallery crowd, all of Big Daddy's reproduced images are unique. In retrospect, Roth's business instincts were right-on. The prints that he personally "touched," whether with an inadvertent donut crumb, a pencil-shaving smear, a special caption or sketch, are now the most sought-after.

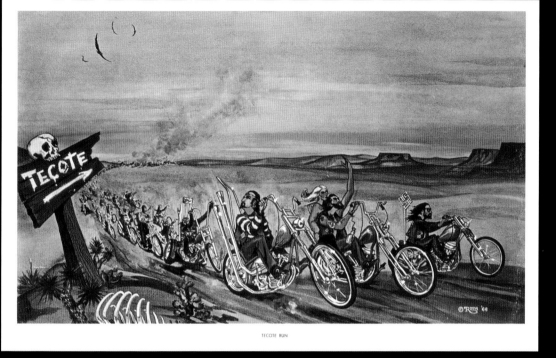

TECOTE RUN

OUTLAW MOTORCYCLE PARADE...SPRINGFIELD, ILL.

Tecote Run, Ed "Big Daddy" Roth poster from 1966 by Roth Studios artist Dave Mann. (courtesy of Jim and Danny Brucker)

Outlaw Motorcycle Parade...Springfield, Ill, Ed "Big Daddy" Roth poster from 1966 by Roth Studios artist Dave Mann. (courtesy of Jim and Danny Brucker)

Some of the most outrageous posters released by Roth Studios were the series of outlaw biker images by artist Dave Mann. Our research indicates Roth published 19 of Mann's images between 1966 and 1968. Mann's art career began with hot rod sketches in his high school notebook, which eventually led to pinstriping cars and to his attendance at the Kansas City Art Institute. During an early 1960s visit to Los Angeles, Mann became infatuated with chopped Harley Davidsons, and he bought a customized 1948 panhead when he returned to Kansas City. In 1963, he merged his passions for custom motorcycles and art and created his first painting, Hollywood Run, which captured the essence of the outlaw biker lifestyle. Soon after, a fellow motorcycle club member sent a snapshot of the painting to Ed Roth, and Mann subsequently painted several poster images for Roth Studios. These outlaw biker posters were featured prominently in Roth's mid - to late - 1960s advertisements and catalogs.

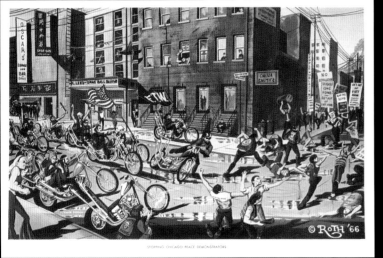

Stopping Chicago Peace Demonstrators, *Ed "Big Daddy" Roth poster from 1966 by Roth Studios artist Dave Mann.*
(courtesy of Jim and Danny Brucker)

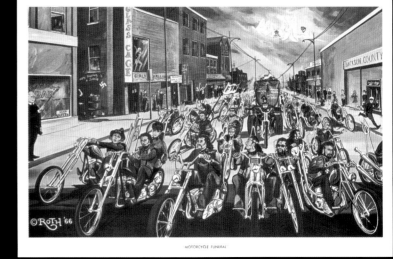

Motorcycle Funeral, *Ed "Big Daddy" Roth poster from 1966 by Roth Studios artist Dave Mann.*
(collection of Jason Kennedy)

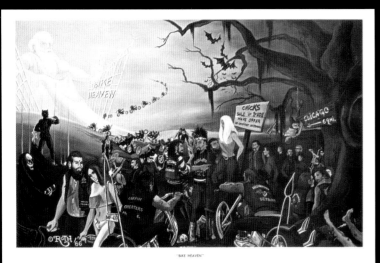

Bike Heaven, *Ed "Big Daddy" Roth poster from 1966 by Roth Studios artist Dave Mann.*
(collection of Jason Kennedy)

Bakersfield 13 Mi., *Ed "Big Daddy" Roth poster from 1966 by Roth Studios artist Dave Mann.*
(courtesy of Jim and Danny Brucker)

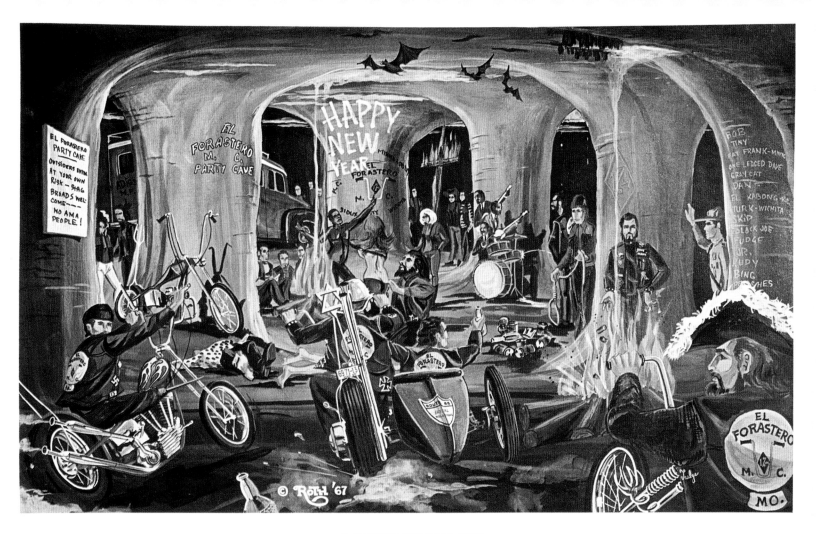

EL FORESTARO NEW YEAR'S PARTY

El Forestaro New Year's Party, Ed "Big Daddy" Roth poster from 1967 by Roth Studios artist Dave Mann. (collection of Jason Kennedy)

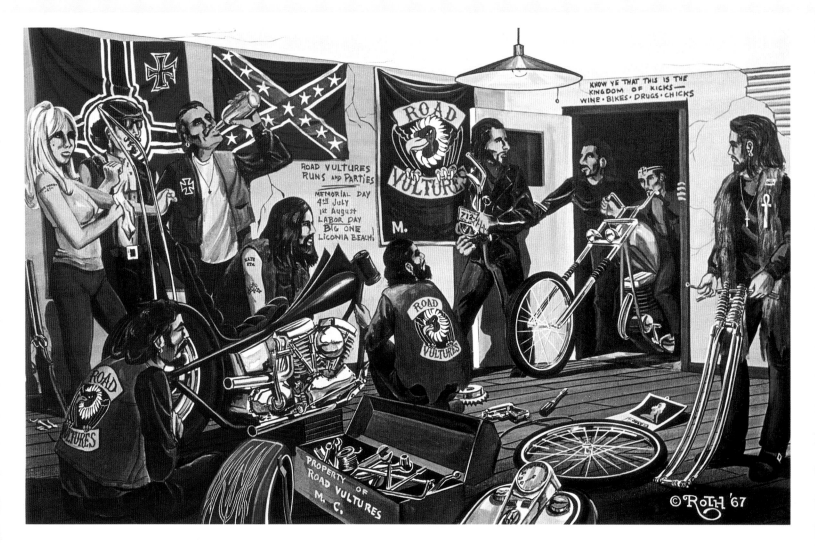

BUILDING A CHOPPER

Building a Chopper, Ed "Big Daddy" Roth poster from 1967 by Roth Studios artist Dave Mann. (collection of Jason Kennedy)

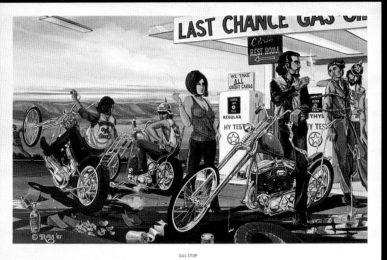

GAS STOP

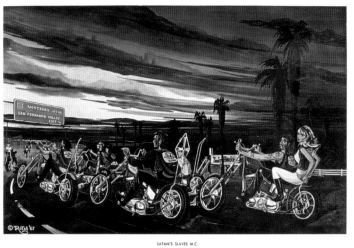

SATAN'S SLAVES M.C.

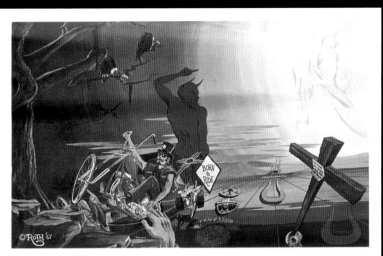

BORN TO RIDE

Above: Satan's Slaves M.C., Ed "Big Daddy" Roth poster from 1967 by Roth Studios artist Dave Mann. *(courtesy of Jim and Danny Brucker)*

Top Left: Gas Stop, Ed "Big Daddy" Roth poster from 1967 by Roth Studios artist Dave Mann. *(courtesy of Jim and Danny Brucker)*

Bottom Left: Born to Ride, Ed "Big Daddy" Roth poster from 1967 by Roth Studios artist Dave Mann. *(courtesy of Jim and Danny Brucker)*

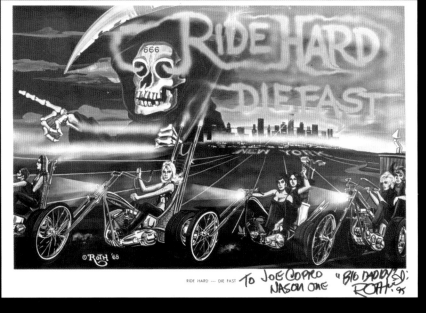

RIDE HARD — DIE FAST

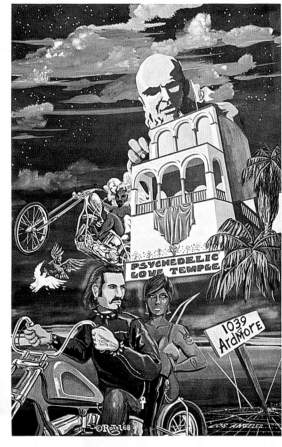

Roth's mid-to-late Sixties advertisements of these outlaw biker posters, Surfer (Maltese) Cross medallions and T-shirt designs depicting German war imagery earned him the reputation of being "...the supply sergeant to the Hells Angels," according to an article in Time magazine. The following quote from a 1967 letter to Roth from a well-known magazine publisher sums up Roth's questionable aesthetics during this time period: "...We are concerned that our magazines, carrying your advertising, include copy which may offend either teachers or parents.... To be as specific as possible, we will accept no advertising for wearing apparel, books or other merchandise containing illustrations or slogans involving crude language, direct or indirect reference to sex or sexual perversion, dope or narcotics. Nazi swastikas are not acceptable. We will not accept the outlaw motorcycle club items, pictures, patches and literature." As with the design of his vehicular creations, Roth constantly pushed the envelope with everything he produced.

Above: Psychedelic Love Temple, Ed "Big Daddy" Roth poster from 1968 by Roth Studios artist Dave Mann. (courtesy of Jim and Danny Brucker)

Above Left: Ride Hard Die Fast, Ed "Big Daddy" Roth poster from 1968 by Roth Studios artist Dave Mann. (collection of Copro/Nason Fine Art)

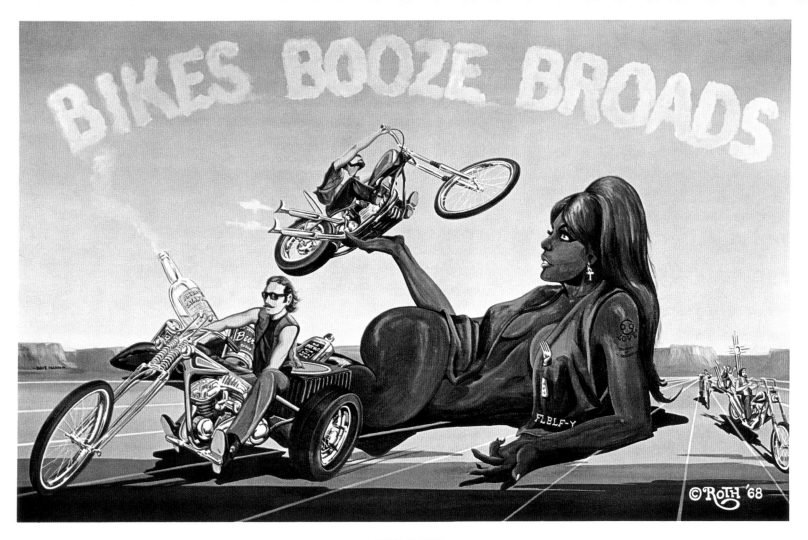

A TASTE OF HONEY

A Taste of Honey, Ed "Big Daddy" Roth poster from 1968 by Roth Studios artist Dave Mann. (collection of Jason Kennedy)

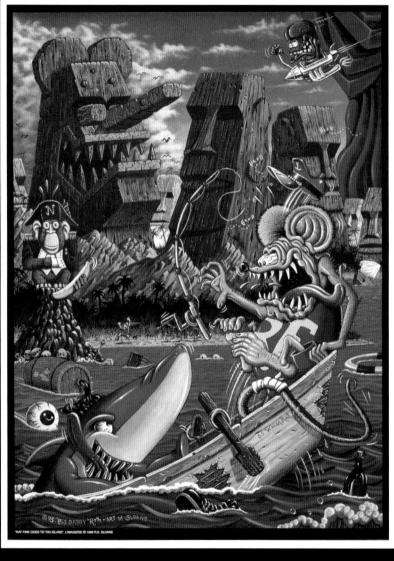

Rat Fink Goes To Tiki Island *poster by R.K. Sloane, published in 1996 by L'Imagerie Gallery.*
(courtesy of Debi Jacobson)

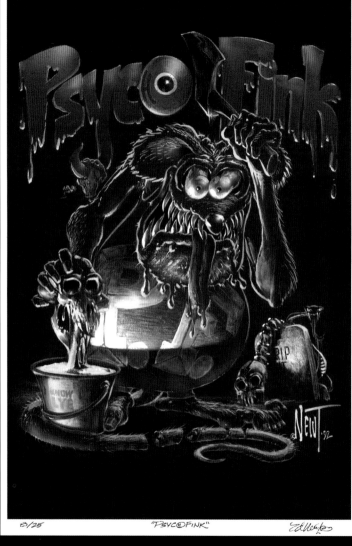

Psycho Fink *by Ed Newton, published in 1992. (collection of Dr. Arthur Katz)*

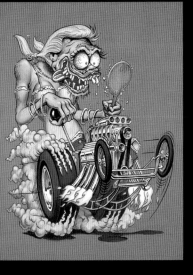
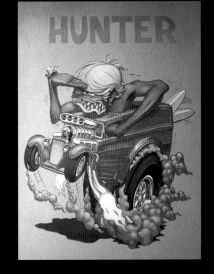
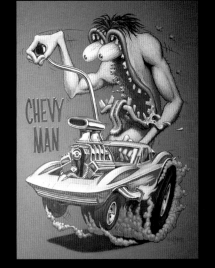
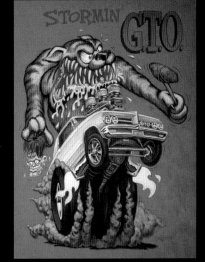
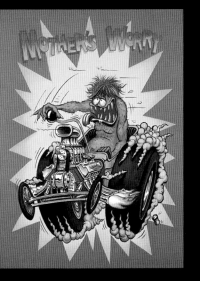
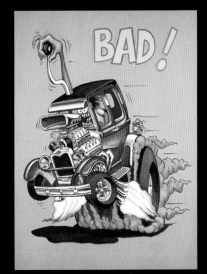
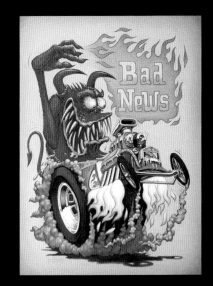
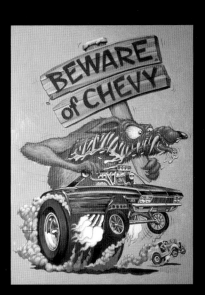

A collection of Ed "Big Daddy" Roth designs painted with oil on canvas by artist Jean Bastarache. These compositions were produced as a mini-poster series published by Roth and Mooneyes in 1996 and 1997. (courtesy of David Chodosh)

Rat Fink vs. The History of Art

BY GREG ESCALANTE

Above: Pinky Meets Finky! (Tribute to Sir Thomas Lawrence), 1992. This was the first known improved painting done by Big Daddy and spawned the idea for this History of Art painting series. The underlying composition was painted by an unknown Salt Lake City Old Master Reproducer with the Rat Fink added by Ed "Big Daddy" Roth. (collection of Brooke Levasseur)

Right: Artist Jean Bastarache in his studio (c. 1996). (photo by D. Nason)

Background: Artist, 1993. Close up of the pencil sketch remarque by Ed "Big Daddy" Roth on a Mother's Worry serigraph. (collection of Coby Gwertz)

The first "finked" master painting made its formal debut at the 1993 Kustom Kulture Show at the Laguna Art Museum. Of all the works of art submitted to the curators, Roth's *Pinky Meets Finky* was the most peculiar. Refined, deliberate, at once sly and crass, and having nothing to do with the car or hot rod culture the exhibition was showcasing, the work seemed to show Roth moving in a new direction. Roth had taken the well-known painting by Sir Thomas Lawrence, popularly known as *Pinky*, and in its reworking his *Pinky* appeared to have been violated by a nervous Rat Fink at her side. This painting immediately appealed to me, and I later got Roth to discuss his latest masterpiece as we stood before it at the museum.

He told me that to him, this piece was dealing with the age-old question of what is, and what is not, Art. Struggling with the concept, he had formulated an experiment to solve the puzzle. He hired a local Old Master reproducer to paint the copy of *Pinky*, and then Big Daddy himself went at it with his own Rat Fink, right on the same canvas. When he was done "improving" the old painting, Ed carted his new work off to a series of car shows, where he proudly displayed it on an easel with a sign reading: "Pinky meets Finky! Which is the better work of art?" Below it, he placed a ballot box. When he counted the votes, he claimed over 90 percent came in favor of Finky being the better work of art.

Later that year, I met with Ed to discuss his ideas for an art exhibition Copro/Nason was curating. Called "The Ultimate Underground Anti-Superhero Showdown" and held at the Julie Rico Gallery, it featured Stanley Mouse, Robert Williams and Roth. He told me that his fans would be more likely to collect all the hot rod monster work that he could paint, and he would be willing to do that. On the other hand, he asked if we would be open to him further exploring his Rat Fink vs. The History of Art series. This is exactly what we wanted — something different! We were more interested in seeing what new compositions he would concoct out of this "History of Art" premise than in seeing him rehash past work. We encouraged Roth to complete a series of works based on historically significant master paintings. Eight more Rat Fink-embellished paintings were completed and ended up anchoring this "Anti-Superhero" show. Needless to say, these paintings were a complete sell-out.

Above: Can't Wait, 1993. Pen sketch by Ed "Big Daddy" Roth contained on correspondence sent in anticipation of the "The Ultimate Underground Anti-Superhero Showdown" exhibition at the Julie Rico Gallery. This epic show, held in December of 1993 and curated by Copro/Nason, featured these depicted Rat Fink vs. the History of Art Series paintings along with works by Stanley Mouse and Robert Williams. (collection of Tom "Top Cat" Cook)

Left: Rat Fink Meets Mona Lisa (Tribute to Leonardo da Vinci), 1993. Rat Fink's improvement to the world's most famous portrait takes the ambiguity out of Mia Dona Lisa's smile. The underlying composition was painted by artist Jean Bastarache with the Rat Fink added by Ed "Big Daddy" Roth. (courtesy of Copro/Nason)

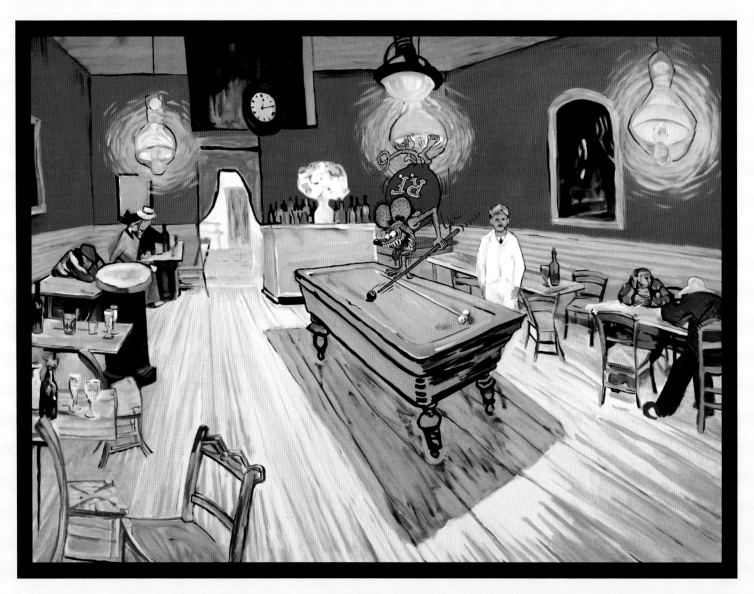

Rat Fink and the Night Café (*Tribute to Vincent Van Gogh*), 1993. Coincidentally, Van Gogh chose the contrasting colors of Rat Fink—green, red and yellow—to execute this composition that he describes as the emotional expression of the "...terrible passions of humanity." Artist Jean Bastarache painted the underlying composition with the Rat Fink added by Ed "Big Daddy" Roth. (courtesy of Copro/Nason)

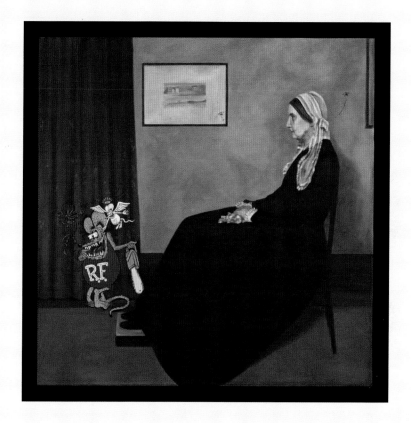

Above: Portrait of the Rat Fink Artist's Mother *(Tribute to James Abbott McNeill Whistler), 1993. The underlying composition was painted by artist Jean Bastarache with the Rat Fink added by Ed "Big Daddy" Roth. (courtesy of Copro/Nason)*

Left: Rat Fink and Nude Descending a Staircase *(Tribute to Marcel Duchamp), 1993. Rat Fink transcending cubism and futurism so as to protect the virtue of the nude figure. The underlying composition was painted by artist Jean Bastarache with the Rat Fink added by Ed "Big Daddy" Roth. (courtesy of Copro/Nason)*

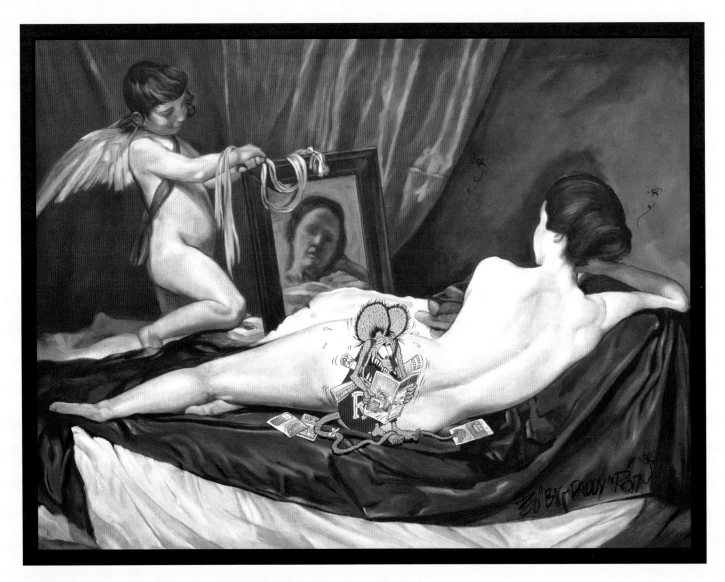

Venus, Rat Fink and Cupid (*Tribute to Diego Rodriguez De Silva Y Velázquez*), 1993. Artist Jean Bastarache painted the underlying composition with the Rat Fink added by Ed "Big Daddy" Roth. (collection of Dr. Arthur Katz)

Persistence of Rat Fink's Memory (Tribute to Salvador Dali), 1993. Rat Fink straightening out the time—no further explanation required!
Artist Jean Bastarache painted the underlying composition with the Rat Fink added by Ed "Big Daddy" Roth. (courtesy of Copro/Nason)

The Eyes Have It (Tribute to Joan Miró), 1993. The underlying composition was painted by artist Jean Bastarache with the Rat Fink, replete with flies, added by Ed "Big Daddy" Roth. (collection of Eric Herrmann)

Composition with Rat Fink Green, Red, Yellow and Blue, No.1 (Tribute to Piet Mondrian), 1993. This composition is extremely ironic in that the squared off Mondrian De Stijl, which is derivative of cubism, is completely contradictory to the curvilinear streamline modern or baroque abstract style attributed to Roth by journalist Tom Wolfe in his classic article for a 1963 issue of Esquire magazine called the Kandy-Kolored, Tangerine-Flake, Streamline Baby. This painting was so popular that Big Daddy did another one with a different Rat Fink image in 1995 (please see page 73). The underlying composition was painted by artist Phil Carlig with the Rat Fink added by Ed "Big Daddy" Roth. (courtesy of Copro/Nason)

Felt-Pen Illustration Series

BY DOUGLAS NASON

"I'm not an artist," Big Daddy would frequently insist, and this remark would invariably trigger my vehement disagreement. Once, in December 1995, we carried on this debate for days while he was a guest at my house. Arguing my side, I told him that he was, in fact, a great artist and that what his fans really wanted was original art he did entirely himself. To my delight, he agreed to do a series of original Rat Fink illustrations to show what kind of artist he really was.

Early the next morning, my then live-in girlfriend woke up in a snit and yelled at me for not having turned on the heat. (BDR didn't like heating or air conditioning.) After she left for work that day, Big Daddy picked up some Magic Marker felt tip pens and began making quick sketches on illustration board. Obviously, Roth had overheard my girlfriend's rant, because his first composition portrayed a comical lady wielding a whip and hollering at a cowardly looking Rat Fink. Roth

continued to bang out one or more illustrations every 20 minutes until we adjourned for lunch (BDR liked his three squares) at a mid-city McDonald's. There, I think he was taken by all the different ethnic groups dining together, because when we got back, he made a drawing of children of various races with a benevolent looking Rat Fink. The piece bore the slogan, "Happiness is a peacefull mixed neighborhood."

Over the course of the next few days, BDR completed 28 of these 14x11-inch felt-pen compositions. Sure, they are a little sloppy, simple and crude, but didn't Picasso say he spent his entire life learning how to paint like a child? Not one of Big Daddy's illustrations took longer than 15 minutes to make, and I'd say they are all pretty epic. The speed at which he was able to illustrate each idea, the inherent humor of each, and his ease at doing them so freely speaks of the artist that he was.

Top Right: Love Slave. *(collection of D. Nason)*

Middle: A Peacefull Mixed Neighborhood. *(collection of Tom "Top Cat" Cook)*

Bottom: Random. *(collection of Keisuke and Shinsuke Sawa)*

Opposite Page: Love Rat *(detail). (courtesy of Copro/Nason)*

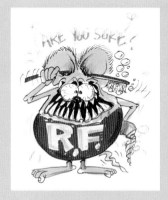
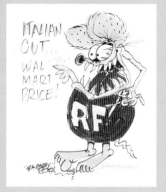
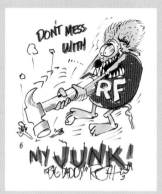

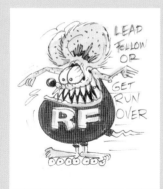

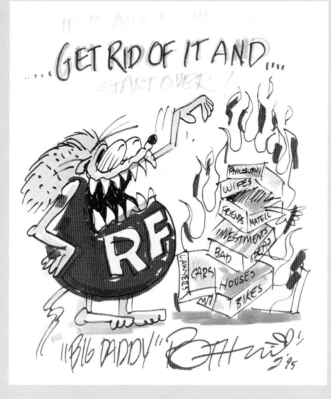

This Page, from left to right:
Top Row:
Lead Follow or Get Run Over. *Big Daddy was always a leader and he moved so fast, you could figuratively and literally get run over.*
Start Over! *Roth always preached that mistakes were all right, that you learn from them, then start over. (collection of Gil Wright)*
Middle Row:
Toon-In or Cut Out. *This one is for our friend Martin McIntosh from Outré Gallery (formerly Toon-In) in Australia.*
Bottom Row:
Send Flowers!
Don't Ask!! *This composition was obviously done before Roth met Ilene—his true love.*
Ride Hard. *This was made for our friend Shawn Attema, a major Roth collector.*

Oposite Page, from left to right:
Top Row:
Bad Hair Days!!!! *The three pinstriped designs at the top of this illustration are some of the best tiki renderings around. This was done for our friends Keisuke and Shinsuke Sawa at Random, a Japanese clothing company.*
Comfy is a Cup O' Hot Cocoa. *This was done for our friend Dan Stiel, who loves drag-boat racing.*
Let's Rumble Yes!!!
I Grind It, I Sign It!! *Big Daddy, the supreme car-show merchandiser, would spend hours and hours signing his creations at these events. He relayed a great story that once after signing autographs all day at a car show, he had to go to the bank to sign some important papers and because he was so used to signing with the Big Daddy between his first and last name, he accidentally signed the documents with the Big Daddy adage.*
Middle Row:
Exercise. *Big Daddy had a home gym and said it was important to keep in shape so he'd have the muscles he needed to build his custom car creations.*
Just Once! All the Sushi I can Eat! *Big Daddy loved sushi and told me that when his friends Shige and Chico with Mooneyes would take him out to eat in Japan, he would consume hundreds of dollars worth of the raw stuff!*
Weld it, Grind it!!! Chrome it! *(collection of Junior Sammet)*
Bottom Row:
You're Just Like Yer Father! *(Big Daddy wasn't known for his spelling.)*
Factory Gold. *This was done for our friend Ramir Milay, who has a gold-plating business.*
Are You Sure? *Big Daddy always complained about brushing his teeth!*
Tokyo Do! *This was drawn for our friends Kunio Ito and Arisa Kurata with Tokyo Do, a Japanese clothing company.*
Don't Mess with My Junk!
(All images courtesy of Copro/Nason unless otherwise noted.)

Rothabilia: Toys & Merchandising

BY DAVID CHODOSH

Above: Self portrait pinstripe glass by House Industries (1998). (photo by Carlos Alejandro; courtesy of House Industries)

Background: Concept sketch for ball (c. mid-1980s). (collection of George Goodrich)

Right: Die-cast Mysterion by Johnny Lightning (1997) and Beatnik Bandit by Hot Wheels (2001). (photo by/collection of Aaron Kahan)

Opposite Page Top: Bandanna issued by Mooneyes (1989). (photo by D. Nason; collection of George Goodrich)

Opposite Page Bottom: Rubber poseable toy manufactured by Jonzo (2001). (photo by Aaron Kahan; courtesy of David Chodosh)

Opposite Page Far Right: King of Hemi's figurine by Danbury Mint (2002). (photo by D. Nason; courtesy of David Chodosh)

How could one man's imagination dream up such beautiful cars and such hideous monsters? I found out that Roth was alive and well in Manti, so I got his number and called. He answered the phone while eating dinner. I told him that Rat Fink was a hero of mine as a kid, though I wasn't sure why, and I wanted to make him into a new toy. Ed really wanted to sell Finky to kids, not just to the hot rod collectors at swap meets, so he let me keep talking. Here's a guy who never repeated himself or anyone else, so I knew this would be a challenge.

I called back relentlessly, faxing sketches and proposing new concepts, which he would improve by penciling in some whacked-out Rothian twist. "Why don't ya work up somethin' like this, and show it ta me when yer ready," he challenged. A few weeks later at the Route 66 Rendezvous, I brought him a prototype of the first ever Rat Fink Plush. It was beautifully hideous, with all the trademark warts and bad teeth that defined Finky. It came complete with the bulging bloodshot eyes, the sagging posture, the pockmarked complexion; and Roth fell in love the second he laid eyes on it. "Maybe yer all right," he admitted and showed it to a crowd of fans waiting for his autograph. "Look at this, a doll even I can cuddle up with." We added a hidden feature to make this toy

even more repulsive — a bad breath odor activated when you scratch Rat Fink's tongue. BDR suggested a pizza scent, since that was Rat Fink's favorite food.

Roth was the ultimate independent producer who veered further and further away from the potholes he believed big business dug in his road, and he stayed the course to free expression. He and I created several toys and other items after that, including action figures and key chains. Each design needed to be different from the status quo. Like a big kid, he was uninhibited and never needed validation. If he felt like something was working

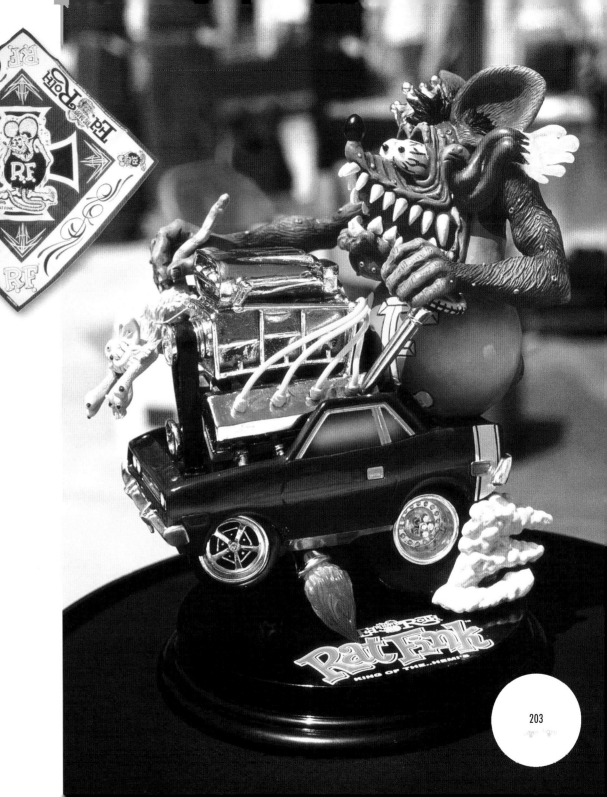

for him, he'd realize that
eventually others would
get it too, even if it wasn't until years later.

When I met him, Big Daddy was a 65-year-
old weirdo who'd, fortunately, never grown up.
I admired that about him. He was the only guy ever
to be pictured as himself on an entire line of toy boxes —
Revell model kits. He worked constantly and loved what
he did, often calling me at 6 a.m. to brainstorm something
new. He was the most daring designer I ever knew.
And although he often looked tired, his mind never slept.

Clockwise From Top Left: Motorcycle helmet by Troy Lee Designs (prototype design from 2002). (photo by Troy Lee Designs; courtesy of David Chodosh) Action figure by Jonzo Inc. (1999). (photo by Ren Messer; courtesy of David Chodosh) Masks of Rat Fink, Drag Lover and Wild Child by Don Post Studios (2002). (photo by/collection of David Chodosh) Dinky and Stinky Rat Fink Plush! dolls by Jonzo Inc. (1997) Dinky, the larger of the two dolls, comes with a scratch-and-sniff card with bad breath that smells of day-old pizza. (photo by Ren Messer; courtesy of David Chodosh) Ed "Big Daddy" Roth Hot Wheels car set by Mattel (2001). This set includes Roth's Outlaw, Mysterion, Road Agent and his 1956 Ford F-100 truck. (photo by/collection of Aaron Kahan)

Opposite Page Clockwise From Top Left: Ed "Big Daddy" Roth Monster T-shirt package boxes (1997). (photo by Carlos Alejandro; courtesy of House Industries) Rat Fink belt buckle by Mooneyes (early-1990s). (photo by D. Nason; courtesy of Ed "Big Daddy" Roth Inc.) Rat Fink watch and keychain by Fossil (2002). The storage box art was based on a computer design of Roth's and pinstriped by artist Greg "Coop" Cooper with bronze figurine sculpted by Larry "Speedo" Henley. (photo by D. Nason; courtesy of Ed "Big Daddy" Roth Inc.) Rat Fink Pen by ACME Studios (prototype rollerball or fountain pen design from 2002). (courtesy of Adrian Olabuenaga with ACME Studios) Wacky Wobbler by Funko (1997). (photo by Ren Messer; courtesy of David Chodosh)

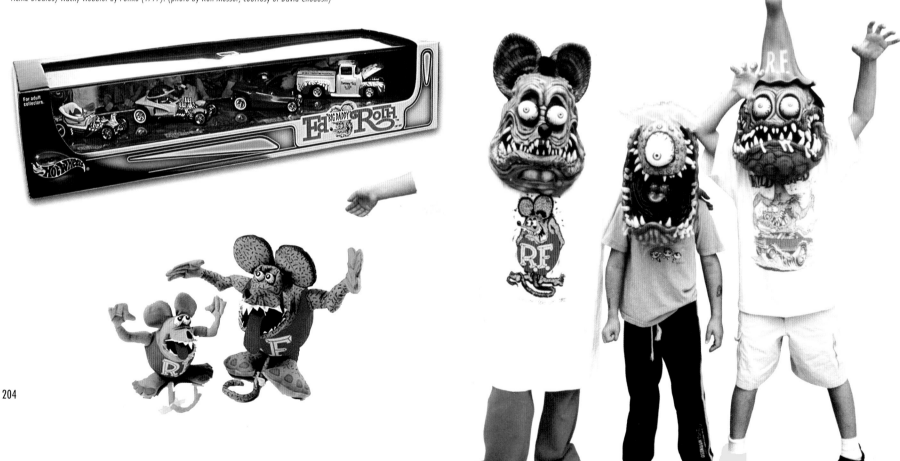

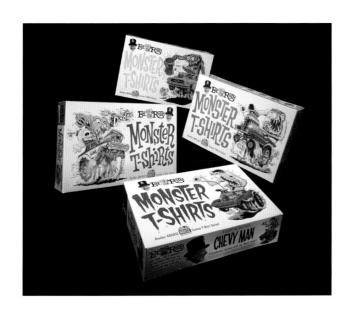

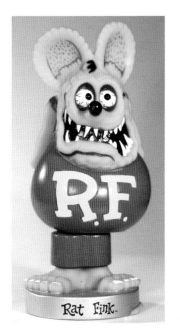

Afterword: Is It Really "Art"?

BY ROBERT WILLIAMS

Above: Ed "Big Daddy" Roth and Robert Williams at the Rat Fink Picnic and Rod Run held in 1991, Costa Mesa, California. (photo by Fred O'Connor)

Opposite Page: Devil with a Hammer and Hell with a Torch (1975) by Robert Williams. This incredibly detailed acrylic on illustration board composition was originally done for a center spread of Hot Rod magazine and pays tribute to two of the most famous custom car builders of all time – George Barris and Ed "Big Daddy" Roth. A contemporary of Roth's, Barris has had a prolific and widely varied car customizing career, building everything from '49 Mercs to the wild and wacky vehicles used in several popular '60s television shows, including the Batmobile, the Munster Koach, the Monkeemobile and the Beverly Hillbillies car. Barris recently said that Roth was a "...fantastic talent and produced phenomenal artistic creations. Perhaps more than anyone in our automotive industry, I knew how he thoroughly enjoyed his ability to design and build cars just for himself. But in doing that, Ed Roth created custom cars that appealed to thousands of fans world-wide."

In that cold grave at the foot of the hill in Manti, Utah, was buried more than a hot rod showman. Ed Roth left us something greater than an adolescent legacy – but to what true artistic extent is debatable.

To fully understand Ed "Big Daddy" Roth's notoriety you would have to view Roth's world in its earlier context.

Edward Roth was a born artist. He had impressive dexterity, an adventurous sense of color, and an investigative imagination. What he didn't have was a damn bit of interest in fine art. But that wasn't unusual, because most artists of the Fifties, Sixties or Seventies who could draw or paint with any facile skill didn't have a place in the formal arts. This was during a period of great reverence for non-objective abstraction. Roth was first of all a hot rodder, and secondly a highly accomplished sign painter. He also did window dressing for Sears department stores.

I say with certain trepidation that Roth told me he did window displays at Sears Roebuck & Co. This means that there is a good chance Ed worked for Sears. Big Daddy was not a liar; in fact he was chronically honest to a fault. But he did have a predilection to embellish a story to the point that it poetically synthesized itself into an Arthurian saga. In short, Roth never told the same story twice.

It is significant to realize Roth's creative direction had already been cast in the early Fifties (about six years before starting his own business) by a frantic little savant in the hot rod world named Von Dutch. Ed was totally mesmerized (as I was myself) by the wild creative output of Von Dutch, the mad pinstriper. Ed quickly followed suit, developing an insane Salvador Dalian persona for himself. For Roth, "crazy" was a well rehearsed affectation. For Von Dutch mental illness was reality.

During the mid-Sixties I was the Roth Studios art director, and I spent five years in rather close proximity to Ed. I knew his thought processes very well. We shared many of the same art influences: E.C. comics, B movies, girly magazines, etc.

A number of his influences could be recognized in this primary cartoon character, "Rat Fink." The name preceded Ed's usage by a few years. It was a West Coast colloquialism that found its way on the Steve Allen TV show in the early Sixties, but Steve Allen never did much with the derogatory catch phrase.

Roth, on the other hand, lit on it, and gave Rat Fink a detestable cartoon self. The influence of Basil Wolverton shows up in the bulging eyeballs. The no-neck and legless torso is taken from cartoon characters from the Fifties called "Nebbishes." The feature that stands out the most dominantly was Rat Fink's attitude and demeanor. The character was always encircled in a halo of flies and a raying aura of sweat droplets. This was augmented with a skin texture of warts, cysts and hairs, plus a mouth complete with alligator dentition and drool. And at his

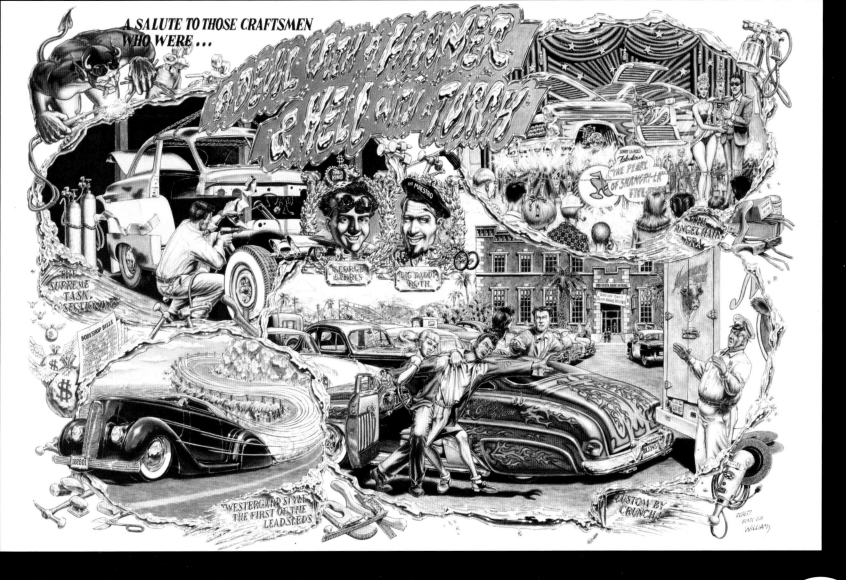

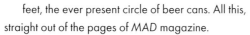

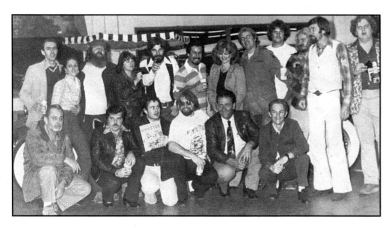

feet, the ever present circle of beer cans. All this, straight out of the pages of *MAD* magazine.

When I started working for Ed, I faced a rather startling dichotomy. I had always harbored the belief that Roth Studios catered specifically to young, street-wise hot rodders like I myself rubbed shoulders with as a high school student. The fact was, Roth's clientele was about 13 on the average, and Ed knew what they wanted. This meant making a science out of dumbing down.

As ridiculous as some of the products were, this by no means meant stupidity reigned supreme.

Ed Roth hired the best. Ed Newton, who did most of the auto concepts and the majority of the T-shirt designs, was one of the premier automotive designers to come out of Art Center School. The artists who worked for Roth had to be good, and they had to have fresh imaginations. The car fabricators were the absolute best. Jim Jacobs and Dan Woods have gone on to gain international reputations that rival Ed's.

Roth required a circle of cohorts that I can only describe as amazing: artists, musicians, bikers, hardened criminals, revolutionaries of both the right and left, and a continual stream of beautiful women.

I remember very clearly, in 1966, when Ed Kienholz debuted the scandalous "Backseat Dodge" art piece at the L.A. County Art Museum, and the response of the artists and writers at Roth Studios. Most of the Roth artists saw this cut-up '37 Dodge as the work of a charlatan with

a very skillful aptitude for public relations. Kienholz gained national recognition overnight, and he did it with slapdash Dadaist style.

Early on, I understood, as did Tom Wolfe, that the Ed Roth phenomenon was a legitimate cultural development and, in turn, the art of our time. Roth would never accept it.

Roth was aware of the psychedelic poster artists — Stanley Mouse was an old friend of his. He knew the Zap Comix underground artists. He befriended Robert Crumb and Gilbert Shelton. He always fully understood how all these West Coast art subcultures were interrelated, but he would not relent in his belief that none of this could be fine art.

Once a year at the Roth Studios, the last day before the Christmas holidays, a large congregation of artists, hot rodders and bikers, and whoever, would spontaneously gather for a drunken Xmas bash. Roth did not sanction this or condone it, we all just drew together. Little would we know that years later these ribald holiday parties would save Ed Roth for posterity.

Between 1970 and 1980, Ed was experiencing the lowest ebb of his life. The IRS hounded him like he was Al Capone. The FBI tried everything to involve him on racketeering charges because of his involvement with the Hells Angels. All the automotive magazines and his hot rod following had long abandoned him. His wife finally dissolved their marriage, and he lost Roth Studios. He was a broken man. During this period, the only real peace and solace he could find was in the Mormon Church.

In 1977, my wife, Suzanne (who also at one time worked for Roth), Skip Barrett (one of Ed's old henchmen) and I decided to revive the old Roth Studios Xmas parties. We talked to Jim Brucker, who owned the Movie World Museum (where he employed Ed Roth as goodwill

ambassador), to let us use the museum as a location for the holiday blast. We contacted as many of the old Roth employees as possible, and invited Roth to come himself. The born-again Ed Roth didn't like the idea and declined. But as the party got going, Ed and his third wife, Bev, showed up at the door. To come up with a name for the event, I christened it the "Rat Fink Reunion." It was a total success. Most of the old group was there, including Von Dutch himself.

The next year the revival was much bigger and open to everybody, and now Ed saw virtue in it. By the third party Ed took charge, and by the fourth Ed had turned it into a major pinstriping conference. As the years went by these parties became progressively larger events moving to new locations in Southern California, eventually spawning auxiliary events finding locations in other states.

When Ed held his last Rat Fink Reunion in 2000, at Mooneyes Equipment Co., it was so large and out of hand that the Santa Fe Springs police had to be called in to control the hot rodders who had run amok. Ed was back on top again, and even more famous than before.

But what of the art? Ed was a good German and brought up to respect authority. If the art constabulary decreed hot rod art as not meeting the criteria for fine art, then that was good enough for Ed Roth. Well, I guess it ain't fine art!

Whatever it is, it's certainly good enough to inspire a new generation.

Right: Who Said Paper Dolls Are For Punks? Ed "Big Daddy" Roth advertisement from June 1966 by Roth Studios Art Director Robert Williams. (collection of Aaron Kahan)

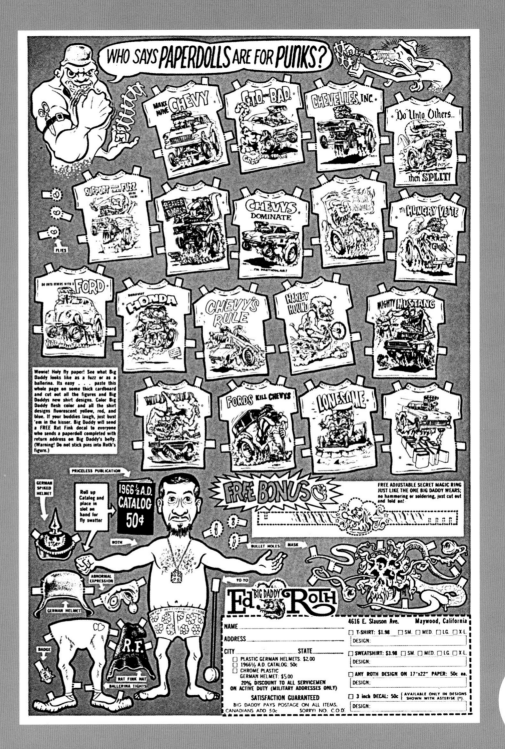

Selected Bibliography

Above: An unnamed and rough concept sketch by Ed "Big Daddy" Roth of a skateboarding image design faxed to artist Ken "Mitch" Mitchroney for final clean up and inking. This image was created by Roth in 2001 and was one of his last T-shirt designs. Roth loved Mitchroney's line work and used him for the final inkings of several of his last designs. (collection of Ken "Mitch" Mitchroney)

Opposite page: Finished line art for Roth's unnamed skateboard image by Ken "Mitch" Mitchroney from 2001. (collection of Ken "Mitch" Mitchroney)

Barlog, Kimberly; *Big Daddy Roth: A Leader of Mice and Men.* Screenplay (October 1994).

Barris, George and Fetherston, David A.; *Barris TV and Movie Cars.* Motorbooks International, Osceola, WI (1996).

Barris, George and Scagnetti, Jack; *Famous Custom & Show Cars.* E.P. Dutton & Co., Inc., New York, NY (1973).

Bottles, Scott, L.; *Los Angeles and the Automobile: The Making of a Modern City.* University of California Press, Los Angeles (1987).

Boyle, Robert H.; "The Car Cult from Rumpsville." *Sports Illustrated* (April 24, 1961).

Bride, Joseph; "Ed Roth Hops Up the Hot Rods Drag Racers' Big Daddy." *Life* Magazine, Chicago, IL (October 16, 1964).

Burt, Rob; *Surf City, Drag City.* Blandford Press/Sterling Publishing Co., New York, NY (1986).

Cleary, Bill; "The Sign of the Kook." *Surfer*, Vol. 7, No. 4, John Severson Publications Inc., Dana Point, CA (September 1966).

Coleman, Lynn; Robert Williams (interview). *Thrasher*, Vol. 8, No. 8; High Speed Productions, San Francisco, CA (August 1988).

DeWitt, John; *Cool Cars, High Art, The Rise of Kustom Kulture.* University of Mississippi, Jackson, MS (2001).

Donnelly, Nora (Editor); *Customized: Art Inspired by Hot Rod, Low Rider and American Car Culture.* Harry N. Abrams, Inc., Publishing (in association with the Institute for Contemporary Art, Boston, MA), New York, NY (2000).

Felsen, Henry Gregor; *Here is Your Hobby... Car Customizing.* G. P. Putnam's Sons, Inc., New York, NY (1965).

Fetherston, David A.; *Moon Equipped, Sixty Years of Hot Rod Photo Memories.* Fetherston Publishing, Sebastopol, CA (1995).

Flinchpaugh, Jennifer; "20 Ft. Tall and Breathing Fire: How Ed 'Big Daddy' Roth Inspired a Generation"; "Good Bye, Big Daddy"; "In Memory of Ed 'Big Daddy' Roth." *Signs of the Times*; ST Publishing Inc., Cincinnati, OH (June 2001).

Fortier, Rob; "Rat Fink Lives!" Access, San Diego, CA (1993).

Franco, Von; "I was a Teenage Monster Shirt Painter." Editors of Weirdosville, Burbank, CA (2000).

Fried, Liz; *Schwinn Sting-Ray.* Motorbooks International, Osceola, WI (1997).

Ganahl, Pat; *Ed "Big Daddy" Roth, His Life, Times, Cars, and Art.* CarTech, Inc., North Branch, MN (2003).

Ganahl, Pat; "Roth." *Street Rodder* (June 1976).

Ganahl, Pat; *The American Custom Car.* MBI Publishing Co., St. Paul, MN (2001).

Garcia, Bob; "Big Daddy Zooms Into Perspective."
Los Angeles *Free Press* (March 10, 1967).

Hagerty, Neil Michael; "Go-Go-Go Von Dutch."
The Comics Journal (October 2001).

Hegge, Robert; "Beautiful Beatnik." *Rodding and Re-Styling*, (January 1962).

Jessee, Terry; *Hot Rod Model Kits. MBI Publishing* Co., Osceola, WI (2000).

John, Long Gone; "Rat Fink: The Unofficial Biography."
Juxtapoz, No. 34, High Speed Productions, San Francisco, CA (September/October 2001).

Kahan, Aaron; "Ed 'Big Daddy' Roth In His Own Words."
Hot Rod Deluxe, No. 2, emap USA/Petersen Publishing, Los Angeles, CA (2000).

Kerr, Leah M.; *Driving Me Wild, Nitro-Powered Outlaw Culture*. Juno Books, New York, NY (2000).

Kohler, Carl; "The Gripes of Roth, A Monsters Tale of Like Terror, Etc." *CARtoons*, Petersen Publishing Co., Los Angeles, CA (November 1963).

Krafft, Charles; "Ed 'Big Daddy' Roth Confessions of a Rat Fink." *The Rocket*, Seattle, WA (March 30 - April 13, 1994).

Kumferman, Larry; "Ed Roth 'Big Daddy' of Trikes."
Custom Chopper (July 1974).

McKenna, Kristine; "Revvin' Up The Rat Fink."
Los Angeles Times (December 20, 1993).

Morton, John O.; *The 'Real' Oakland, Volume One; It Ain't Gonna Work, Volume Two* (combined in two volumes). St. John Design Studio, Aptos, CA (2000).

Petersen, Robert and the Editors of *Hot Rod; The Best of Hot Rod*. Special Collectors Edition (1986).

Perdomo, Lou and Waugh, Dave; "The Last Showdown: Ed 'Big Daddy' Roth." *International Tattoo Art*, Butterfly Publications, Ltd., New York, NY (November 2001).

Polizzi, Rick; *Classic Plastic Model Kits Identification & Value Guide*. Collectors Books, Paducah, KT (1996)

Pouncey, Edwin; "Born Dead: The Dark Side of Ed Roth's Weirdo Factory." *Bizarre*, Issue 56, London, UK (March 2002).

Ressner, Jeffrey; "The Far-Out World of Ed 'Big Daddy' Roth." *Airbrush Action* (September - October 1987).

Roth, Ed "Big Daddy"; *Pinstriping by Roth*. Roth booklets (1981).

Roth, Ed "Big Daddy" and Thacker, Tony; *Hot Rods by Ed "Big Daddy" Roth*. Motorbooks International, Osceola, WI (1995).

Roth, Ed "Big Daddy"; *How to Paint Signs and Build Crazy Cars*. Roth booklets (c. 1980s).

Roth, Ed "Big Daddy" with Kusten, Howie "Pyro"; *Confessions of a Rat Fink, The Life and Times of Ed "Big Daddy" Roth*. Pharos Books, New York, NY (1992).

Roth, Ed "Big Daddy"; *Whatever Happened to the Beatnik Bandit?* Roth booklets (1984).

Schorr, Todd; "Finks R Us, A Fond Recollection and Brief History of the Plastic Fink Models of the 1960's." *The Art of Kitsch, L.A.X. (Language Art Expression)*, Vol. 1, No. 2, L.A.X. Axis, Glendale, CA (1990).

Smythe, John; "The History of the World and Other Short Subjects, or From Jan and Dean to Joe Jackson Unabridged." *Skateboarder* (May 1980).

Southard, Andy Jr.; *Hot Rods of the 1950s.* Motorbooks International, Osceola, WI (1995).

Staniford, Mike; "The World of 'Big Daddy' Ed Roth, Interview with a Rat Fink." *Baby Boomer Collectables*, Vol. 2, No. 10, Antique Trader Publishing, Dubuque, IA (July 1995).

Stecyk III, C.R.; "Ed Roth: Confessions of the High Priest." *Juxtapoz*, No. 1 (Premiere Issue), High Speed Productions, San Francisco, CA (Winter 1994).

Stecyk III, C.R. and Colburn, Bolton; "Kustom Kulture, Von Dutch, Ed 'Big Daddy' Roth, Robert Williams and Others." Last Gasp of San Francisco, San Francisco, CA (1993).

Stecyk III, C.R. et al; "Remembering Roth, 'Big Daddy' Roth, En Memoria Morte." *Juxtapoz*, No. 34, High Speed Productions, San Francisco, CA (September/October 2001)

Stecyk III, C.R.; "Surf Nazis and Other Objectionable Material." *Surfers Journal*, Vol. 2, No. 10, San Clemente, CA (Winter 1992).

Vance, Mike and Deacon, Diane; *Think Out of the Box.* Career Press/New Page Books, Franklin Lakes, NJ (1997).

Walker, Sloan and Vasey, Andrew; *The Only Other Crazy Car Book.* Walker Publishing Co., Inc., New York, NY (1984).

White, Timothy; *The Nearest Faraway Place.* Henry Holt and Company, Inc., New York, NY (1994).

Williams, Robert; *Hysteria in Remission, The Comix & Drawings of Rbt. Williams* (Introduction by Gilbert Shelton). Fantagraphics Books, Seattle, WA (2002).

Williams, Robert; *Malicious Resplendence, The Paintings of Rbt. Williams* (Introduction by Walter Hopps; Text by C.R. Stecyk). Fantagraphics Books, Seattle, WA (1997).

Williams, Suzanne; "Big Daddy's Gone, Rat Fink Lives On." *Juxtapoz*, No. 33, High Speed Productions, San Francisco, CA (July/August 2001).

Wolfe, Tom; *The Kandy-Kolored Tangerine-Flake Streamline Baby.* Farrar, Straus and Giroux, New York, NY (1963).

Zone, Ray; "The Chrome Kid Robert Williams and An Interview with Ed 'Big Daddy' Roth. *Fanfare*, No. 5 (Summer 1983).

Background: Dipstick finished line art by Ken "Mitch" Mitchroney from 2001. This image was created by Roth in 2001 and was one his last T-shirt designs. (collection of Ken "Mitch" Mitchroney)

Opposite Page: Dipstick and Atomic Fink rough sketches by Ed "Big Daddy" Roth in 2001, which were faxed to artist Ken "Mitch" Mitchroney for final clean up and inking. Atomic Fink's name, which originally started out as A.P. for Atomic Punk, was later changed to Main Rat. This design became the last Rat Fink T-shirt issued by Roth while he was still alive. (collection of Ken "Mitch" Mitchroney)

Opposite Page Top Right: Artist Ken "Mitch" Mitchroney proudly displaying the Main Rat T-shirt at the 2002 Mooneyes Xmas Party in Whittier, California. (photo by D. Nason)

HELP

OK MITCH
BABY...
TRY THIS!
ED

"The fax machine spewed out Ed's new bug-eyed ugly Rat Fink design – the 'Atomic Fink.' 'The new Fink for the new millennium, Ken.' I drew, we played fax tennis. Next thing I know, it's become the 'Main Rat,' and it's competing with the one-shot on Ed's belly at the next Mooneyes party. I'm glad to have been midwife to the new Fink, because it was the last piece of art Ed and I did together before he died."

– Ken "Mitch" Mitchroney

Biographies

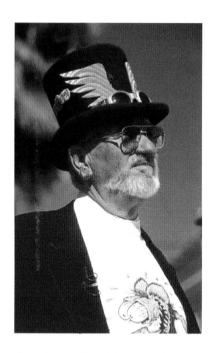

Above: Ed "Big Daddy" Roth donning a top hat and his Main Rat T-shirt at what would be the last Rat Fink Reunion he would attend, at Mooneyes in Santa Fe Springs in December, 2000.
(photo by Marc Gewertz)

Opposite Page Top: Ed "Big Daddy" Roth cooling off in the sweltering heat at Moldy Marvin's 1st Annual Rat Fink Party, Kustom Kulture Extravaganza, held in June, 2000 in North Hollywood, California.
(photo by D. Nason)

Opposite Page Bottom: Rat Fink... The Original is a single-color hand-pulled serigraph signed and numbered by Ed "Big Daddy" Roth. Published in 1994 by Copro/Nason, this Rat Fink was from Roth's original unaltered image from 1963. Shown here is a monoprint airbrushed by Von Franco.
(courtesy of Copro/Nason)

DOUGLAS NASON spent much of his preadolescent, baby-boomer, 1960s youth the way a lot of us did – building Ed "Big Daddy" Roth model kits and collecting Rat Fink decals. Little did he know back then that just a couple of decades later (after earning a Bachelor degree in Cultural Anthropology and establishing Copro/Nason Fine Art), he would have the good fortune to collaborate with Roth on some art projects. Realizing what an influence Roth was, not only on himself but on popular culture in general, Nason advised Roth that a book on his art was in order. Nason began gathering quality photos of Roth's creations, and *Rat Fink: The Art of Ed "Big Daddy" Roth* is the culmination of that effort.

Nason is the author of *Night of the Tiki: The Art of Shag, Schmaltz and Selected Primitive Oceanic Carvings*, and is the co-author of an upcoming book, *The Art Of Von Dutch: An American Original*. His writing and photography have appeared in magazines such as *Islands, Juxtapoz, Barracuda, Los Angeles, LA WEEKLY, World Explorer, International Tattoo Art* and *H2O*. His photography was featured in Chris Pfouts' book *Hula Dancers and Tiki Gods* and he has exhibited at La Luz de Jesus Gallery and the J. Moore Gallery.

GREG ESCALANTE is the founding curator of *Juxtapoz* magazine and Board President of Santa Ana's *Grand Central Art Center*. Escalante has supported underdog art for more than a decade, having been instrumental in organizing the *Kustom Kulture* exhibition at the Laguna Art Museum and co-curating the first museum show featuring *Edgar Leeteg* (the father of black velvet painting). He also co-authored the definitive book on the subject. Most recently, he helped organize the hugely successful *Surf Culture: The Art History of Surfing* show at the Laguna Art Museum. In 1991, Escalante merged his fledgling art-publishing business with Douglas Nason, forming Copro/Nason Fine Art. This resulted in a successful partnership in which the pair curates and publishes an ever-increasing roster of newbrow art projects. When not curating and supporting the arts, Escalante can be found surfing A-frame peaks in Surfside, California.

ROB FORTIER, Editor of *Custom Rodder* magazine, is a fine connoisseur of all things Roth. His previous position as a photojournalist for *Street Rodder* magazine offered him the opportunity to establish a close relationship with Roth during the building of his last two projects, Beatnik Bandit II and Stealth. This allowed him to appreciate Big Daddy's "mystique" even more than from Roth's early influences on Fortier as a kid, reading worn-out *Choppers* magazines and various comix. Good or bad, Roth left an impression in Fortier that will never die!

DOUG HARVEY is an artist and writer living in Los Angeles. He is Art Critic for the *LA WEEKLY* and has previously written essays on Margaret Keane, Tiki Culture, and J. Edgar Hoover's knick-knack collection. His first exposure to Big Daddy Roth was during childhood, through uncredited images of Rat Fink circulating in the schoolyard. With the advent of his interest in underground comics, Harvey began to recognize the full extent of Roth's influence on American popular culture.

REN MESSER is a writer, photographer and filmmaker living in Los Angeles. Her work has appeared in *Night of The Tiki*, and in the upcoming book, *The Art Of Von Dutch: An American Original*, and *Super X Media*. She is a well-known producer of surf and skate films and recently produced a film festival in association with *Surf Culture: The Art History of Surfing* at the Laguna Art Museum. A surfer and skater, she hopes to continue to bring surf and skate culture to a wider audience, and explore projects that examine the importance and relevance of youth culture. Long live Rat Fink.

ED NEWTON grew up in San Jose, California, where his teen years read like a scene right out of the movie *American Graffiti*. After two years at UCLA and two at Art Center, he found that his newly formed airbrush shirt painting business was not only lucrative but great fun. At this point in time, Ed Roth convinced "Newt" to join forces so they could build some wild show cars together and create even more weird and wacky art on shirts and

decals. Roth allowed Newt to do freelance design work on the side for other custom car builders, toy companies, specialty automotive companies and magazine publications. After BDR closed Roth Studios in 1970, Newton moved to Ohio to become Roach Studios' Creative Director for the next 15 years. Over the last couple of decades, Ed has done a lot of corporate design work, in addition to offering his own line of Limited Edition Prints. He also licenses his custom car designs and illustration talents to companies like Testor's and Revell-Monogram, and his recent Hot Wheels Collectibles "Lowboyz" are still being produced by Mattel, Inc. Most recently, Ed's focus is on a web site, Motorburg, Inc., a venture that includes an E-commerce Automotive Magazine and Gallery.

CRAIG STECYK, master of surf and skate journalism, was most recently the guest curator for the *Surf Culture: The Art History of Surfing* exhibit at the Laguna Art Museum. He also co-wrote and appeared in the award-winning skateboarding film *Dogtown and Z-Boys*, and most of his early skate essays were reprinted in the just-released book *Dogtown: The Legend of the Z-Boys*. But surfing and skating aren't his only loves. He was co-curator of the historically significant *Kustom Kulture* art exhibit in 1993, and was a friend and confidant of Ed Roth's. He spent hours with Big Daddy in 1992 interviewing him on video, and so is well qualified to contribute on matters concerning Roth. Stecyk is an acclaimed artist and photographer, with work in collections ranging from the Smithsonian to the Spence Collection.

A national art treasure, **ROBERT WILLIAMS** is the only living artist among those headlining the 1993 *Kustom Kulture* exhibit at the Laguna Art Museum. Most recently he had his compendium of underground comics published, which should serve to catch up the X, Y and probably Z generations on what an outlaw artist hero he is. Flying against the abstract and minimal art movements of his time and doing so by sheer will-power, imagination and skill, he has carved a niche in the art world that has made him a guru and the undisputable father of a very influential low brow art movement. Don't believe it? Just pick up his eight-year-old (and running strong) art magazine, *Juxtapoz*. Robert Williams is the spiritual son and direct descendent of Ed "Big Daddy" Roth. Together their art temperaments synergized and fit like a glove, creating one of the great artistic relationships of all time. Working day-to-day as Roth's idea man and master draftsman, Robert Williams knows the Ed Roth story better than anyone.

TORNADO DESIGN is an award-winning graphic design studio located in the historic Helms Bakery in Culver City, California. Founded in 1992 by creative directors Al Quattrocchi and Jeff Smith, Tornado specializes in creating unique entertainment advertising, music packaging, and corporate communications. Other work includes books, corporate identities, and product packaging.

Rat Fink: The Art of Ed "Big Daddy" Roth has been a labor of love for the Tornado crew, particularly designer Aaron Kahan. We hope it serves as a glowing tribute to Big Daddy's contribution to the Southern California car and art culture. The Roth book marks Tornado's second collaboration with Douglas Nason, following *Night Of The Tiki: The Art of Shag, Schmaltz and Selected Primitive Oceanic Carvings*. The team is currently working on a book that grew out of the recent art exhibition they co-curated in Southern California, *Von Dutch: An American Original*. Cruise by the studio at www.tornadodesign.la

COPRO/NASON is a fine art publishing company and art galley located in Culver City, California. Since 1991, it has published fine art serigraphs and lithographs by important contemporary California artists, including Ed "Big Daddy" Roth, Robert Williams, Sandow Birk, Von Franco, Liz McGrath, Coop and Shag. Copro/Nason's published images are included in the Laguna Art Museum's permanent collection and have appeared in the catalog for the museum's landmark hot-rod inspired *Kustom Kulture* exhibition. Their images have also been seen in The Los Angeles Times, Washington Post and several other publications. Gallery co-owners Douglas Nason and Greg Escalante have curated several groundbreaking gallery and museum shows, including the *Ultimate Anti-Superhero Showdown* (1993), *Von Dutch Tribute* (1996), *Tiki Art* (1997, 1998 and 1999), *Calivera Kustom* (1997), *Kittin's 'n' Kad's* (1998), *Leeteg Tribute* (1999), *Metro Madness* (2000), *Night of the Tiki* (2001) and *Charles Krafft's Porcelain War Museum* (2002). Nason and Escalante have also served as art directors for several projects with advertising and clothing companies.

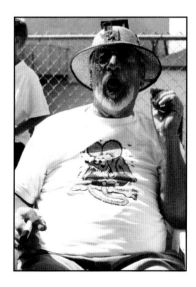

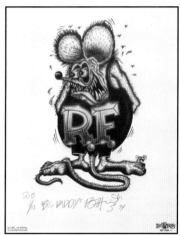

"Once a Rat, Always a Rat... Rat Finks Forever!"
— Ed "Big Daddy" Roth

Acknowledgements

First thanks goes to the contributing artists, writers, designers, collectors, photographers credited previously with special thanks to Ilene Roth, David Chodosh and Bert "The Shirt" Grimm for their licensing, encouragement and support. Big Daddy Roth was so incredibly dynamic and was always involved with a variety of projects with many people, it would be impossible to acknowledge everybody who directly or indirectly influenced this publication. Notwithstanding, we would also like to thank the following noteworthy individuals who have not yet been previously credited herein: Johnny Ace; Hamid Afrasiyabi; Josh and Glen Agle; Piet and Lisa Agle; Naomi Alper with 8-Ball; Kevin Ancell; Susan Anderson; Anthony Ausgang; Jim Balsam; Brett Barris; Jean Bastarache; Bird Betts; Sandow Birk; David Brown; Lee Butera; Phil Carlig; Art Chantry; Bolton Colburn; Greg "Coop" Cooper; Katie Costanza; Jeremy and Joshua Cushner; Jim Darling; Rudi F. Diamco, Second Lt. USAF; Robert "Bobby K" Dornan; Robert F. Eagleye; Temma Kramer; Kristin and Isabella Escalante; Aren Fanning; Michael Farr; Jeff and Naoko Fieldson; Scott Fletcher; Miori Foster; Jeff Fox with Barracuda; Ed Fuller; Keith and Helena Glass; Hunter Gratzner Industries; Gabe Griffin; Shauna Grimm; Janet Goodrich; Andrea Harris; Jesse James; Dare Jennings; Leslie Mark Kendall, Justin McCormick, David F. Myers and Michael Palumbo with Petersen Automotive Museum; Chico Kodama, Shige Suganuma and Gary Naito with Mooneyes; Sven A. Kirsten; Charlie Krafft; Arisa Kurata and Kunio Ito with Tokyo Do; Troy Lee Designs; Jerry Madrid with Madrid Skateboards; Mike and Sharon Marshall; Rebecca Marvel; Moldy Marvin; Mike McGee; Mark McGovern; Liz McGrath; Rob Menapace; Bob and Shirley Mitchell; Jim and Tina Mitchell; Garry Mizar; Beverly Morgan; Julie Nishikawa; Jamie O'Shea; Selena Osterman; Chris and Sherri Pfouts; Stuart and Judy Spence; Larry Reid; Andrew Reitsma; Marcia Renny; Ed Riggins; Dennis Roth; Howard "Reno" Roth; Mark Ryden; Julia Sassone; Holly Sherratt; Michael Shapiro; Mike Shea; Sherry Shelley; Billy Shire with La Luz de Jesus; R.K. Sloane; Kent and Stephanie Stanton; Otto von Stroheim; Annie Tucker; Ron and Colin Turner; Lila Wallich; Jeff Wasserman; Ruth Waytz; Diane and Brian Weissberg; Suzanne Williams; David Wilson with the Museum of Jurassic Technology; Lena Zwalve and Glen Bray. Special honorable posthumous love to Craig Myers the most generous and enthusiastic supporter of underdog art we have ever known.

Ed "Big Daddy" Roth's business card when he worked out of his house in La Mirada, California in the 1980s. (collection of George Goodrich)

Into The Valley of Finks and Weird-ohs is an acrylic on canvas masterpiece by Todd Schorr. (2003) (collection of Mark Parker)

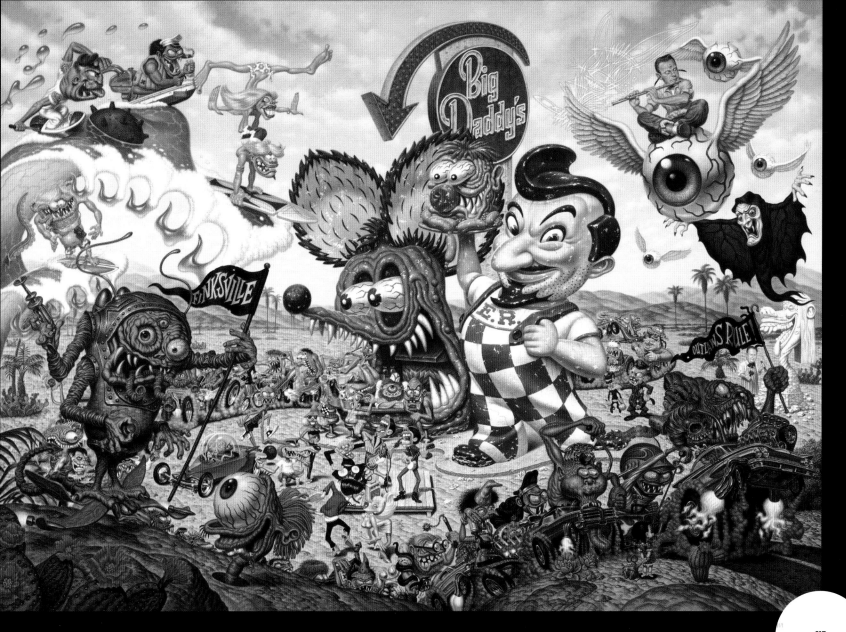

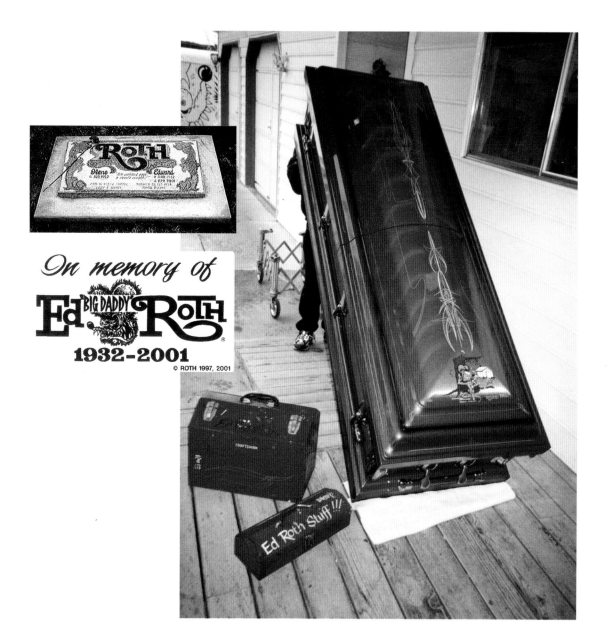

Above: Ed "Big Daddy" Roth sleeping in his car, c. early '60s. From the late '50s all the way up until his 2001 demise, Roth always preferred sleeping in or near his car when he was on the road. (photo collection of Verne Hammond)

Center: Ed "Big Daddy" Roth's coffin and his paint boxes before he was laid to rest in Manti, Utah. The coffin was striped by a few of Roth's pinstriping friends, including the likes of Greg "Coop" Cooper, Magu, Bobbo, Steve Kafka and Bob Spina. (photo collection of Dr. Arthur Katz)

Top Left: Ed Roth's gravestone in Manti City Cemetary, Manti, Utah. (photo collection of Dr. Arthur Katz)

Lower Left: In Memory of Ed "Big Daddy" Roth 1932-2001 sticker issued by Keith "Dice King" Pedersen. (collection of D. Nason)

Opposite Page: R.F.R.I.P. is an acrylic on illustration board image, done in 2001 as a memorial to Roth's passing, by House Industries artist Adam Cruz. (courtesy of House Industries)

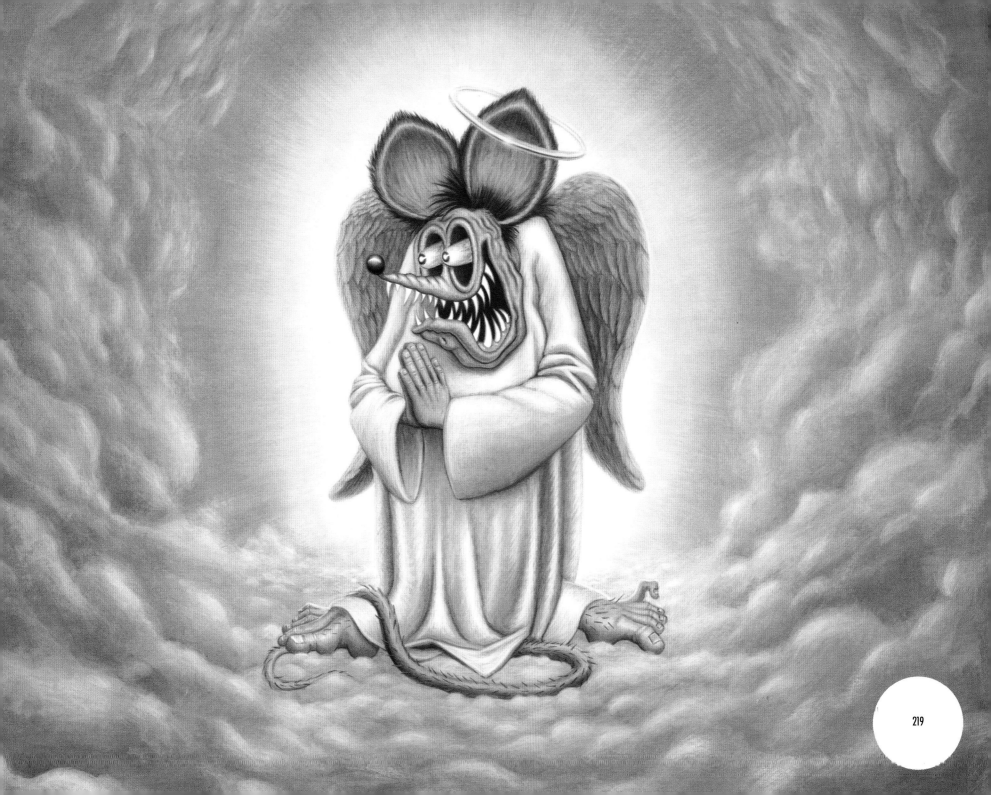

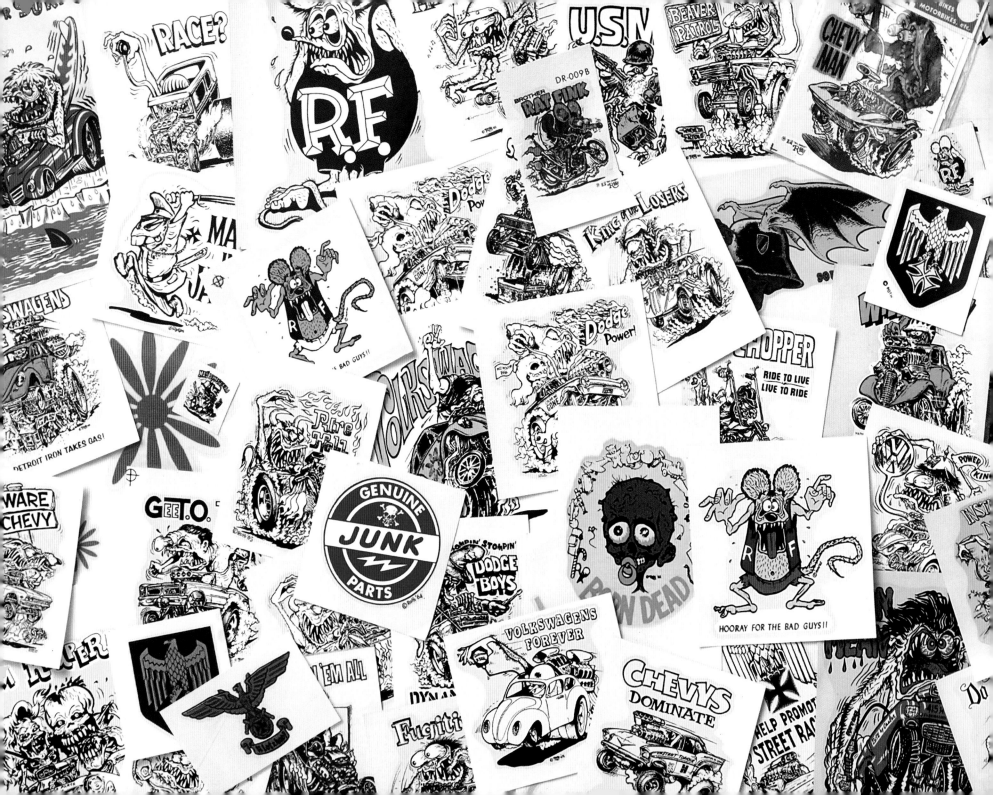